Nailed

Nailed

**THE HISTORY OF NAIL CULTURE
AND DZINE**

DAMIANI
STANDARD PRESS

HISTORIAL TIMELINE OF NAIL ADORNMENT

- - -

GLOBAL CONTEMPORARY NAIL CULTURE

- - -

DZINE'S INSPIRATION, APPROPRIATION, HOMAGE [OPENING WORDS BY KIM HASTREITER]

- - -

'IMPERIAL NAILS' NYC EXHIBITION

As a child of first generation Puerto Rican immigrants in the United States, well paying jobs were scarce. So in order to supplement extra income, my mother created a bootleg salon in our home. I clearly remember the horrible smell of the chemicals but enjoyed hearing the women gossip about current events or personal issues while getting a makeover. I loved having people over to the house and the sense of community it created. I wanted to re-create this feeling and tell a story that was honest while still keeping true to my language and body of work. In a sense, my exhibition and project, "Imperial Nail Salon" (named after a custom high-end clothing boutique owned by Mr. Dapper Dan, an 80's fashion designer based in Harlem on 125th street. Dapper Dan created one of a kind, customized clothing that incorporated highly recognizable accessory logos like those of Gucci and Louis Vuitton, featuring them in non-traditional ways), is a homage to my mother. As with my investigation and studio practice of Kustom Kulture, I found the same passion within this community of people and those creating these special objects. The more involved I became, the more I learned this really is an art form. The people involved in this community have no formal art training, yet their passion to make beautiful, over-the-top ornamental objects is what truly struck me, hence the body of work. It has reminded me why I'm an artist and why I choose to create. In the end this culture allowed me to present a visual dialogue using materials in a very unorthodox manner that wouldn't normally be presented in an institution and question how culture and commodity plays into human, social and objectified relationships. Most importantly and historically, the development of Nail Art Culture is about the community that has been built within the confines of a salon, the friendships that develop and the stories that are shared. CARLOS DZINE ROLON

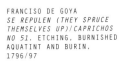

FRANCISO DE GOYA
*SE REPULEN (THEY SPRUCE
THEMSELVES UP)/CAPRICHOS
NO 51*. ETCHING, BURNISHED
AQUATINT AND BURIN,
1796/97

From the gold-flecked nails of the Ming dynasty royalty to the makeshift kitchen salons in inner city Chicago, nail embellishment has provided a social, artistic and historic mirror of humanity's eternal and omnipresent desire to adorn. The custom manicure, now a multi-billion dollar service industry, has become a widely accessible status symbol heavily influenced by quick-cut trends and shifting social prerogatives. A ubiquitous-yet-underplayed art form ripe for consideration, nail art operates as a lens through which to view our contemporary civilization. Traditionally, washing and caring for the hands and feet has always held a strong symbolic presence in history, with descriptions of the feet of Jesus being washed, oiled and buffed by a woman's hair. In line with our eminent history of decoration, our bodies continually express our deepest aesthetic inclinations, and fingernails offer a crucial vehicle for ornamentation. Essentially mammalian claws, our nails have evolved to become tiny canvases for the intricate and evocative application of human culture.

- -

FINGER AND TOE STALLS.
EGYPTIAN, REIGN OF
THUTMOSE III (R. 1479-
1425 BCE). GOLD SHEET.
FLETCHER FUND, 1926
© THE METROPOLITAN MUSEUM
OF ART / ART RESOURCE, NY

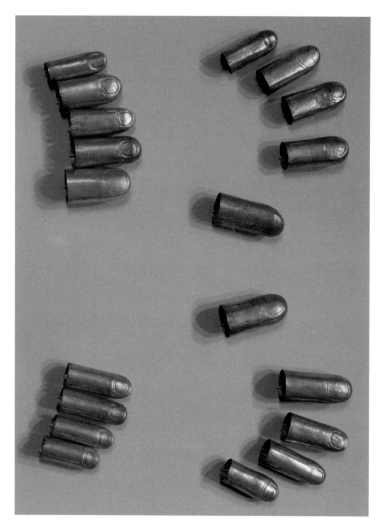

In Ancient Egypt, the color of one's nails was used to indicate social status and sex appeal. Using a rich stain made from the dried and crushed leaves of the flowering henna shrub, Egyptians colored both their hair and fingernails with henna. Providing some of our first glimpses into the legacy of nail adornment, traces of red tint have been detected on the hands and nails of mummies more than 5,000 years old, and hieroglyphics denote the existence of manicuring. Queen Nefertiti has been depicted with finger and toenails painted ruby red, while Cleopatra preferred a deep crimson. In Egypt, nail painting as fashionable for both men and women—Egyptian commanders painted their nails to match their lips before they went into battle. Across the Red Sea, in a 5,000-year-old Sumerian tomb, archaeologists found a gold cosmetics case containing a metal rod meant to push down the user's cuticle: a unique precursor to the modern tools of the manicure.

ANCIENT CEDAR COSMETIC
BOX CONTAINING PRECIOUS
GLASS JARS FILLED WITH
OILS AND PIGMENTS,
AS WELL AS COSMETIC
APPLICATORS.

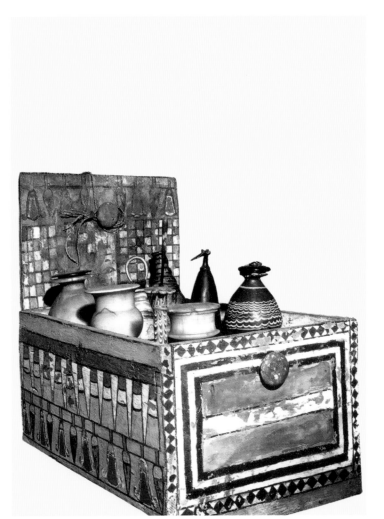

In Mycenaean Greece, artifacts excavated from frescoes suggest that saffron gatherers wore tinted nails. Ideal for creating the base for a stain, saffron threads contain carotenoids, which possess of a rich golden-yellow hue. The people of the Indus Valley Civilization, located in what is now northwest India and Pakistan, stained the tips of their fingers with a coppery red pigment derived from the Kerria Iacca, an insect that secretes a scarlet substance now commonly used as a dye in cosmetics and fabrics. The Indus Valley people wore their nails long and polished, trimming them using special clippers and buffing and filing them against rough walls. Ancient Romans also tinted their nails with insect dye, and invented the process of dissolving dried insect pigment into an ethyl alcohol, creating liquid shellac. This brush-on colorant became a precursor to nitrocellulose lacquer, the primary ingredient in almost all modern nail polish.

IV. MEHNDI BEAUTY IN
ANCIENT INDIA

- -

BACK OF A WOMAN'S HAND
PAINTED WITH HENNA.
PHOTOGRAPHER UNKNOWN.
1984

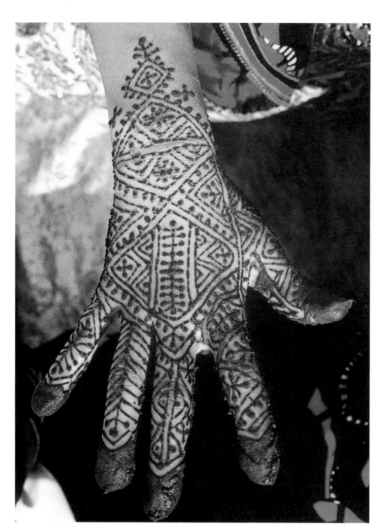

Mehndi, derived from the Sanskrit word mehandika, began in ancient India and remains a significant part of folk decorative art in India. The elaborate application of henna on a woman's hands, fingers, and nails symbolizes eroticism and feminine beauty. Indian mothers decorated their nails following the birth of a child to bring fast recovery and protection, illustrating how this female-centric practice encourages social gathering and an environment for shared time and conversation. Though an Indian woman's motivation for adorning herself was traditionally based more in ritual than glamour or materialistic artifice, similarities tie the age-old practice of Mehndi to Western culture's modern manicure. As with the elaborate layering of lacquers found in contemporary custom nails, Mendhi is applied in complicated gradations and layers, and its complex details are achieved today with the use of stencils and adhesives, and varying strengths of color.

V. MEDIEVAL AND MIDDLE
AGE BEAUTY REGIMES

- -

THE DEVIL APPLYING
COSMETICS. ENGLISH
WOODCUT, EARLY 17TH
CENTURY

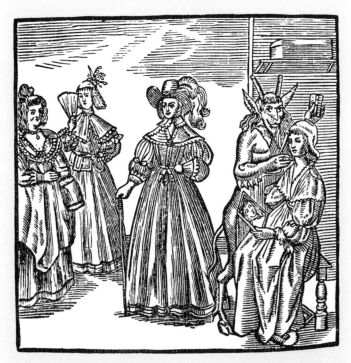

The devil applying cosmetics

Though not as technologically advanced as contemporary manicure services, the adornment of one's nails was as much of a time investment in the Medieval and Middle Ages as it is today. This era harkened a movement toward experimentation, with women applying a wide variety of plant- and mineral-based colors on their faces and hands. In Ireland, Madder root was crushed and finely blended to create a red pigment used to stain the fingernails. A waiting game to be sure, the root had to be left in place in order to dry and to take to the surface, and little or no activity could be performed during that time. Early versions of modern manicuring tools can also be traced to this period, reflecting the general rise of regular bathing habits. Considered necessary tools by many, the supple surfaces of leather scraps were used to buff the nails to a soft shine, and nail shears have been unearthed in many gravesites, having been buried along with their late owners.

CHINESE ANCESTRAL
PORTRAIT. GOUACHE ON
PAPER, DATE AND
PROVENANCE UNKNOWN.
COLLECTION OF
CARLOS ROLON, CHICAGO

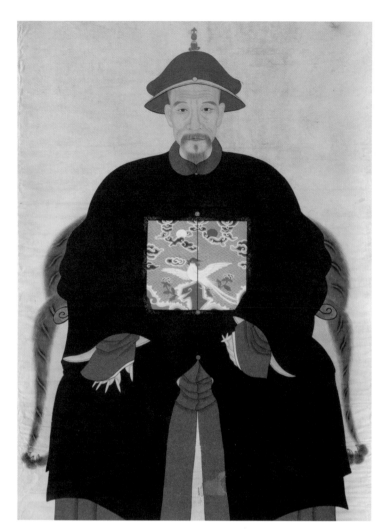

The illustrious rise of the fake nail began in early Chinese civilizations. Men and women who sought to emphasize their social standing—as well as protect themselves from evil spirits—wore long nails that expressed their freedom from manual labor. This trend led to the wearing of nail protectors, which were often ornate and sculptural, with complex cloisonné designs inlaid with precious stones. Elite court women would wear two or three nail shields on each hand, indicating a leisurely existence, while dancers wore metallic tips to enhance and highlight their exotic hand movements. Prior to 600 B.C., the Chinese used rose, orchid and impatiens petals to create nail colors. When combined with alum and applied to the nails, the flowers yielded an array of red and pink tones. During the Chou Dynasty, men and women of the highest nobility would decorate their nails with sprinklings of gold and silver dust.

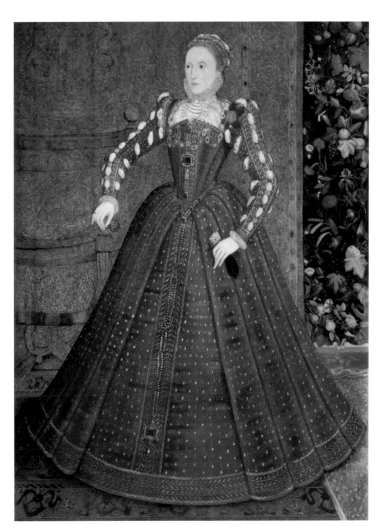

'HAMPDEN' PORTRAIT OF
ELIZABETH I OF ENGLAND.
AN EARLY FULL-LENGTH
PORTRAIT OF THE
YOUNG QUEEN IN A RED
SATIN GOWN.

Religious institutions condemned women for using cosmetics and instead empha-
sized the importance of feminine purity. Still, many women of this era paid a great
deal of attention to the powdering and rouging of the face as well as to the elabo-
rate preparation of their hair. However, little record exists concerning the practice
of nail coloring. Instead, hands were kept immaculately clean with slightly shiny
nails suggesting the use of varnish.

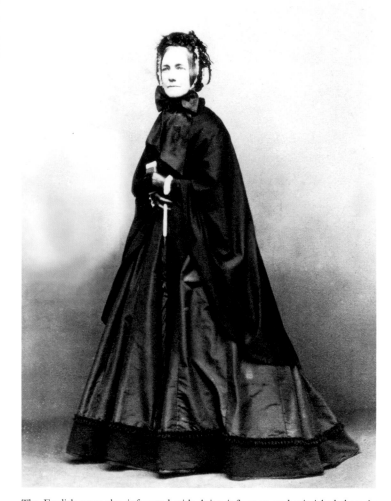

The English were also infatuated with Asian influences and mimicked them in style and taste. In the late 17th century, the English upper class began growing the nail of their pinky finger to an extreme length. When visiting the home of a friend or acquaintance, the pinky nail-bearer gave a stealthy scratch at the door with the elongated claw, rather than a simple knock. Moral purity heavily influenced beauty during the Victorian period, and unstained hands, with white and regularly formed nails, were esteemed as an aesthetic must, linking physical hygiene and moral purity. While colored and artificial nails swept up women's fashion in parts of Europe, British Victorian women valued cleanliness and morality over ostentation and adornment. Nails were kept almond-shaped, short, and slightly pointed. At the height of this ascetic chic, just a little lemon juice or vinegar and water were used to whiten the nail tips.

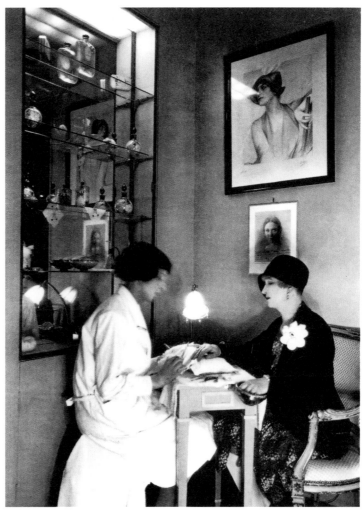

IX. EARLY 20TH CENTURY
NAIL INVENTIONS

...........................

PHOTOGRAPH OF THE ANTOINE
BEAUTY SALON IN PARIS.
1929

In the early 20th century, the manicuring industry dramatically shifted to what it is today, when rapidly drying nitrocellulose lacquers—originally used in automotive paint—were introduced to nail polish enamel. It is French makeup artist Michelle Menard who is credited with the concept of adapting high-gloss car paint to nail color. Menard's revolutionary liquid polish quickly gained popularity for its simple application technique and unmatched brilliant gloss. With the advent of the modern polish, several trends emerged. Leading MGM studios manicurist Beatrice Kay invented the "moon manicure" look, where pink polish was applied to only the central part of the nail, while the tip and the lunula—the lighter crescent-shaped visible base of the nail often called the moon—was left white. The French manicure—which originated in 18th-century Paris—was inspired by the delicate beauty of natural nails.

French Princess de Faucigny-Lucinge is credited with igniting the trend—quickly adopted by Hollywood starlets and society queens—of matching vibrant red nails to summer-tanned bodies. In the early 1930s, decorative nail appliqués began appearing in the form of flowers, hearts, and other celebratory symbols, and before his Tupperware empire infiltrated American households, Earl Tupper was known for making such embellishments. Charles and Joseph Revson's Revlon shot to success with the introduction of the first commercially available nail enamels to American women. Notably, they used pigments rather than dyes to produce more vivid and longer-lasting colors. By 1930, manicuring was such an intrinsic part of the beauty routine that a cosmetologist at the time encouraged women to budget for 26 annual manicures. However, at the end of this era World War II, a shortage of nitrocellulose for nail enamel had to be supplemented with film scrap by manufacturers.

XI. THE BRAVE NEW NAIL OF
THE 1950'S

..........................

WOMAN PAINTING HER
FINGERNAILS.
PHOTOGRAPHER: NINA LEEN,
1950'S

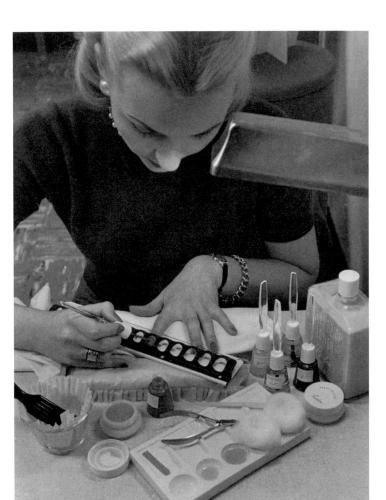

When dentist Fred Slack broke his nail in 1954, he invented a realistic-looking artificial nail extension with an acrylic polymer originally used to fill cavities. This innovation prompted a revolution in the use of artificial nails. After working with different materials, Slack and his brother finally developed an ideal formula, and started a company: Patti Nails. Patti Nails, along with Glamour Nails and Mona Nails, would go on to dominate the nail business until the early 1970s, when acrylic nails would become more practical and easy to apply. Ironically, these new false nails would make domestic tasks, considered very important in this time period, cumbersome. The 1950s nail was either red or pink, medium-length, tapered at the ends and oval in shape. Matching one's nail lacquer to lipstick became the predominant trend, and in an attempt to create heat over this imperative, Revlon launched its wildly successful Fire and Ice advertising campaign in 1952.

MAGAZINE ADVERTISEMENT,
PHOTOGRAPHER UNKNOWN,
OCTOBER 1968

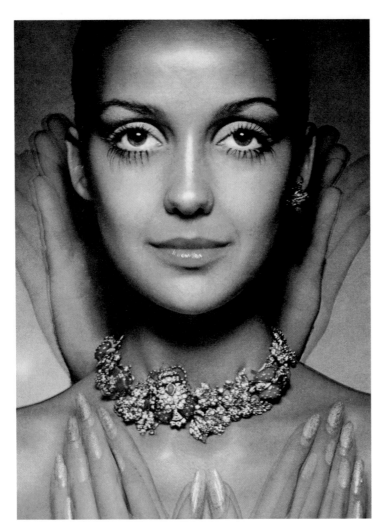

While the older generation held onto the more traditional bright corals and deep reds, American teen-aged girls were given a polarizing palette of hues to choose from: by the summer of 1965, cosmetics manufacturer Estée Lauder had 41 shades of nail color. Softer, muted ivories, tans, pearls, pastels, and translucent polishes were met with the more outlandish, candy-colored, glittery novelty tones, complete with playful appliqués. In London, the major proponents of these color schemes were the Mods. Up against the au natural hippies, the Mods went from wearing pearl pinks, whites, and nudes in the day to flashing brightly-colored nails adorned with painted flowers and designs brushed on with artist's oil paint at night. Following suit, Mary Quant, the British mod fashion maven, launched a line of cosmetics that included her 24-karat gold leaf nail product, Nail Bullion, which glimmered with flecks of shiny silver, while London-based Biba offered purple and black nail varnishes.

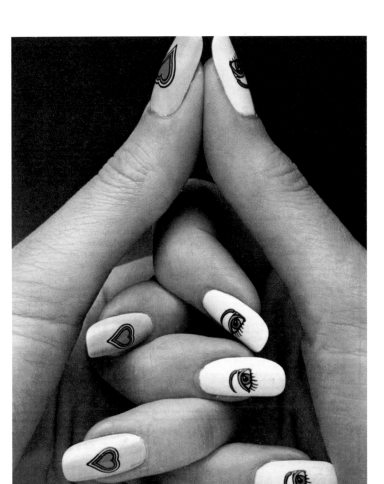

XIII. BACK TO NATURE IN
THE 1970'S

..........................

MAGAZINE ADVERTISEMENT
FOR *THE COLORIFICS*.
PHOTOGRAPHER UNKNOWN.
APRIL 1973

The playfulness of the 1960s left little restriction for nail art in the 1970s. In May 1970, Vogue featured an iconic image of pedicures by Chilean makeup artist Jose Luis using Givenchy designs. These indulgent fads did not entirely catch on, and by the following year a new awareness of the environment and individual well-being led to an emphasis on back-to-nature cosmetics: the so-called natural look came to define the next several years. Plain, buffed nails were popular, however lengths stayed a moderate medium. Clear varnish topcoat on over the colored polish became a staple manicure choice. While mainstream fashion tended toward simplicity, a number of subcultures influenced cosmetic trends. Black nail polish was brought into the mix with the help of music icons David Bowie, Freddie Mercury, and KISS, and rocker Ozzie Osborne never failed to wear his black nails on stage and for photo shoots.

IMAGE BY JOHN HEDGECOE
FROM *JOHN HEDGECOE'S
ADVANCED PHOTOGRAPHY*.
1982

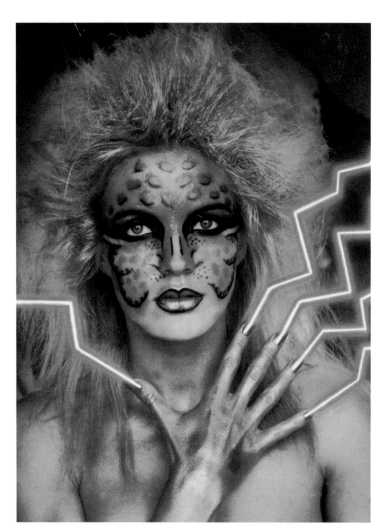

By the 1980s, nails were painted in neon and jewel tones, textured with glitter, shaped square and emboldened with acrylic enhancements. These outrageous styles contrasted nicely with the powerful, polished women's fashion statements that developed during this time, and companies like Avon and Mary Kay offered complete cosmetic color palettes to take the guesswork out of choosing the right color. During this period, urban women began to indulge in weekly manicures, indicating growing popularity in the pampering and beauty industries. In 1981, Essie Weingarten premiered a line of polishes in unconventional colors, with charmingly irreverent names. The line has since grown from 12 colors to more than 200 by 2011. Also founded in 1981, salon staple OPI became globally renowned for its shades designed by founder Weiss-Fischmann, based on her ultra-'80s mantra of "color forecasting, sense of style and instinct for what women want."

NEWSPAPER FEATURE.
PUBLISHED IN NEW JERSEY.
AUGUST 31, 1997

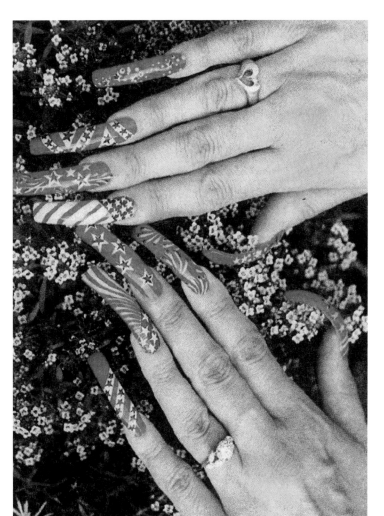

Like much of pop culture in the 1990s, nail art took a turn toward grunge, with post-apocalyptic colors like Roach, Smog and Rust by Urban Decay highlighting the anti-glam trend. The '90s psychedelic rave scene also got a nod from Hard Candy, which packaged its nail polish with bubble gum machine rings. Bling inspired nail art heralded a return to excess in the 2000s, when high-end labels ruled the fashion-conscious. In 2005, Essie created "I Do," a polish blended with powdered platinum and priced at $250 per bottle, earning its rank as the most expensive nail polish in the world. Celebrities helped to drive nail art in this period, when stars flaunted extra short nails splashed with chic jewel tones and novelty shades. As awareness about climate change began to enter social consciousness, in the later '00s, nail technology moved toward green manufacturing, and many polishes, including the RGB line, have been developed with fewer toxic chemicals.

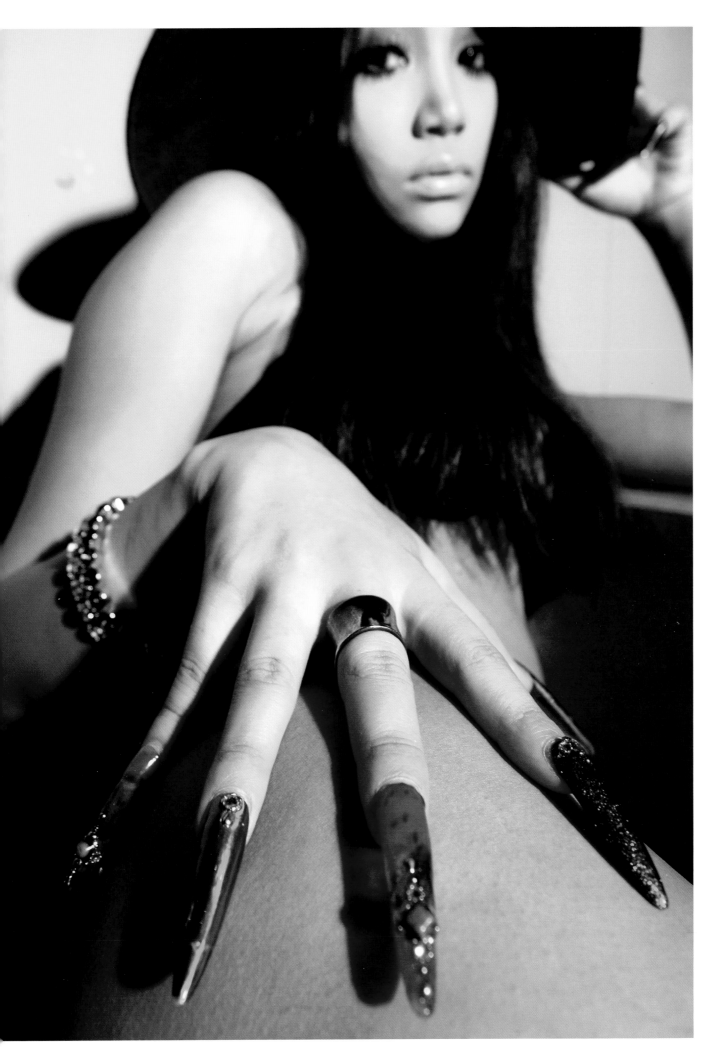

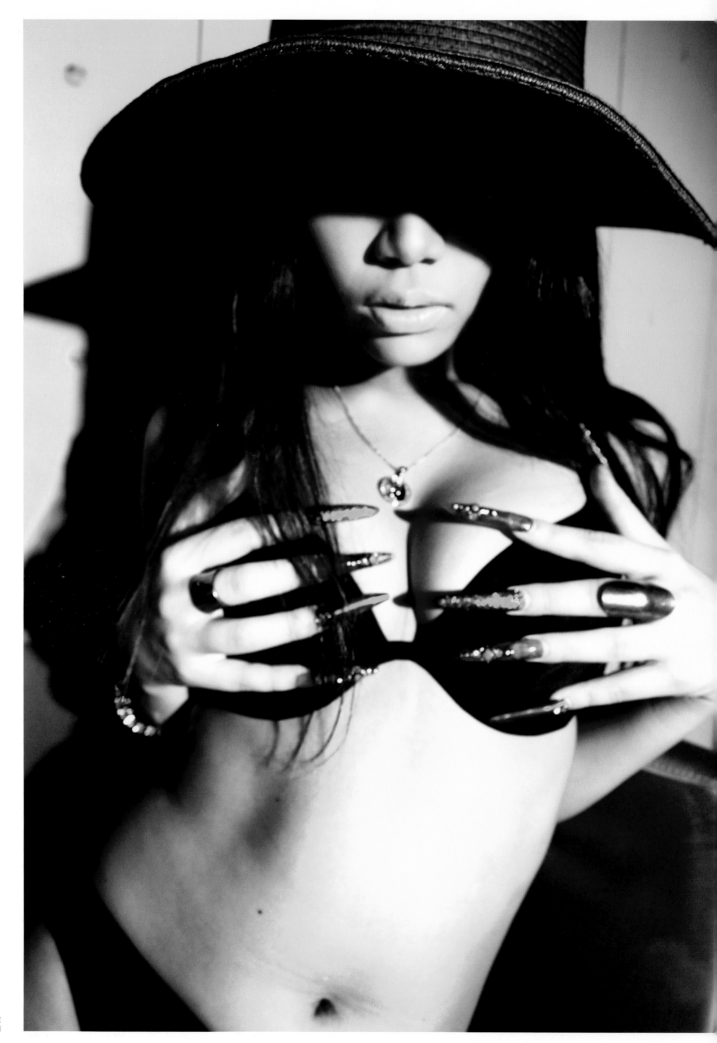

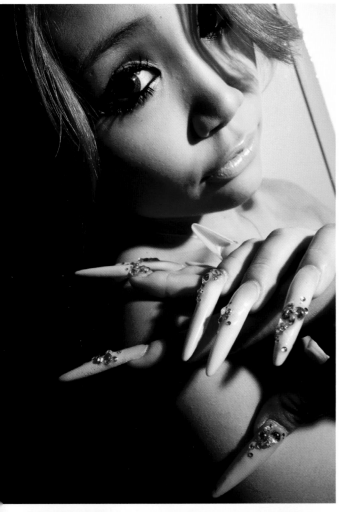
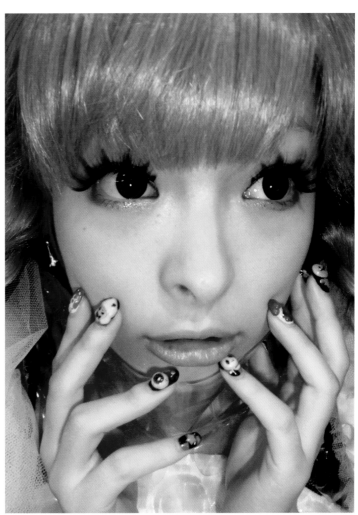
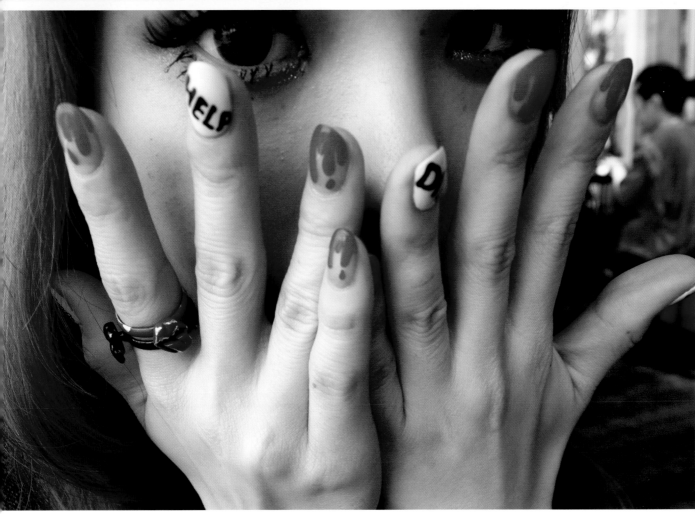

PHOTOS/ YONE
[JAPAN]

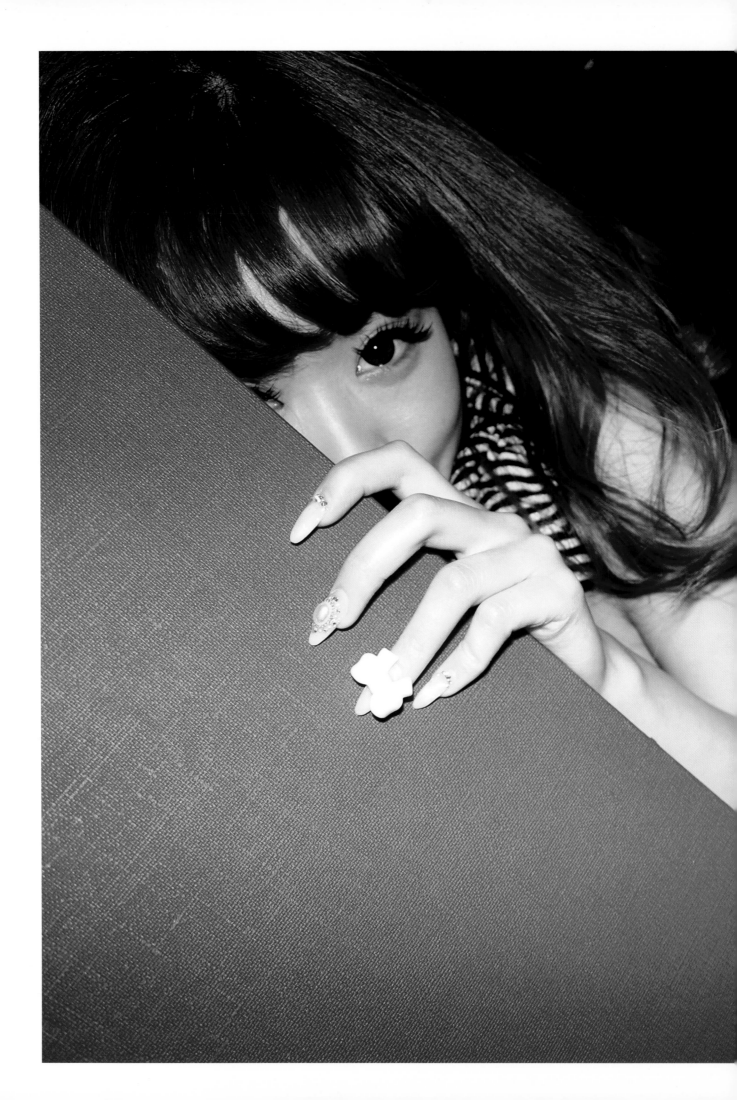

PHOTO/ YONE
[JAPAN]

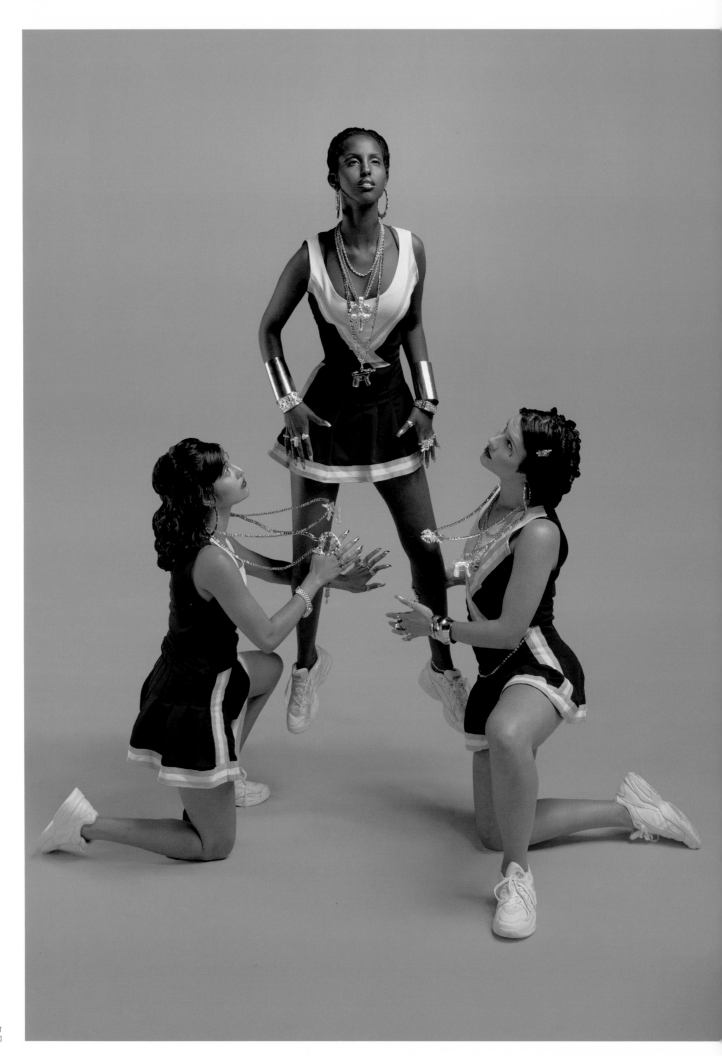

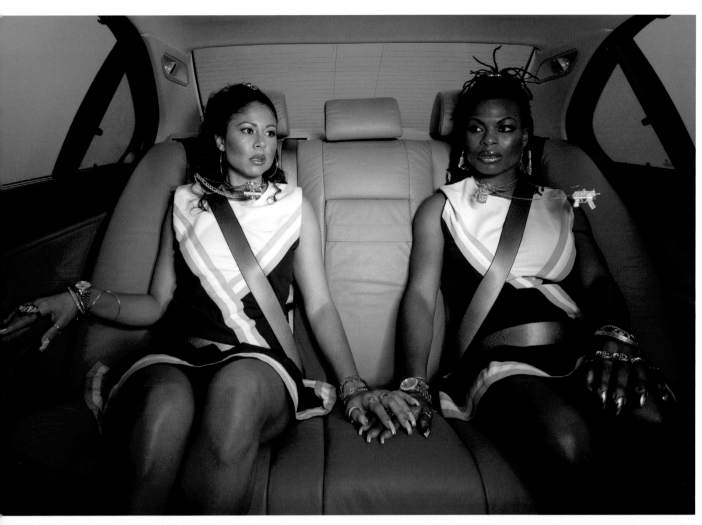

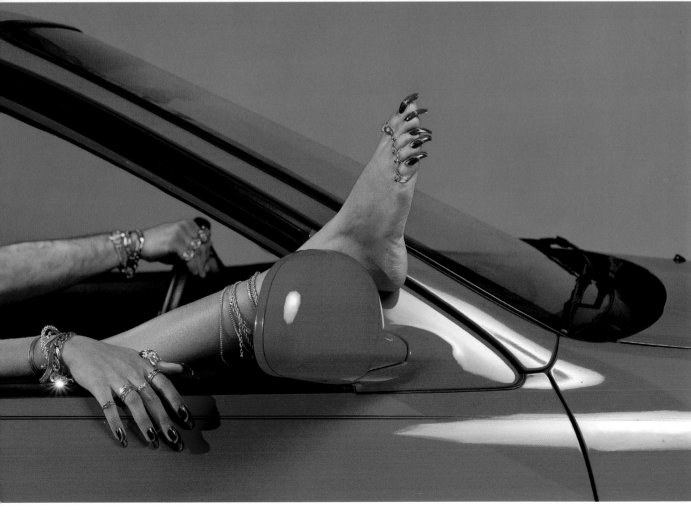

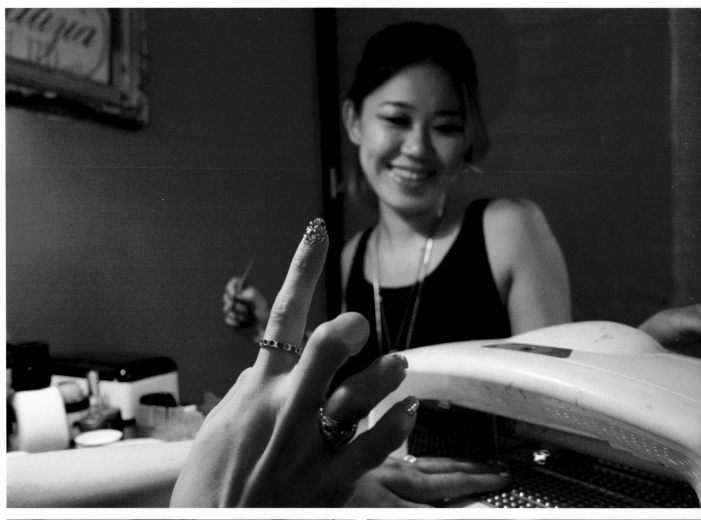

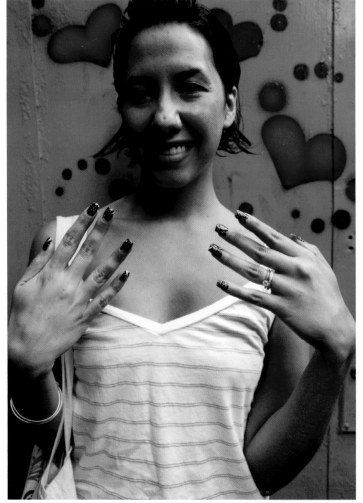

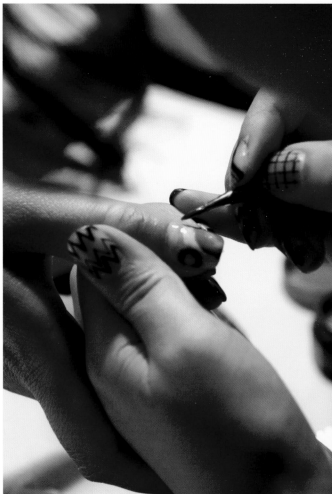

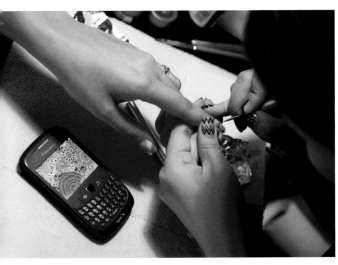
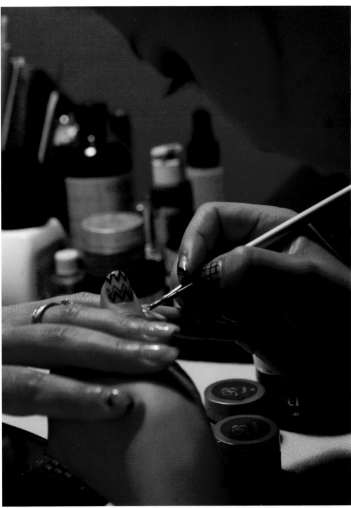
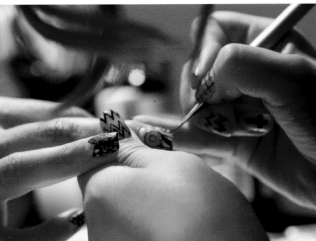
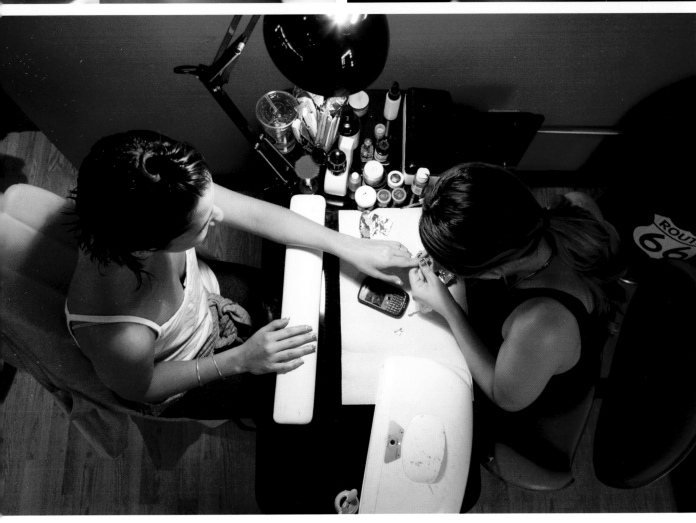

PHOTOS/ CHRIS MOSIER
[NEW YORK]

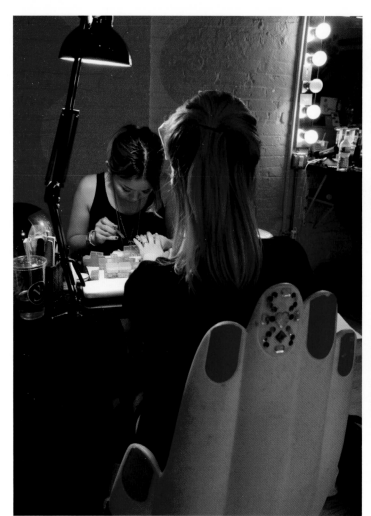
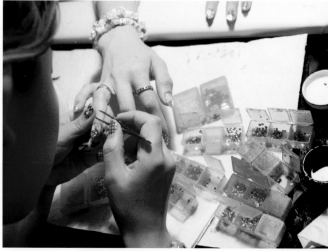
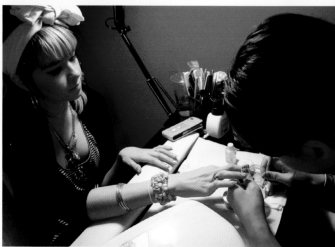
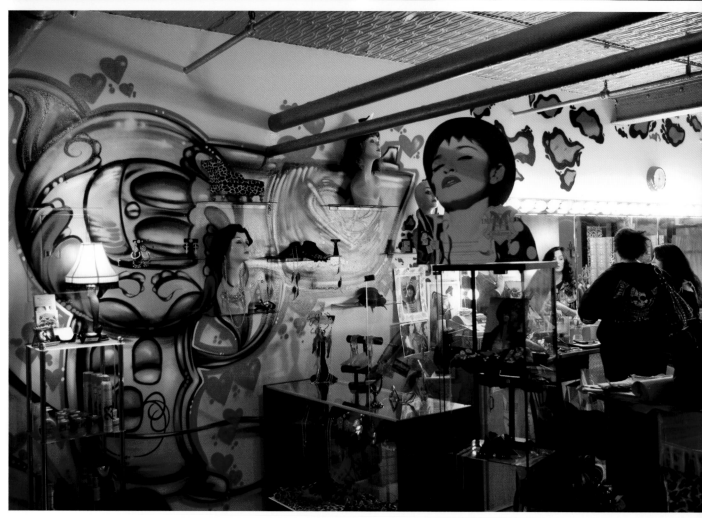

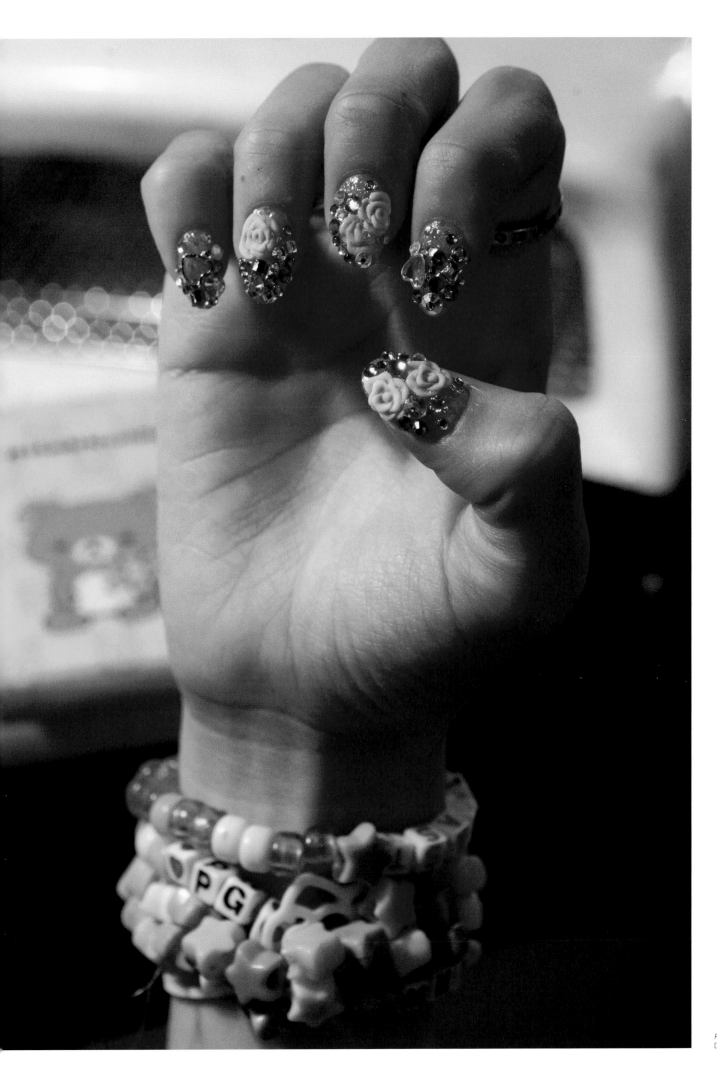

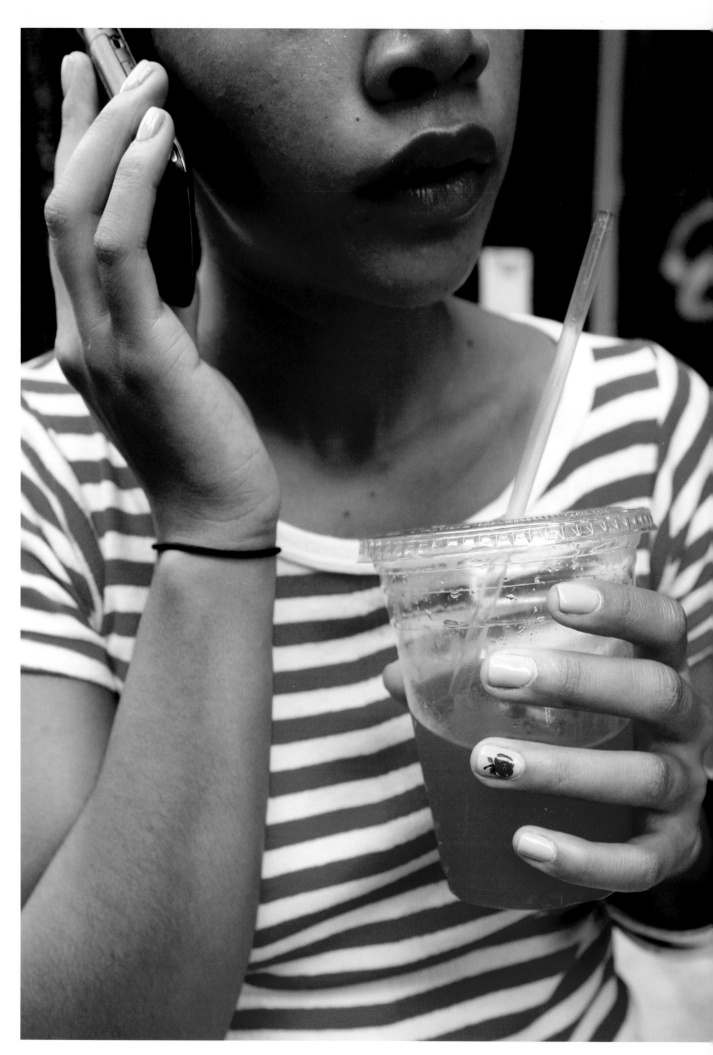

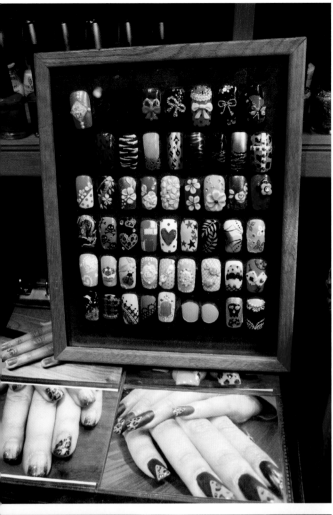
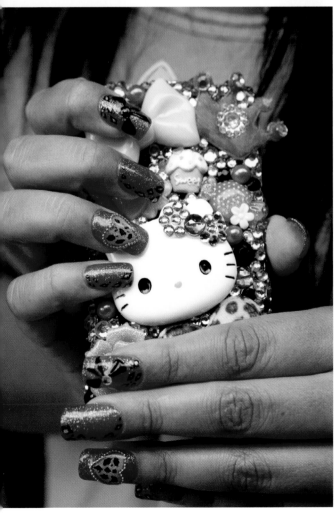
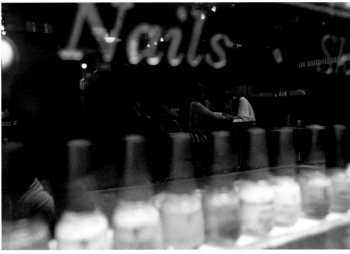
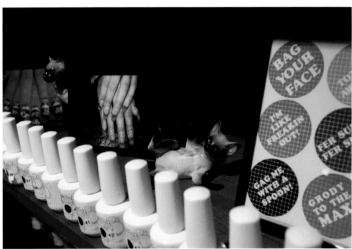
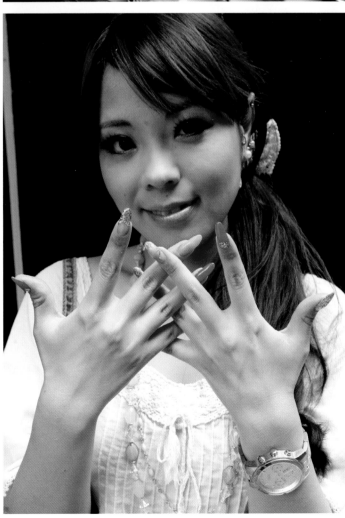

PHOTOS/ CHRIS MOSIER
[NEW YORK]

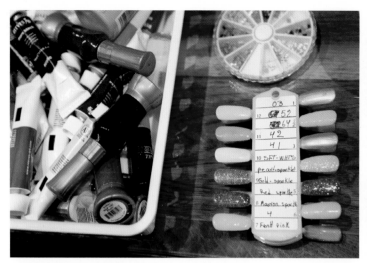

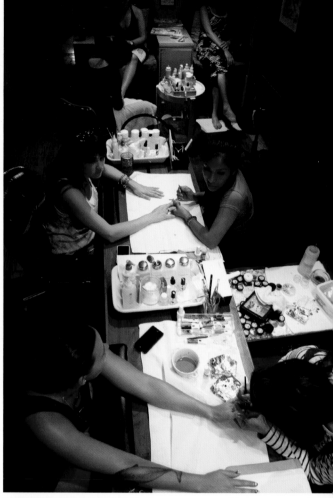

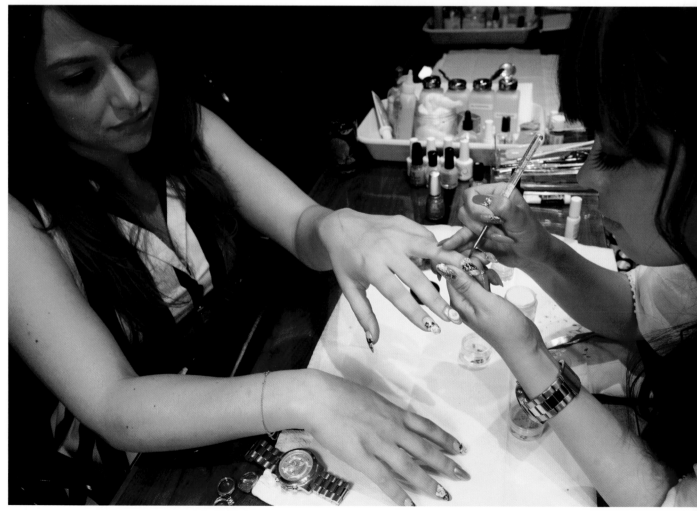

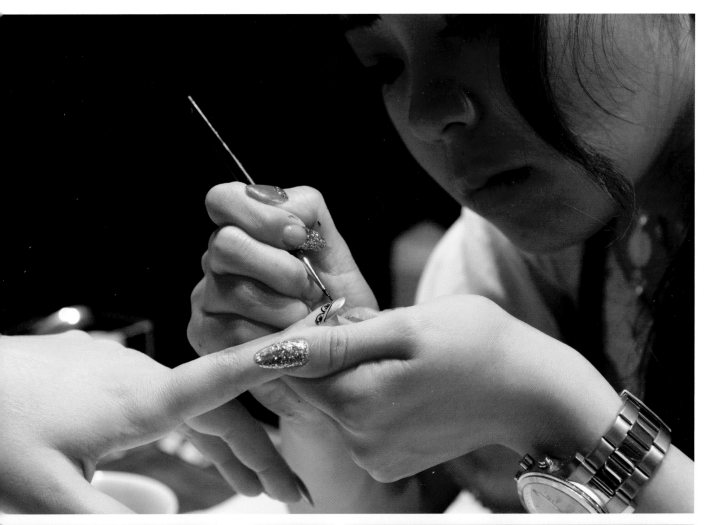

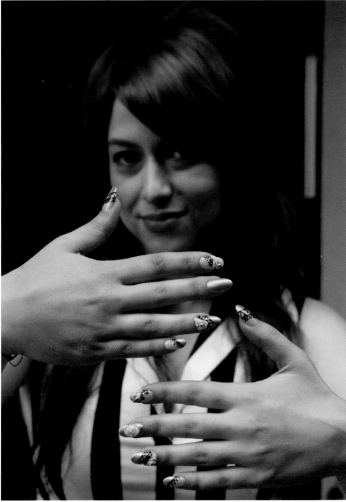

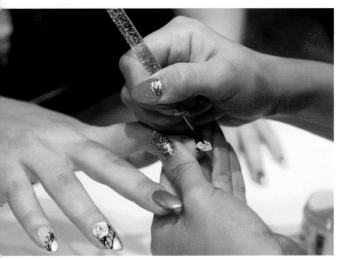

PHOTOS/ CHRIS MOSIER
[NEW YORK]

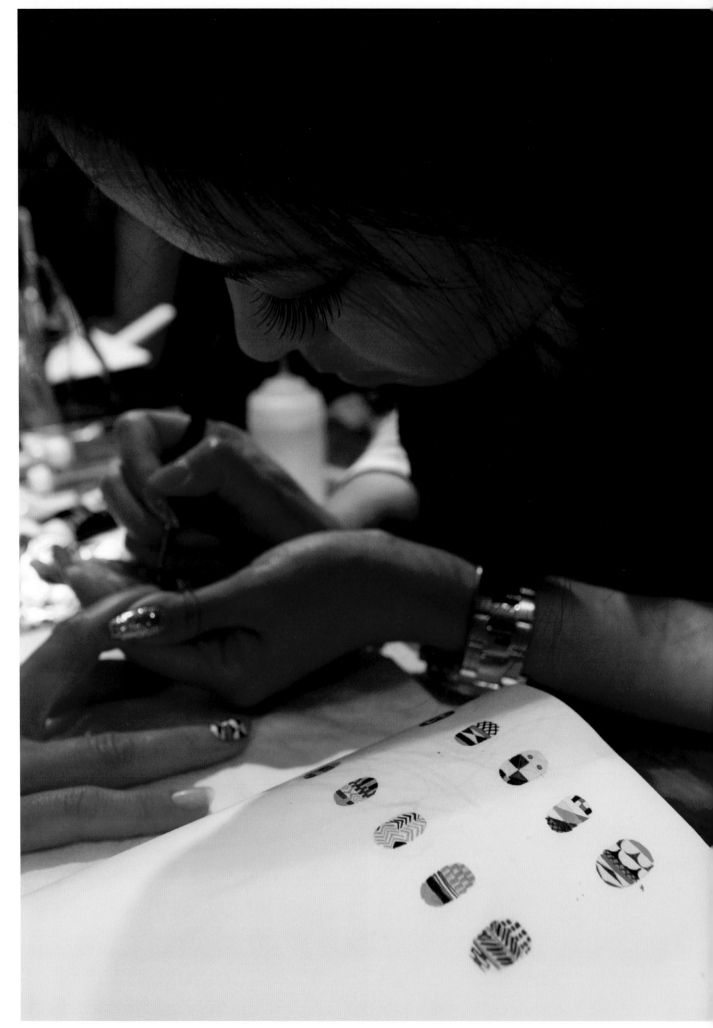

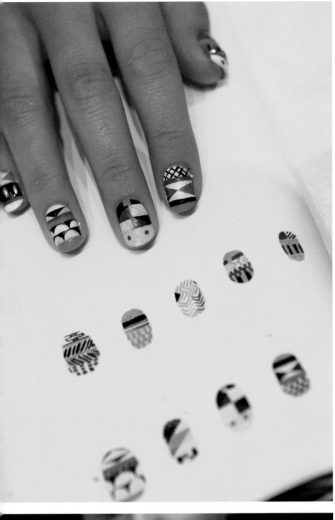

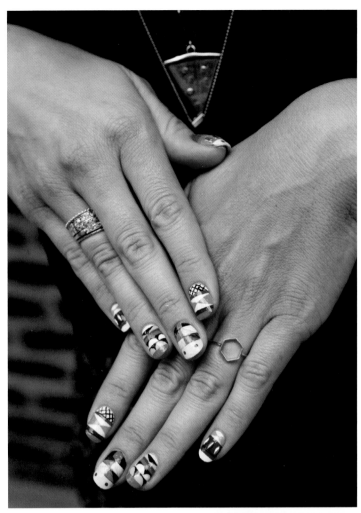

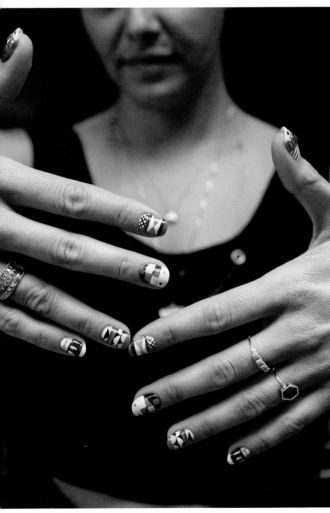

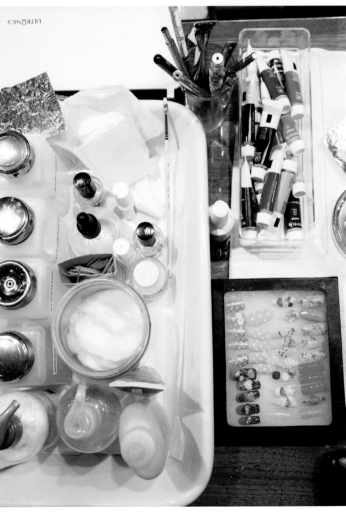

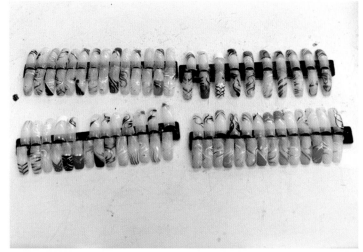

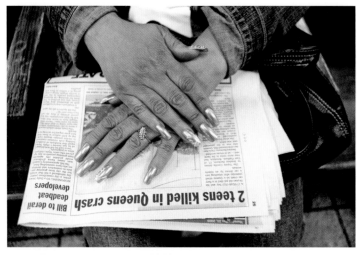

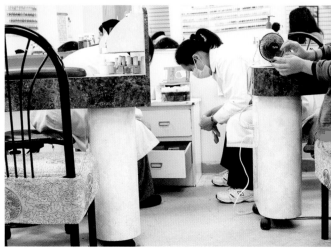

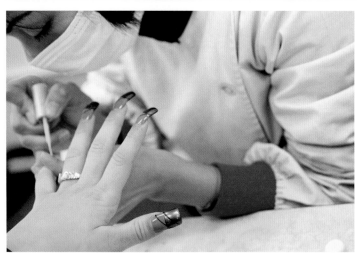

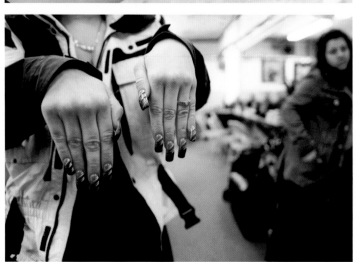

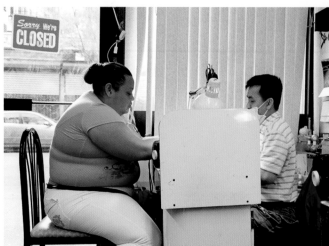

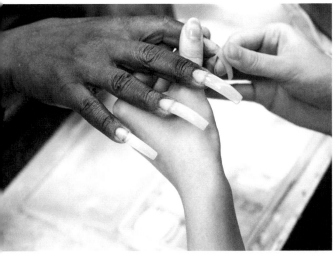
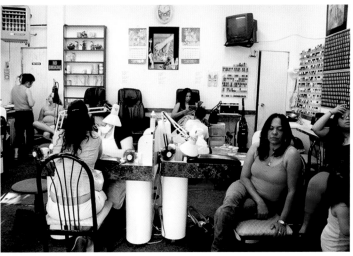
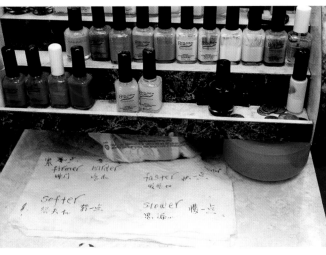

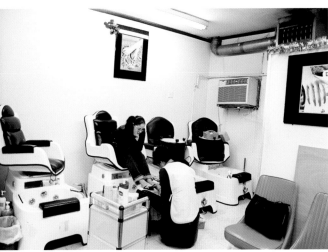
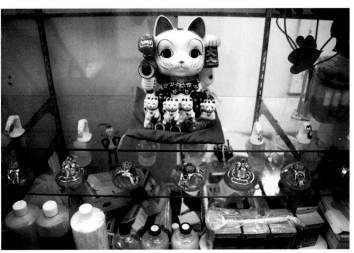

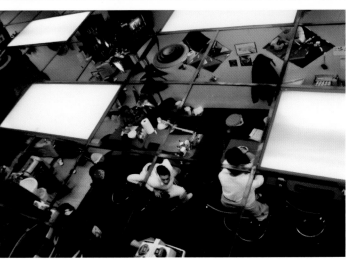

PHOTOS/ MOLLY SURNO
[NEW YORK]

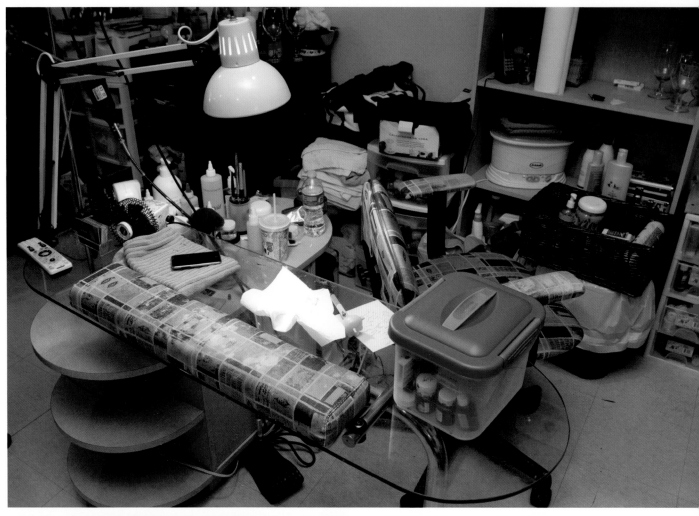

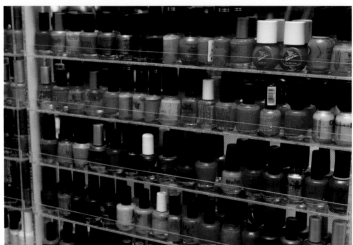

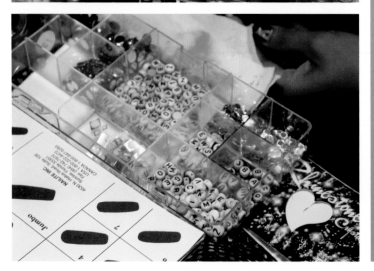

SALON RULES

1) NO Children *unless child is being serviced*

2) NO Profanity

3) NO Sexually explicit conversation

4) No Pets

5) No Show fee enforced
$10.00 up-fee before next service

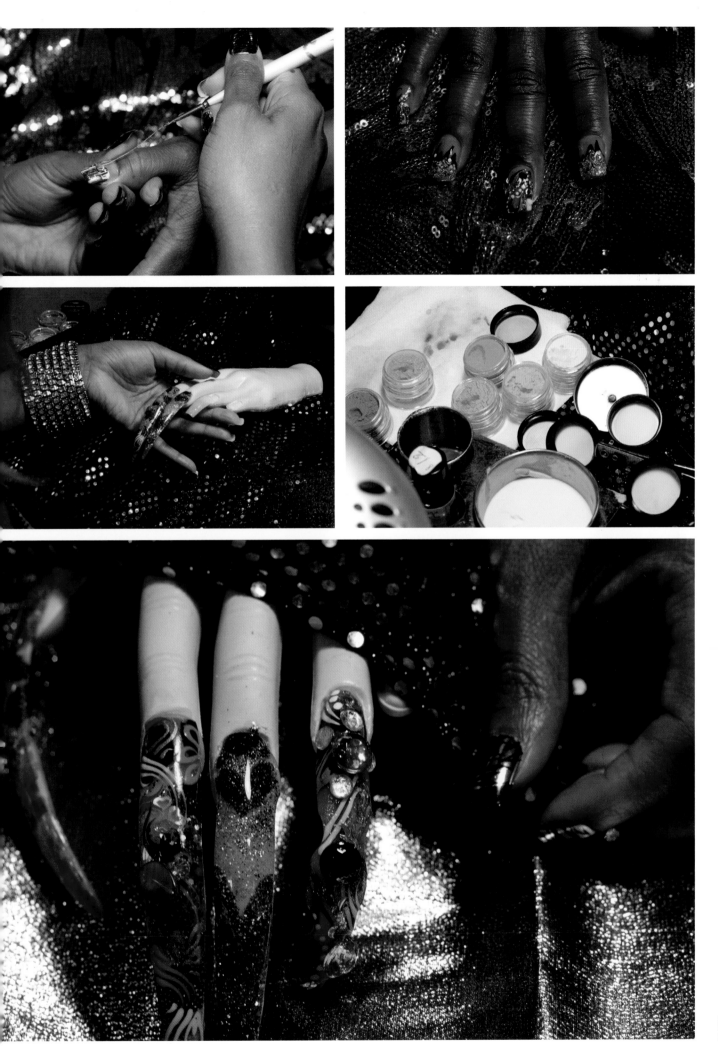

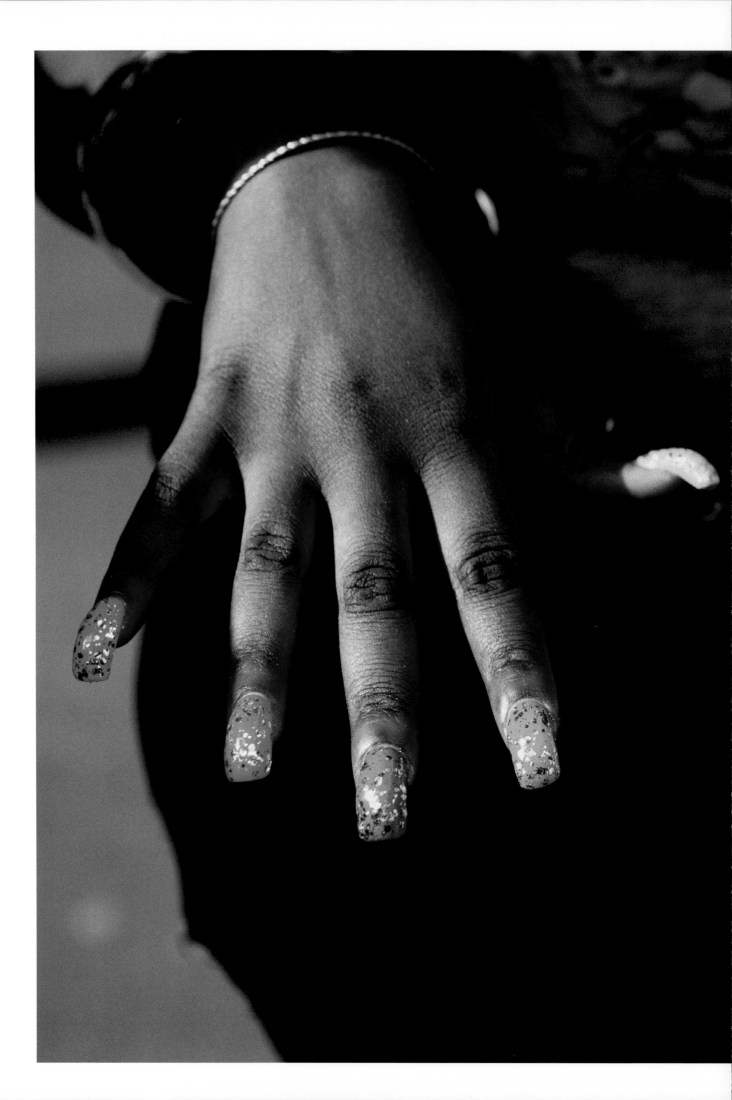

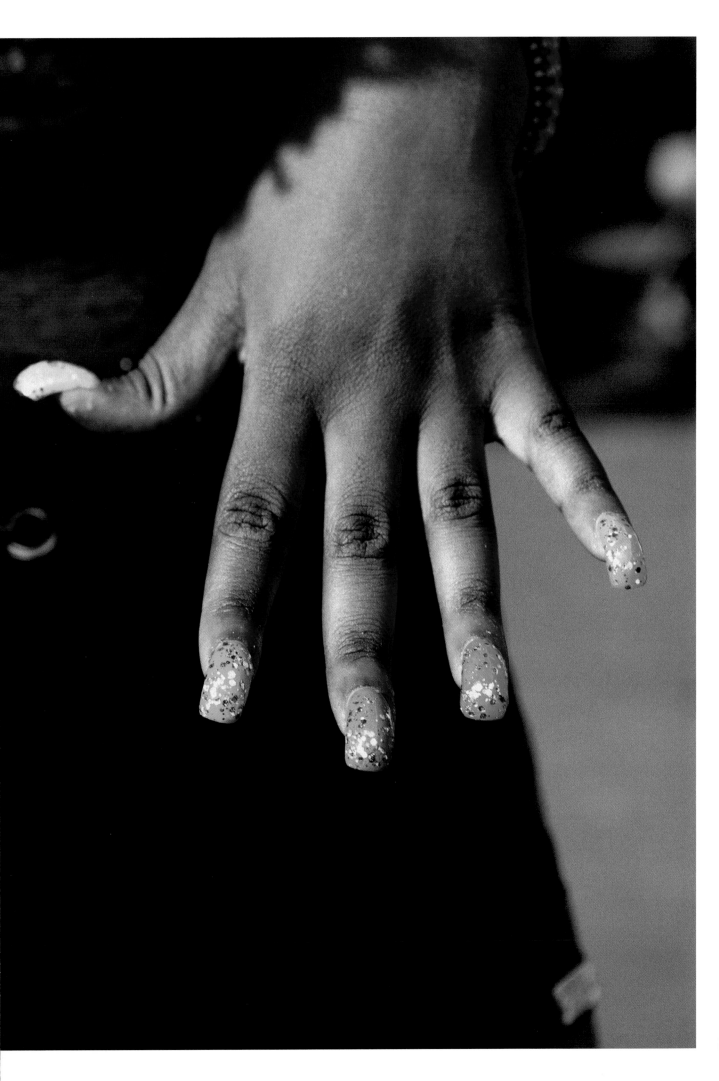

PHOTO/ MAI PERELLO
[FRANCE]

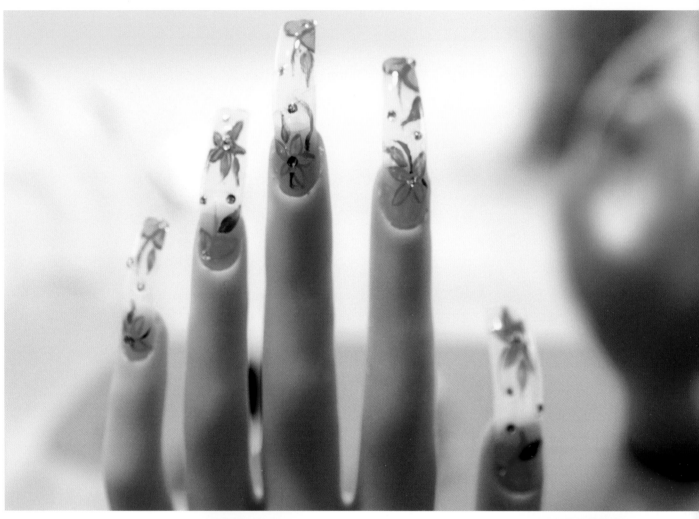

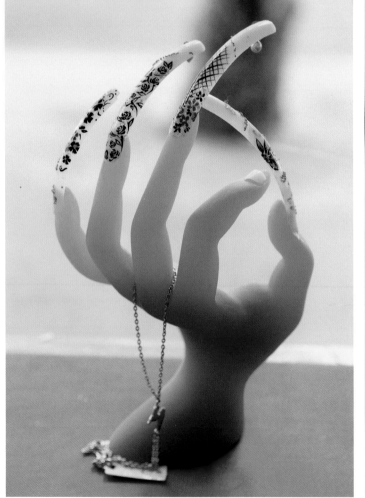

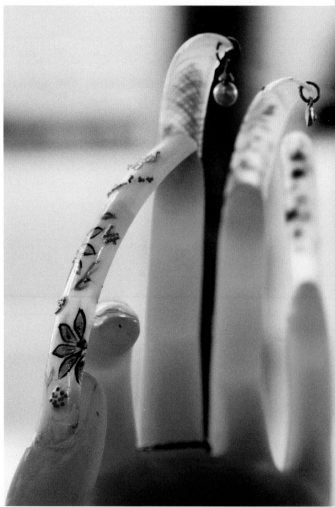

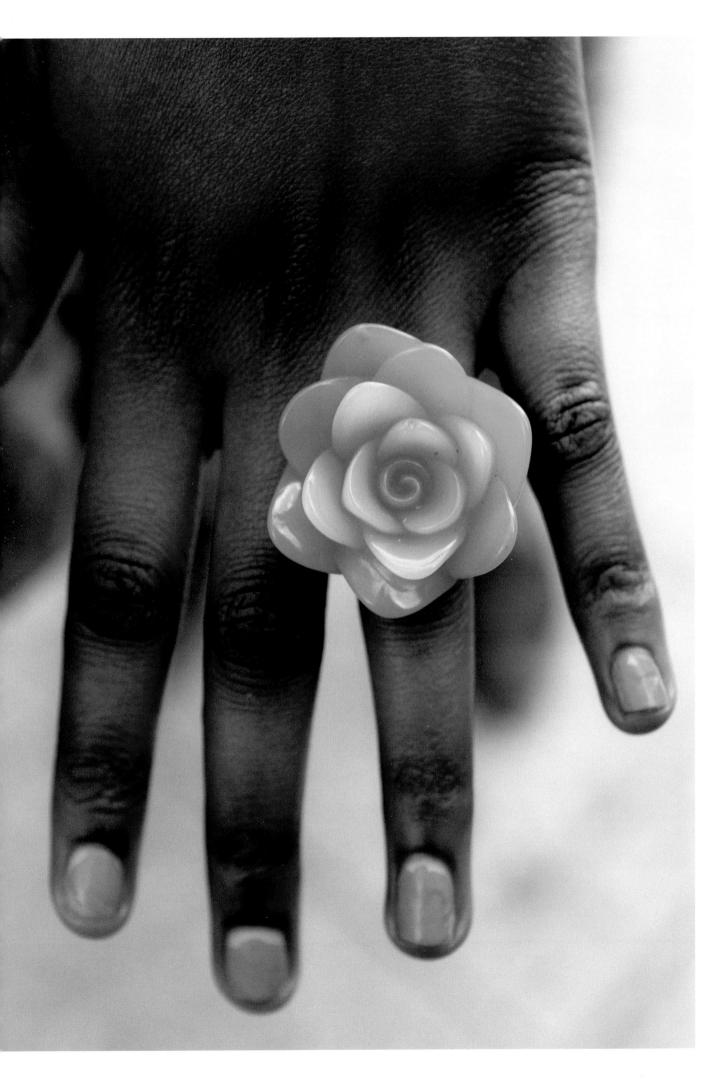

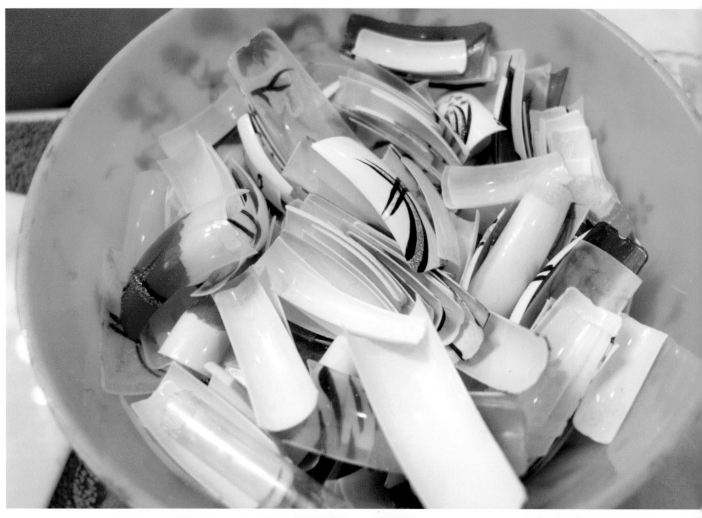

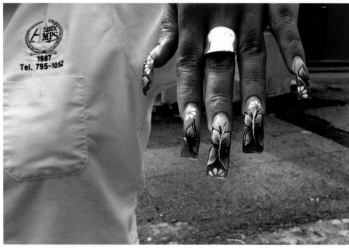

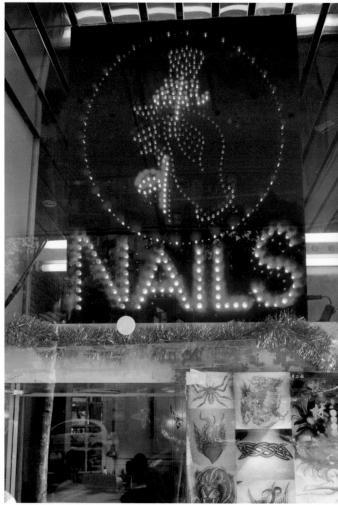

PHOTOS/ CARLOS ROLON
[FRANCE & PUERTO RICO]

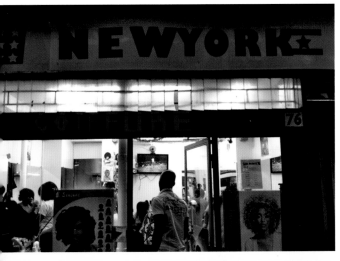

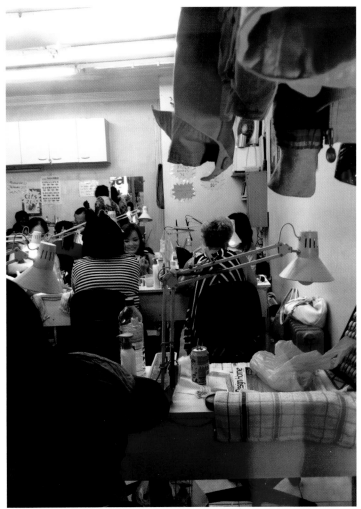

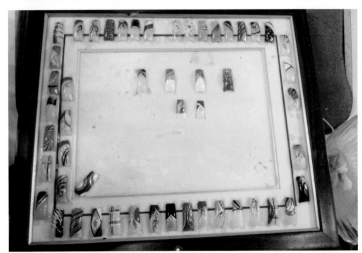

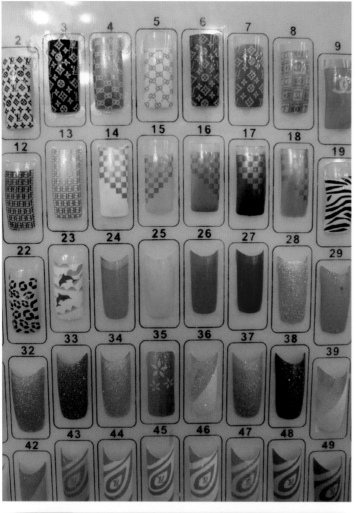

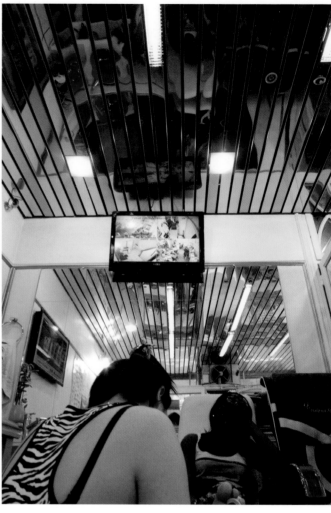

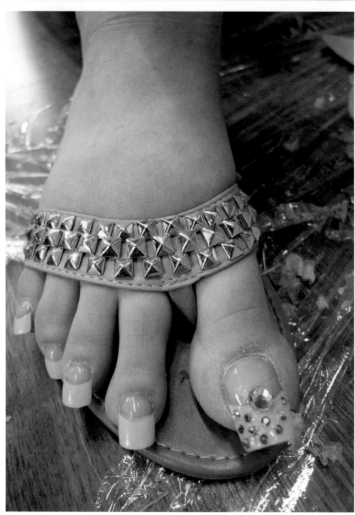

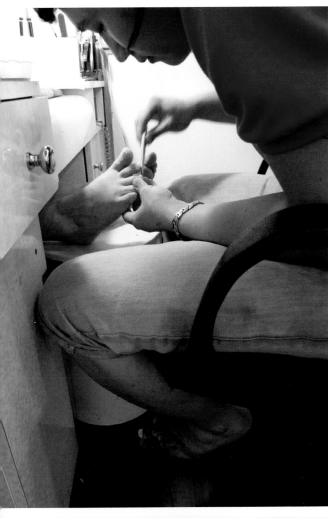
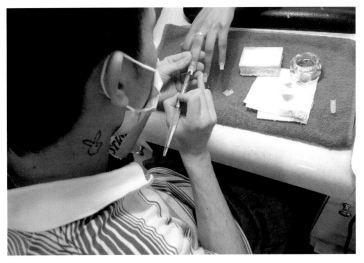
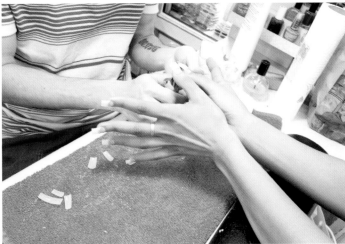
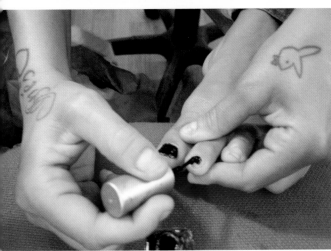
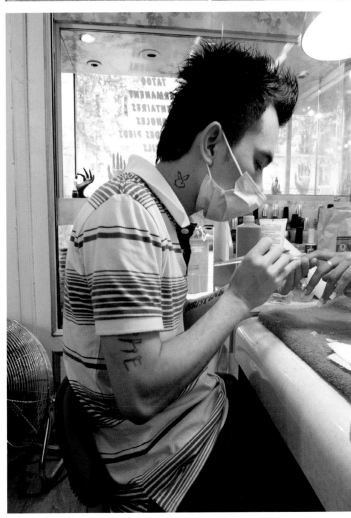
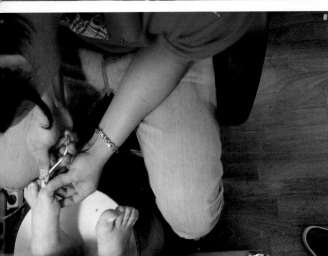

PHOTOS/ CARLOS ROLON
[FRANCE & PUERTO RICO]

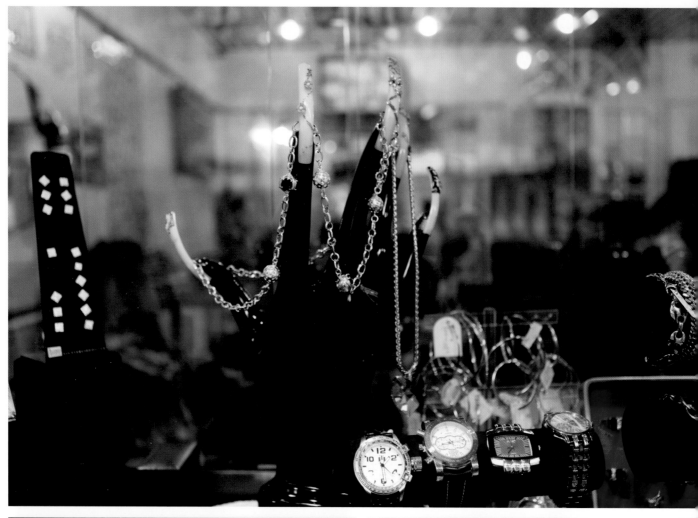

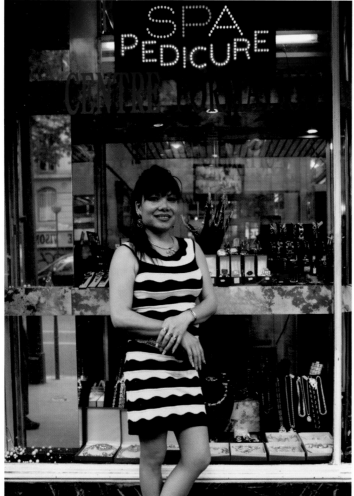

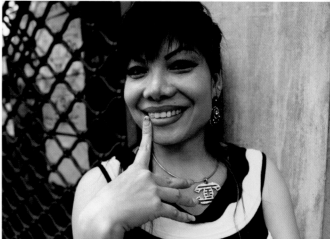

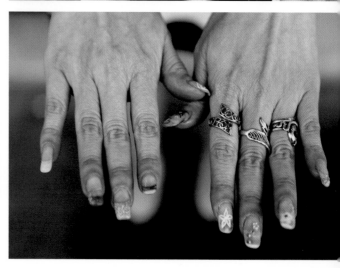

PHOTOS/ MAI PERELLO
[FRANCE]

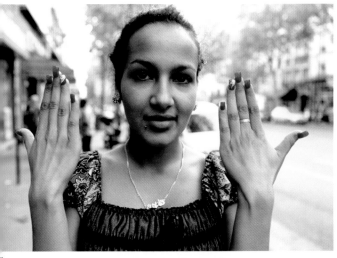
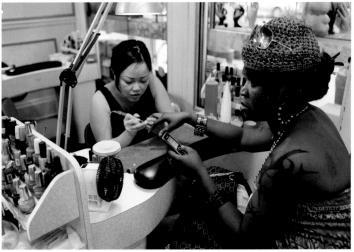
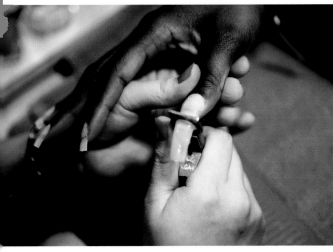
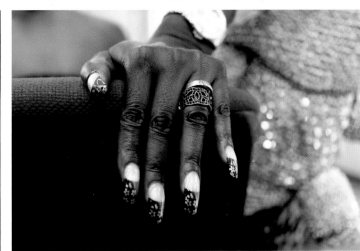

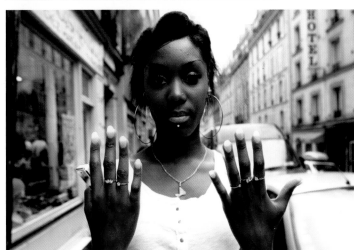
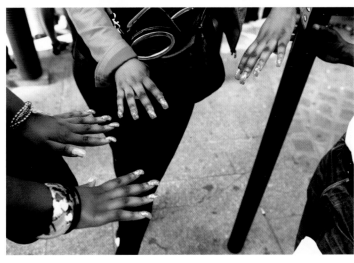

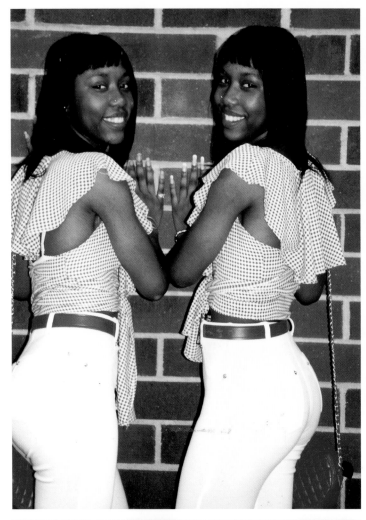

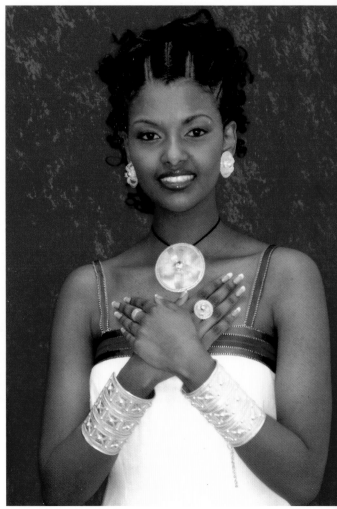

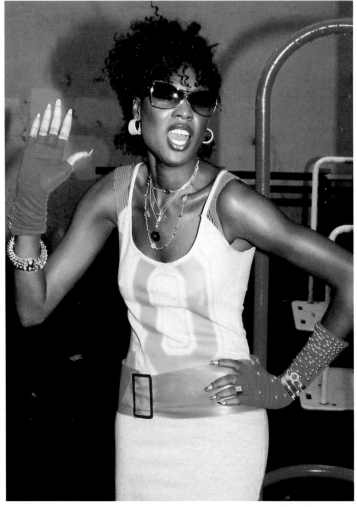

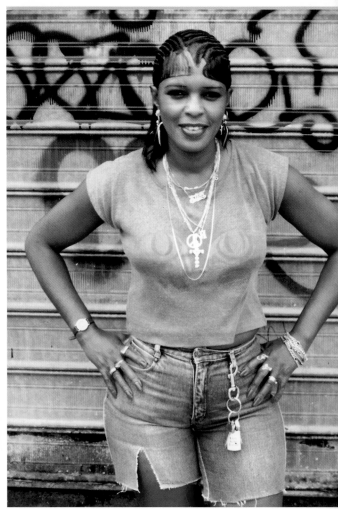

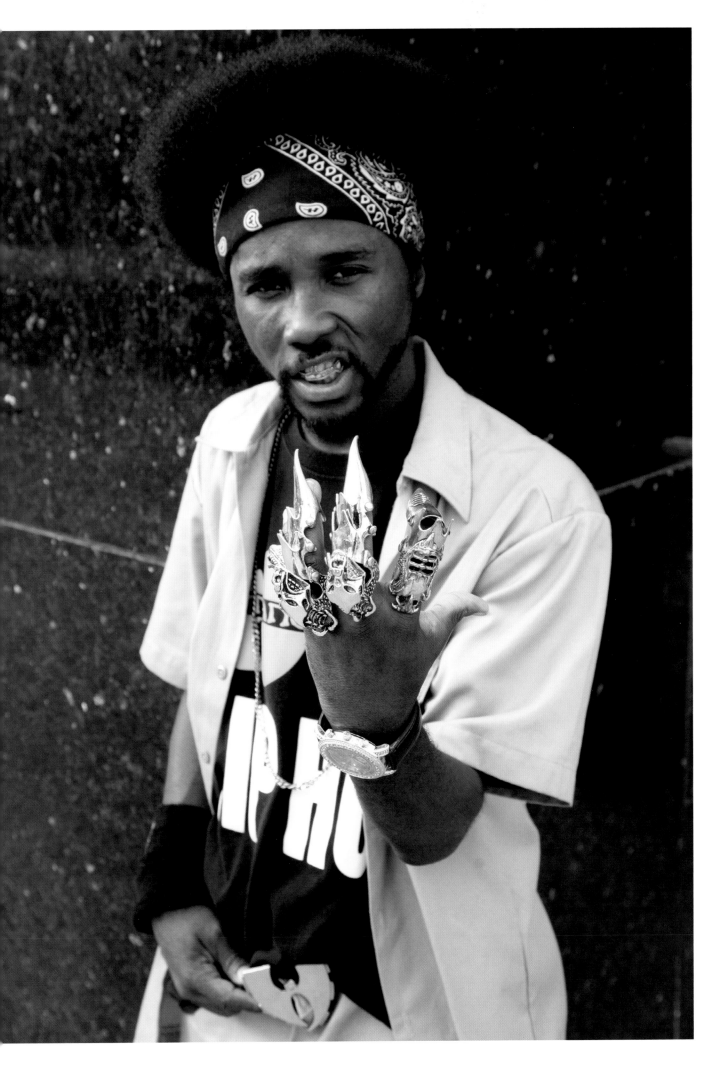

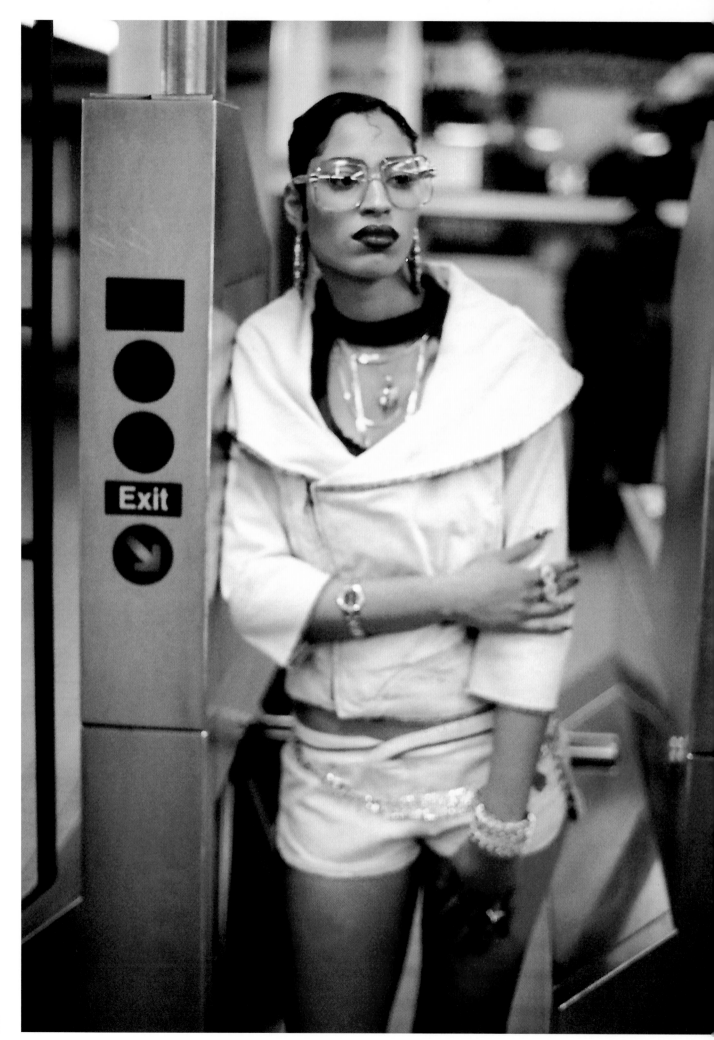

Exit

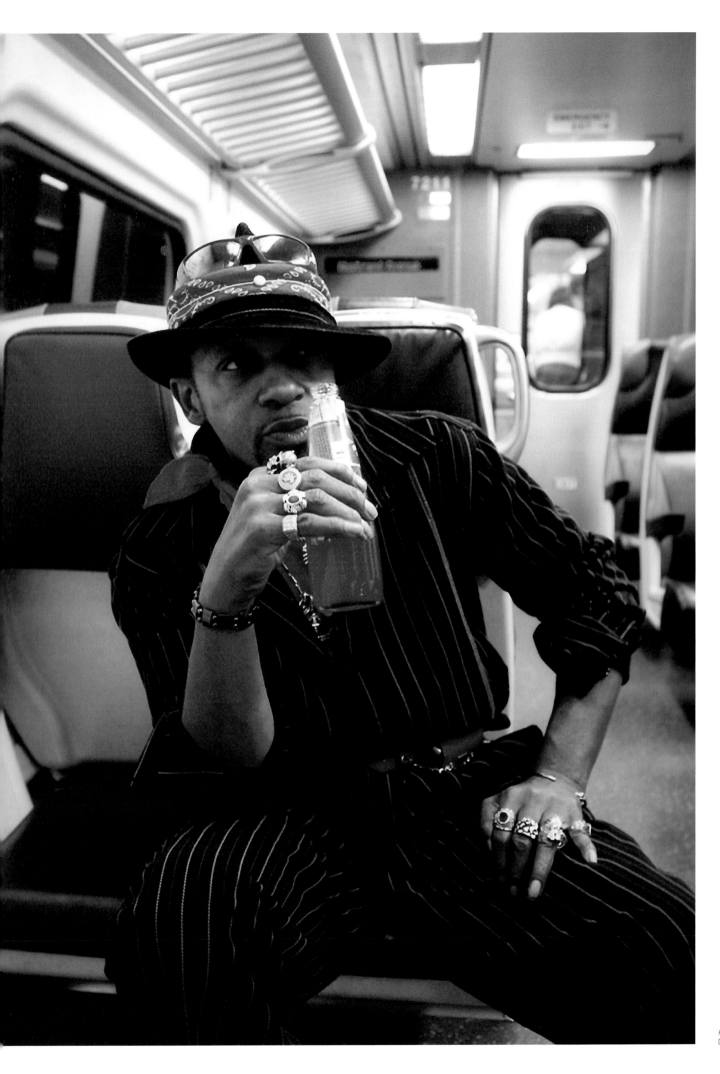

PHOTO/ JAMEL SHABAZZ
[NEW YORK]

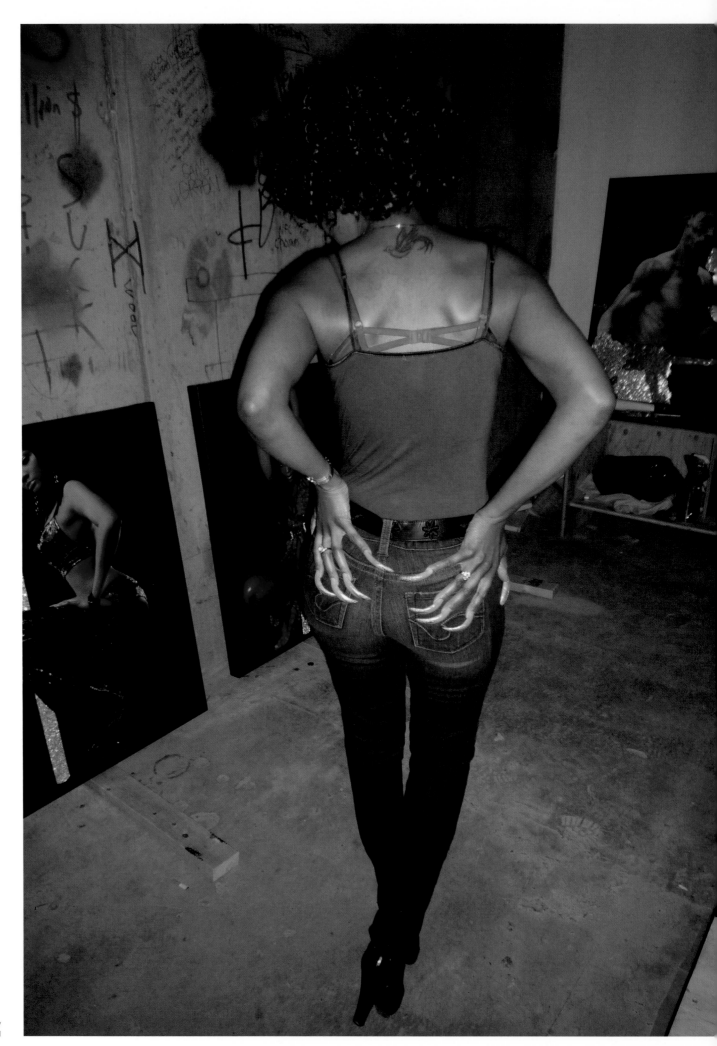

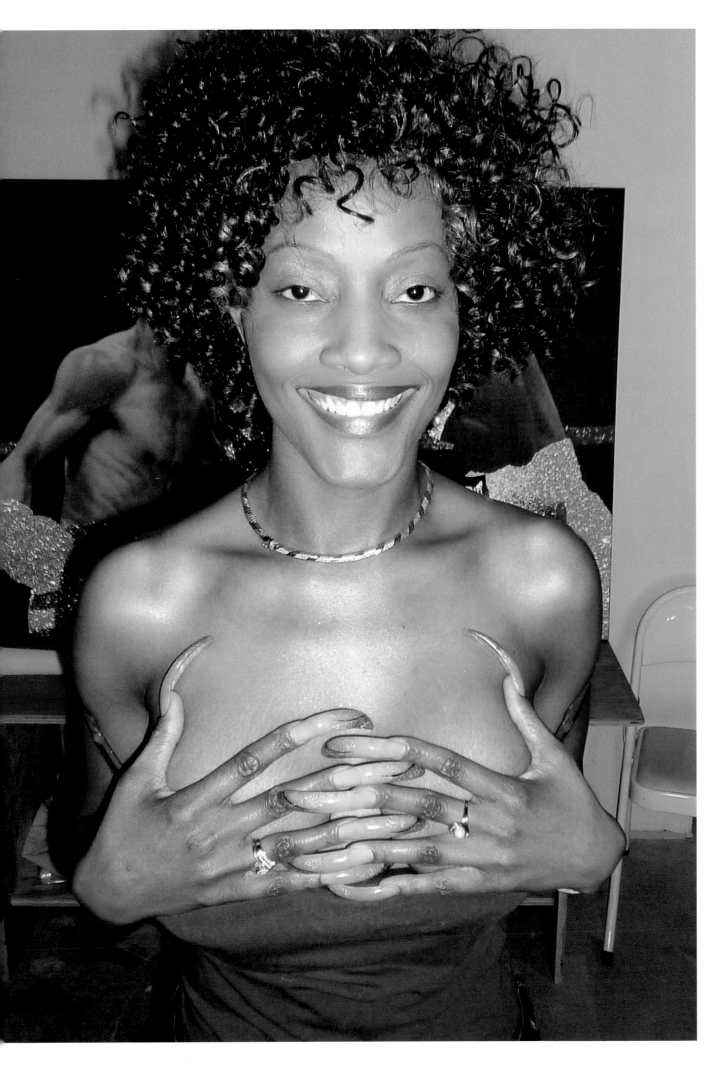

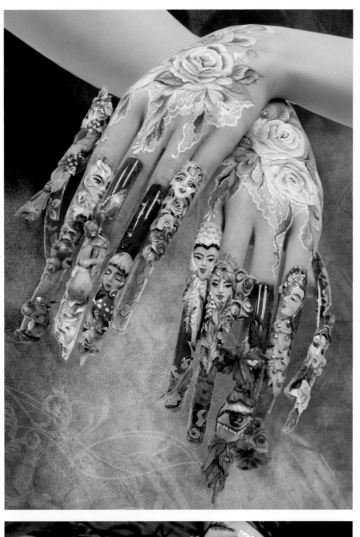

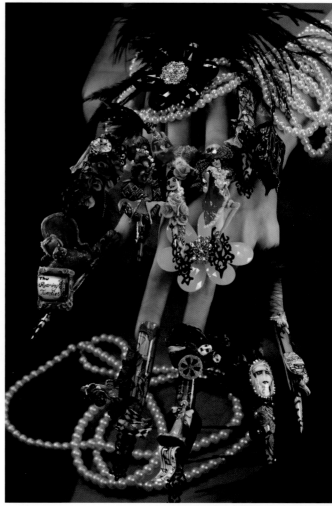

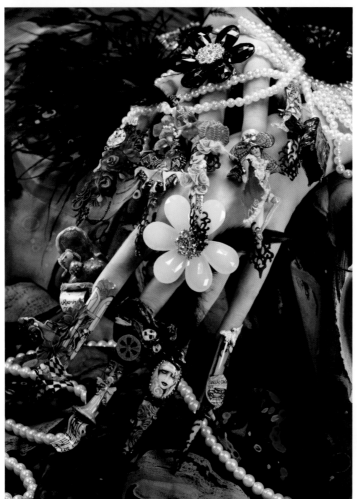

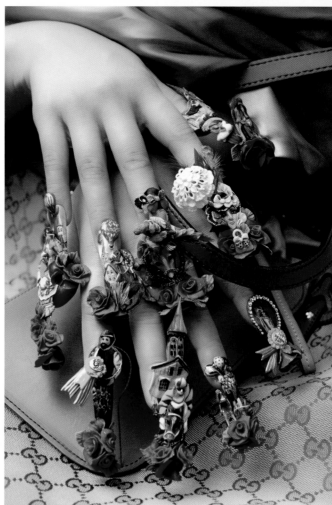

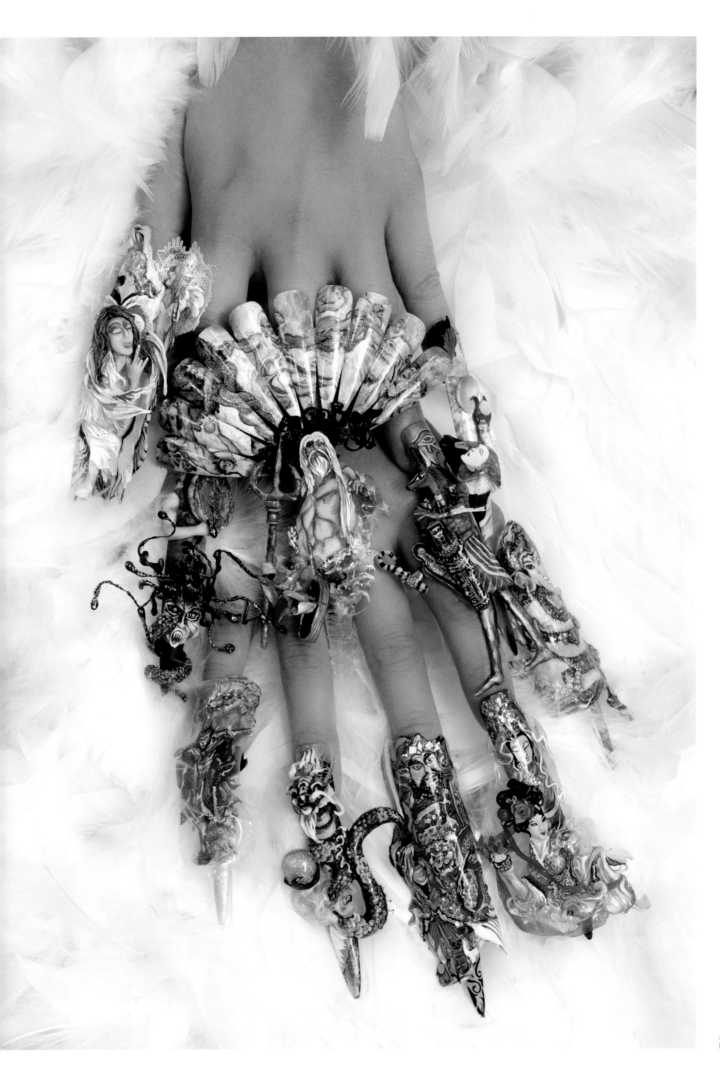

PHOTO/ CATHERINE WONG
[SINGAPORE]

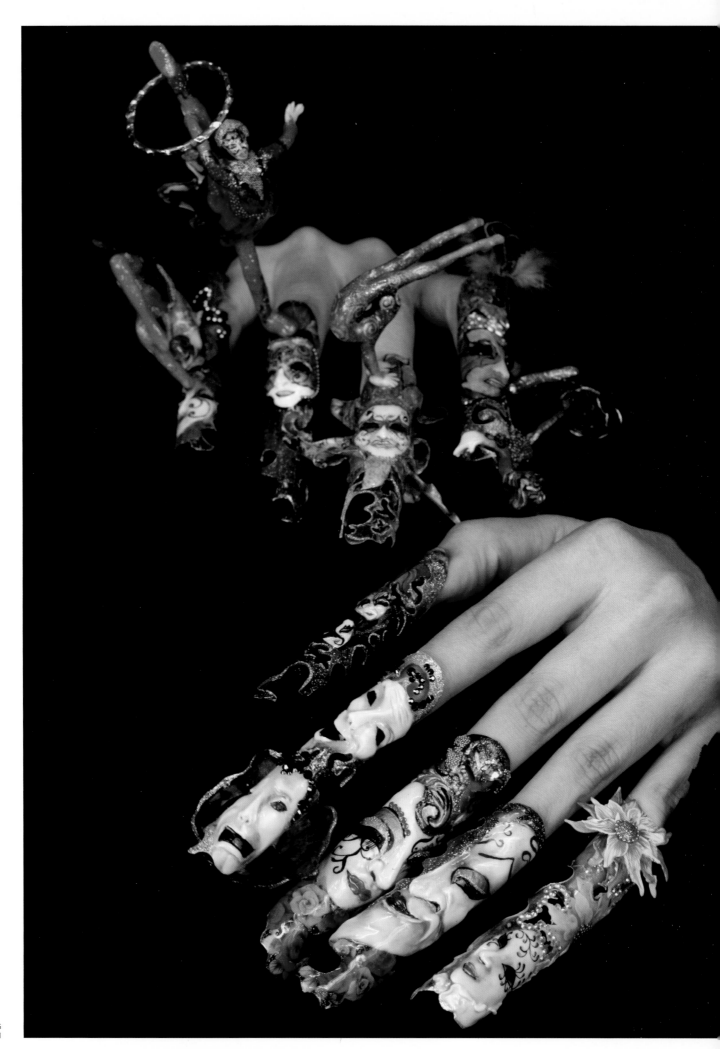

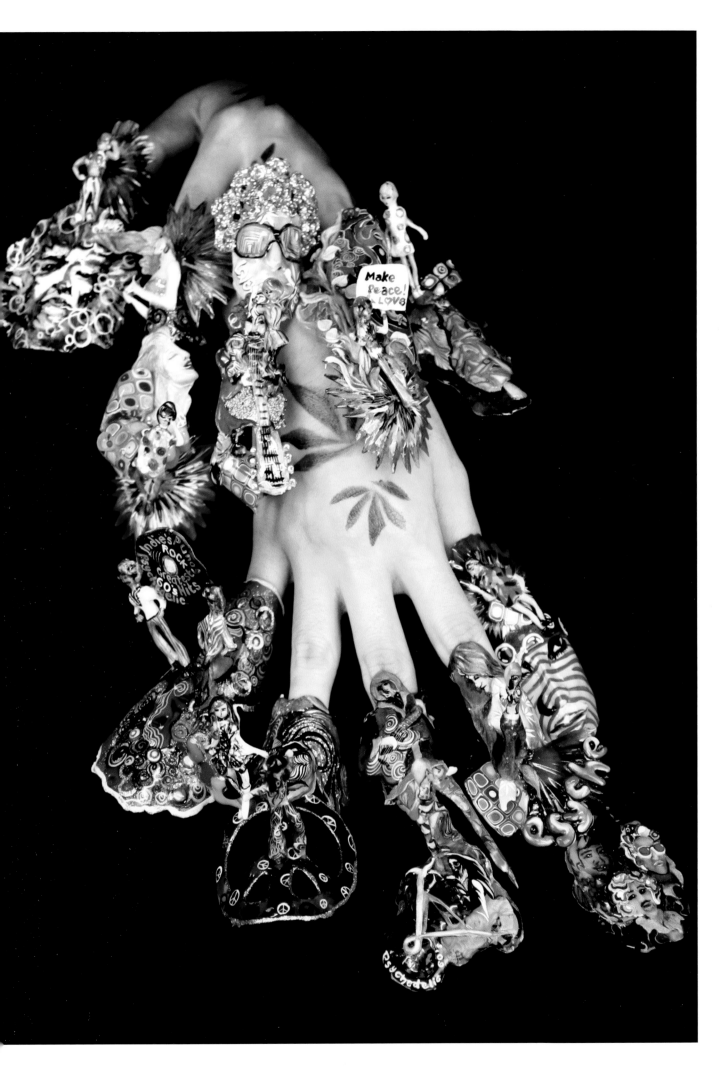

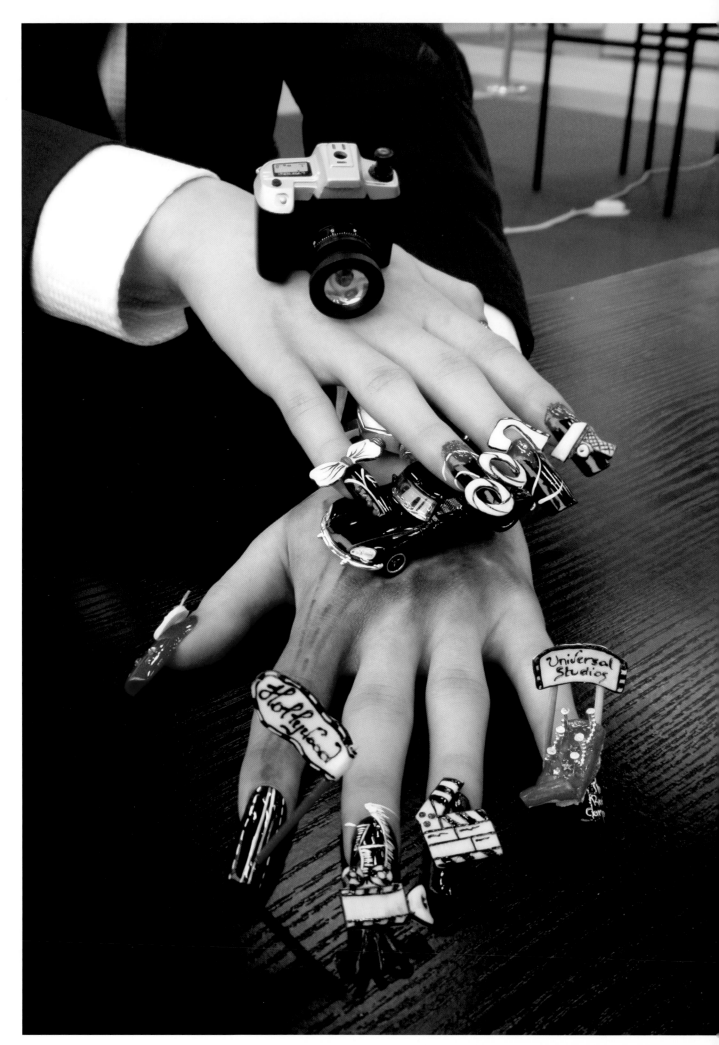

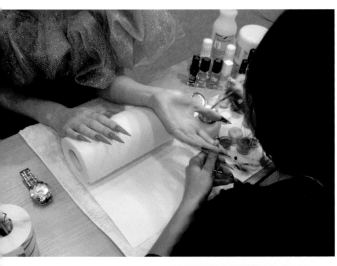

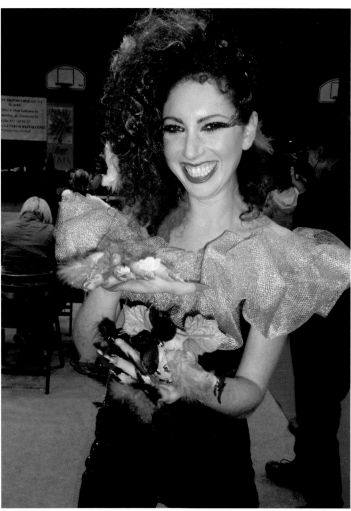

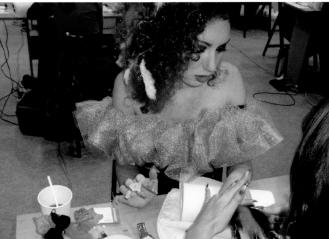

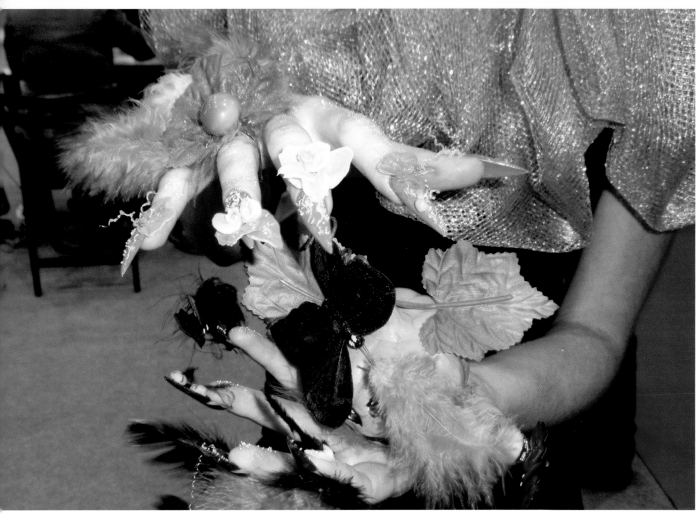

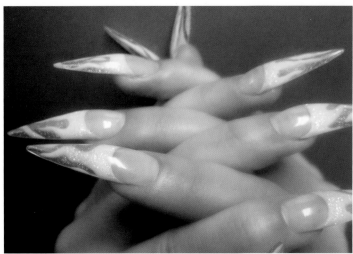
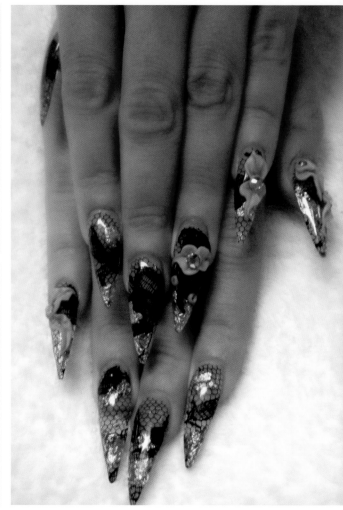
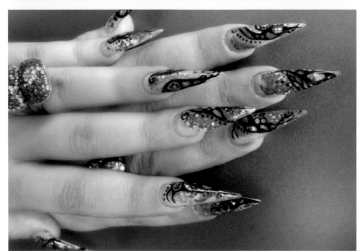
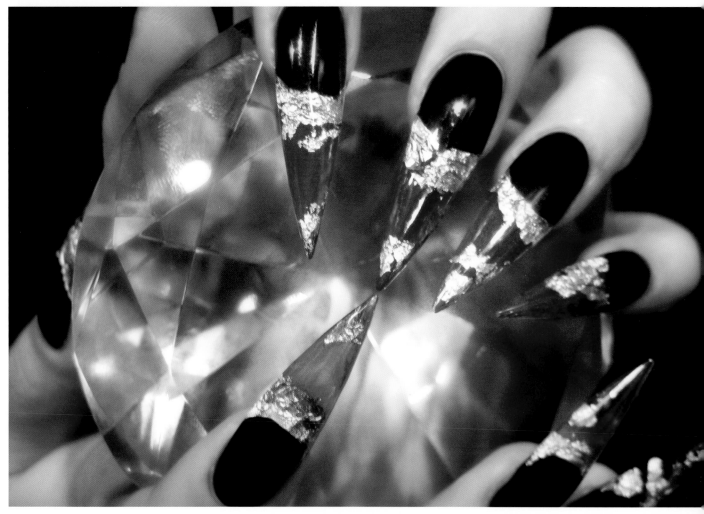

PHOTOS/ IGOR J. IJOVIC
[SERBIA]

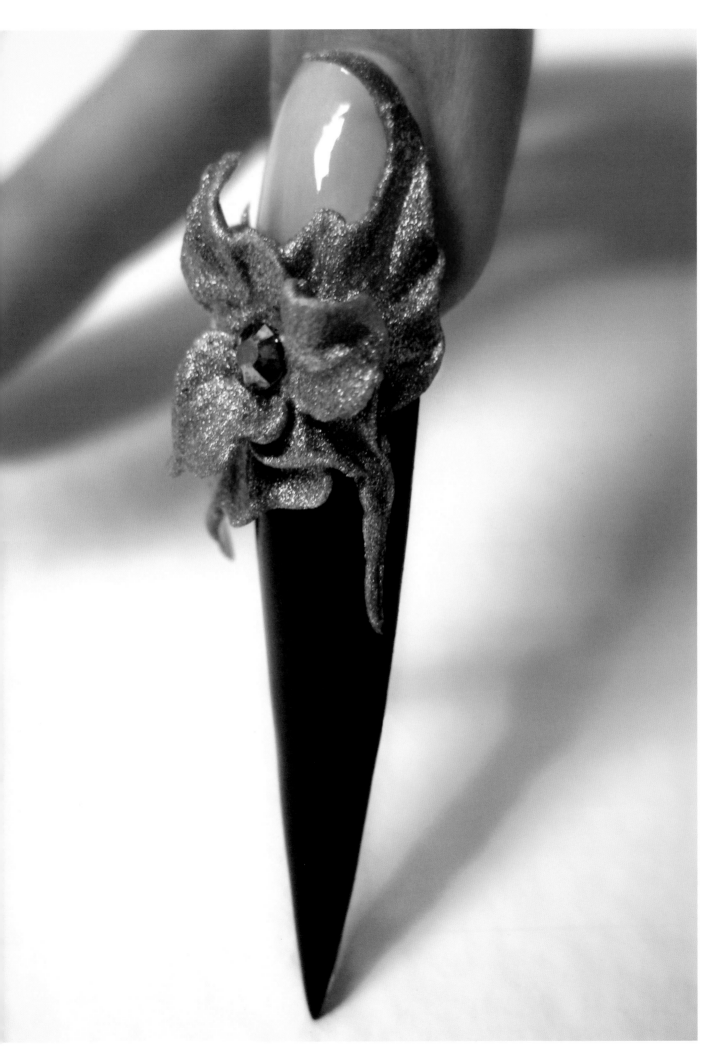

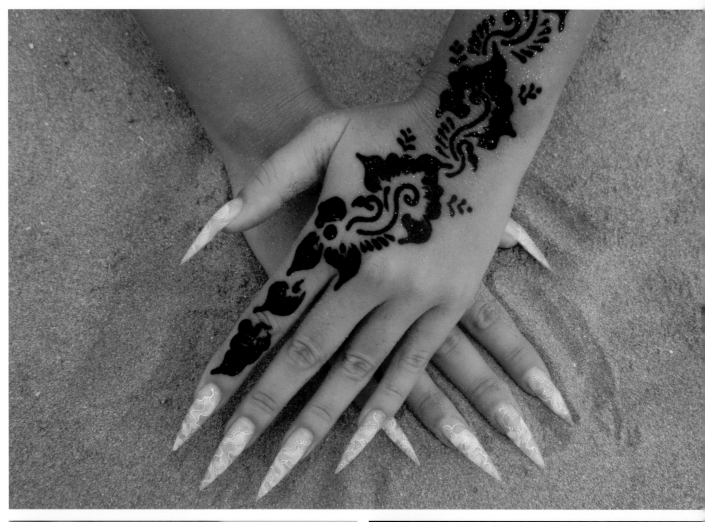

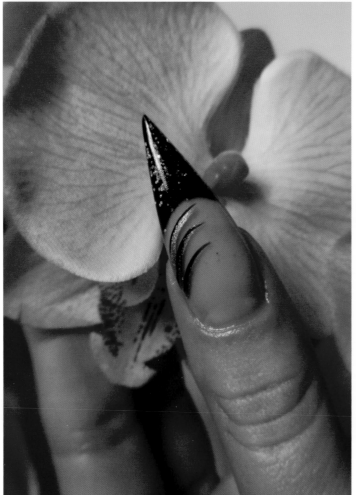

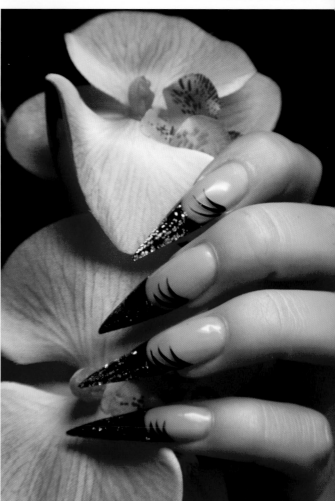

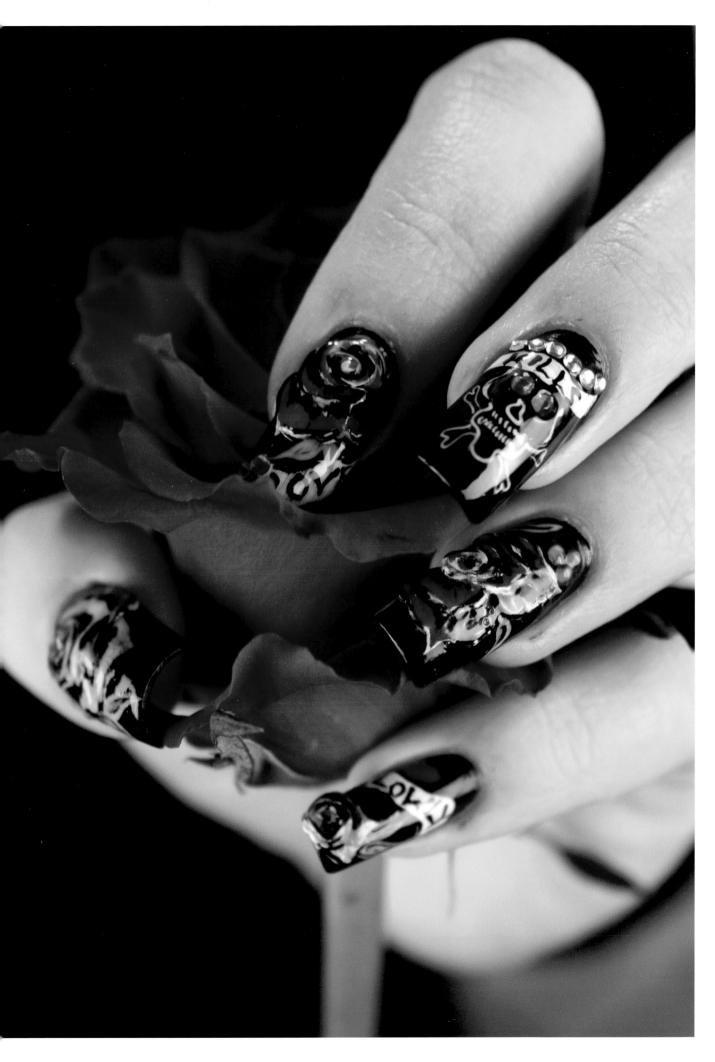

PHOTO/ MONIKA ZBIJOWSKA
[POLAND]

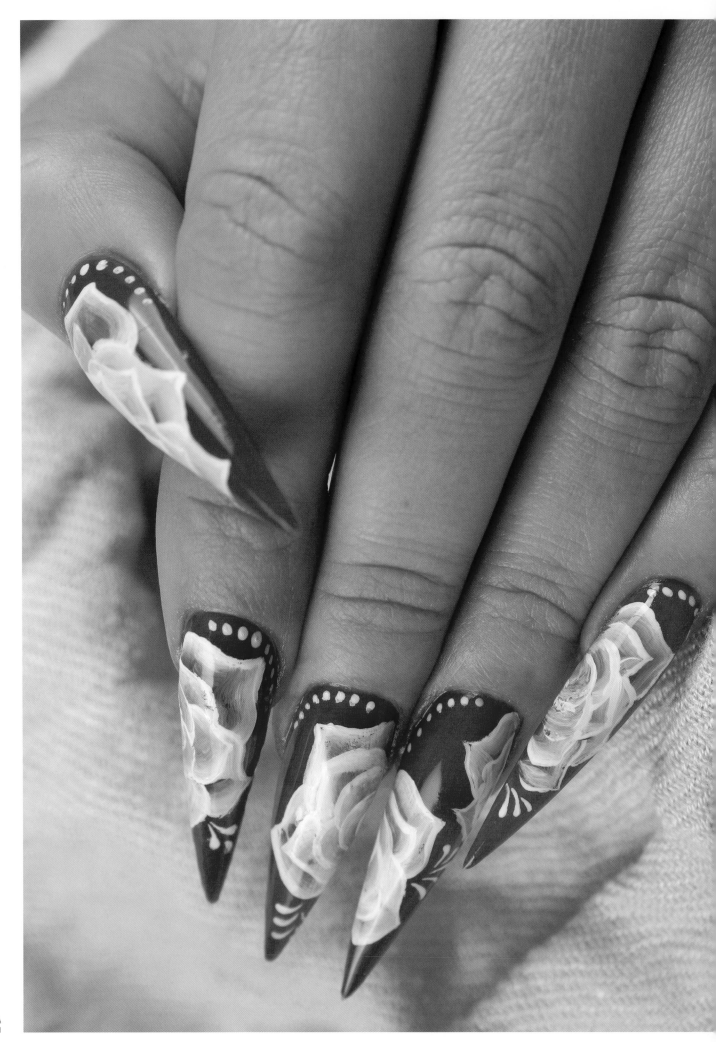

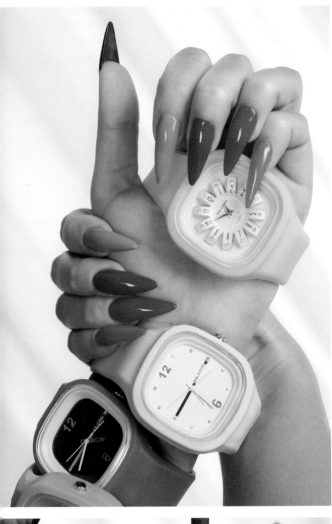
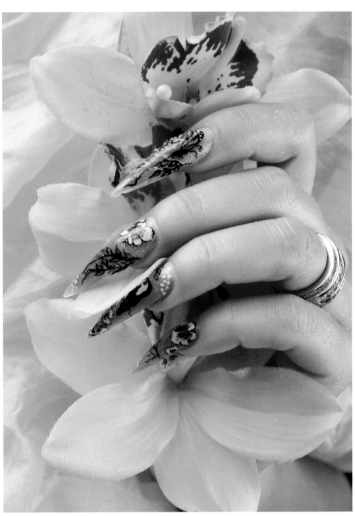
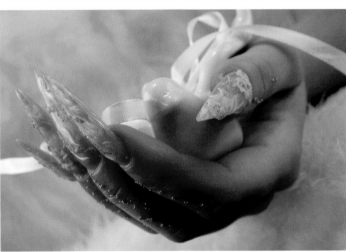
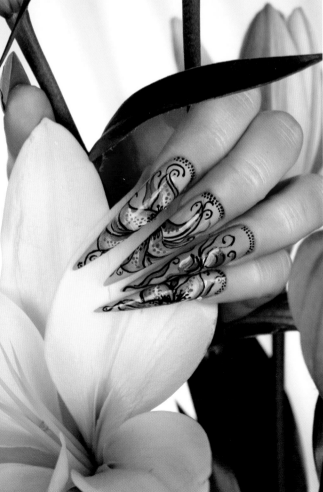
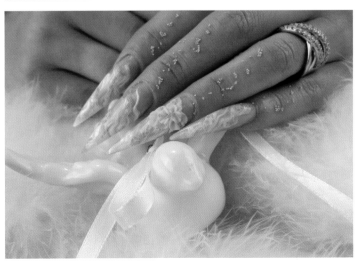

PHOTOS/ MONIKA ZBIJOWSKA
[POLAND]

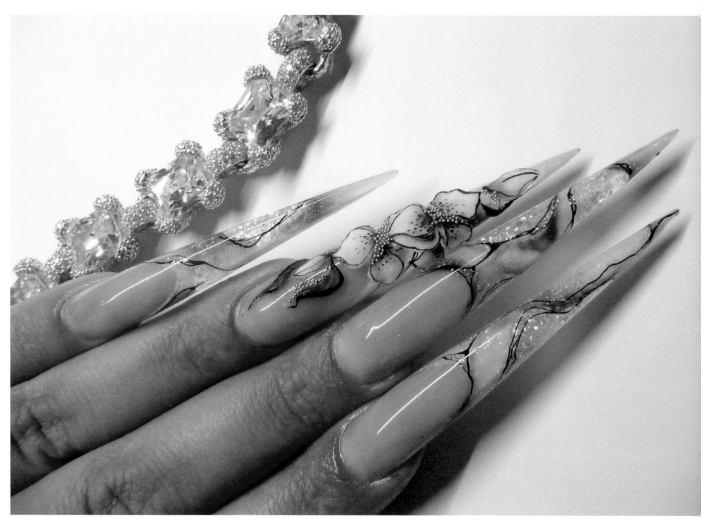

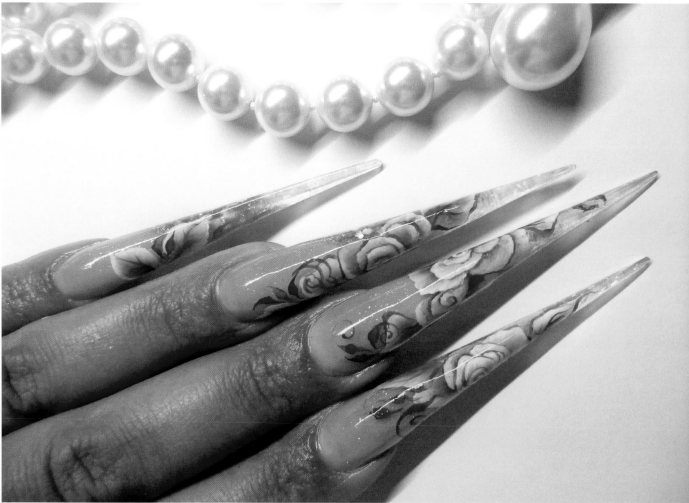

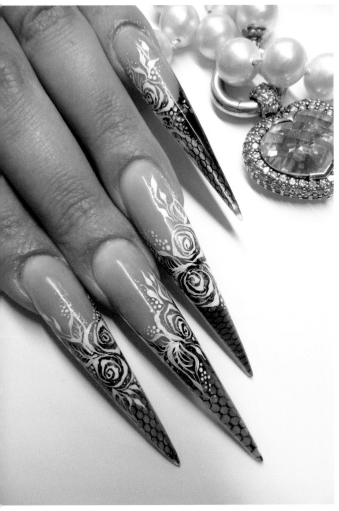
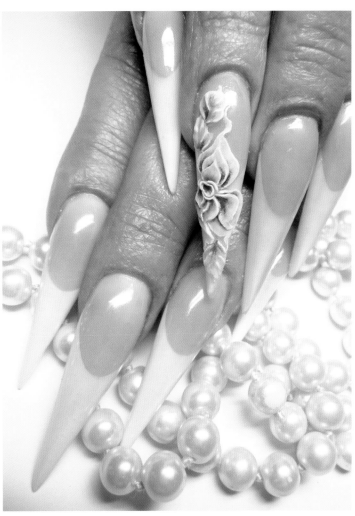
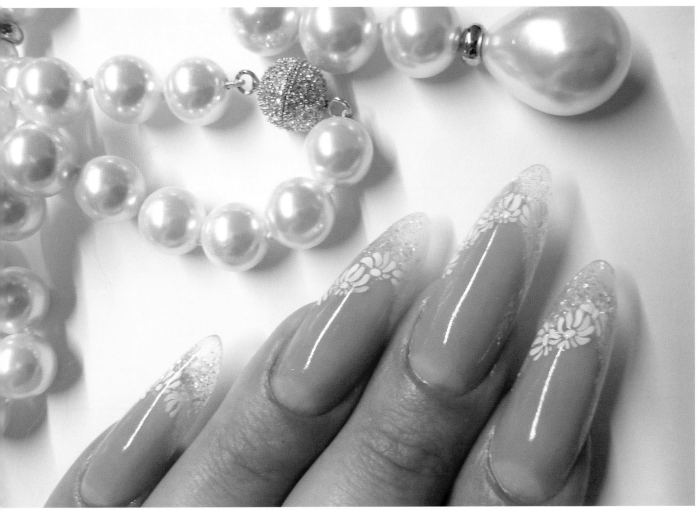

PHOTOS/ PAULINE FEINAUER
[DEUTSCHLAND]

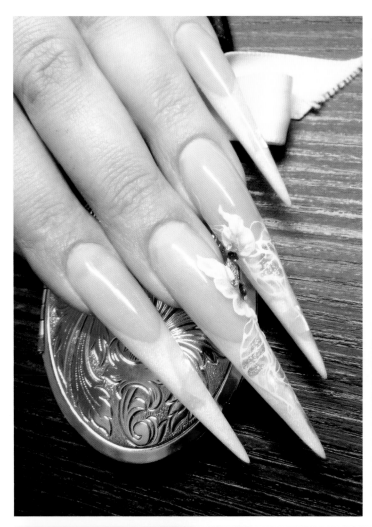
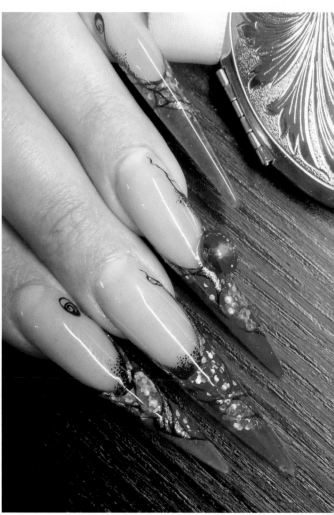
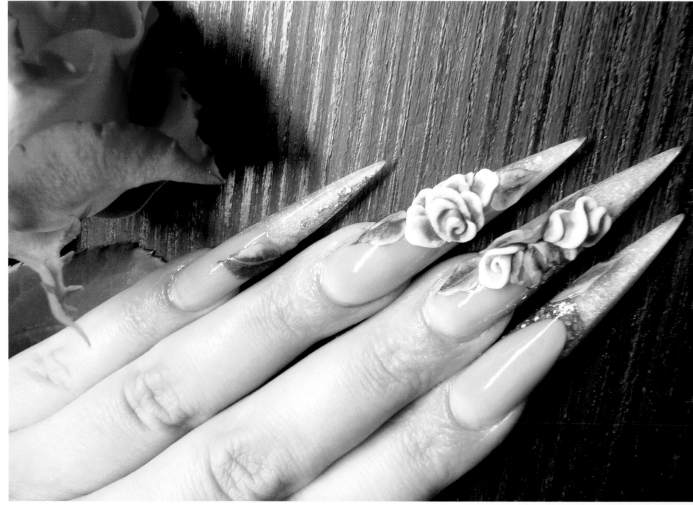

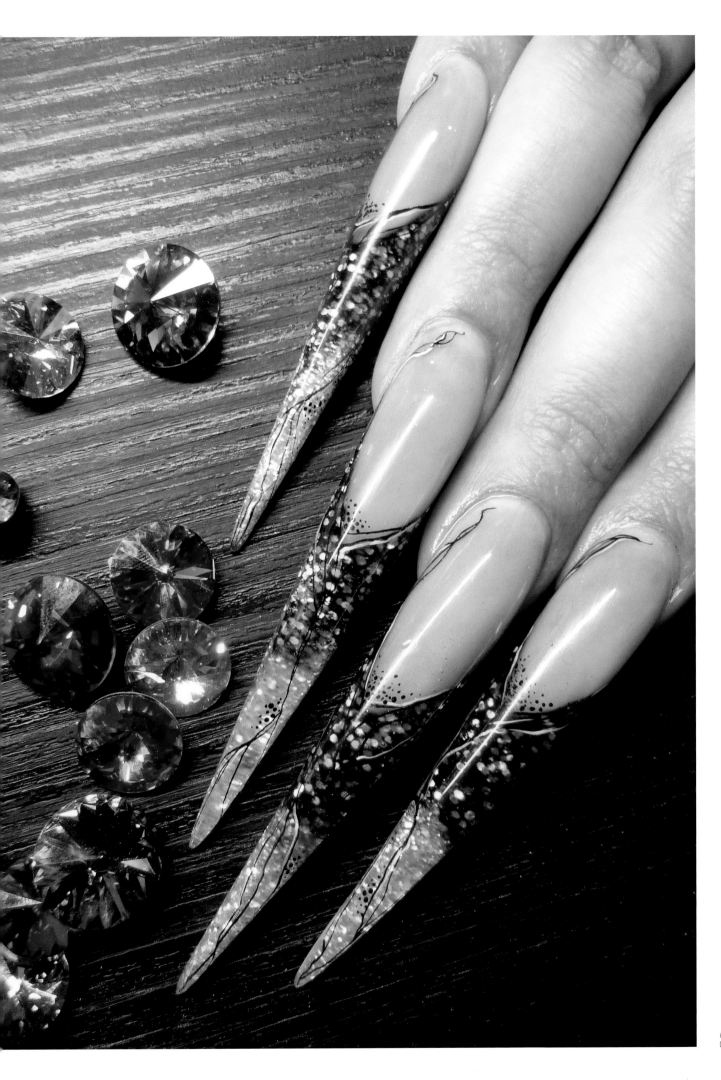

PHOTO/ PAULINE FEINAUER
[DEUTSCHLAND]

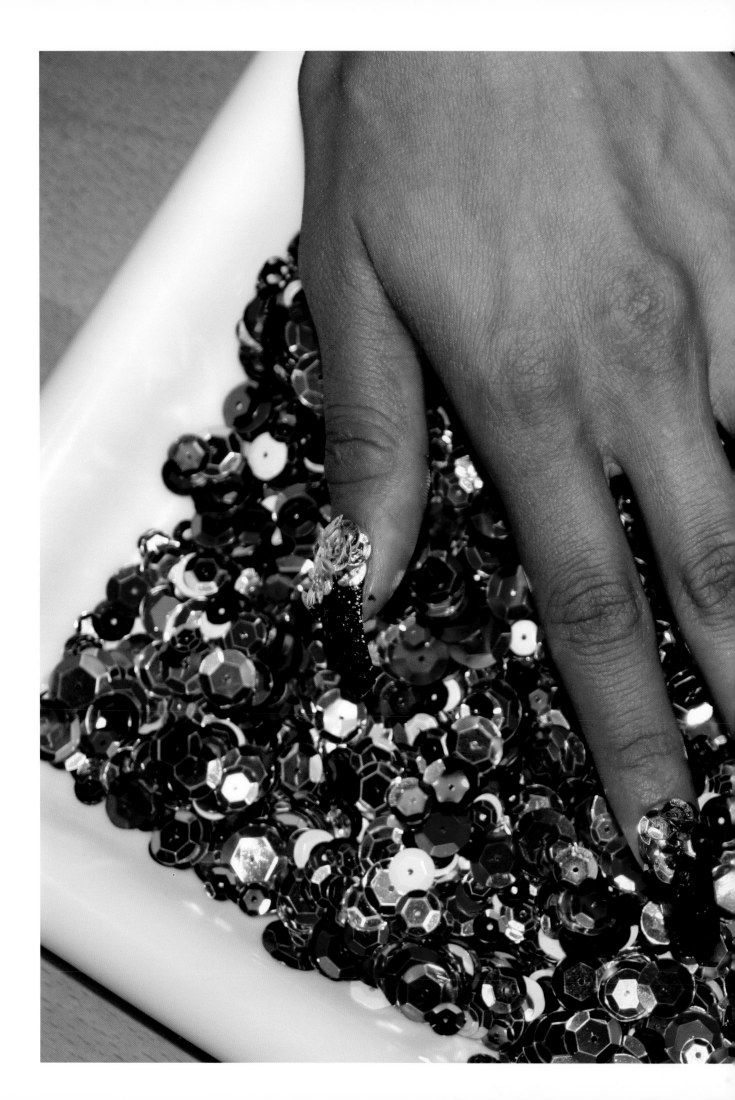

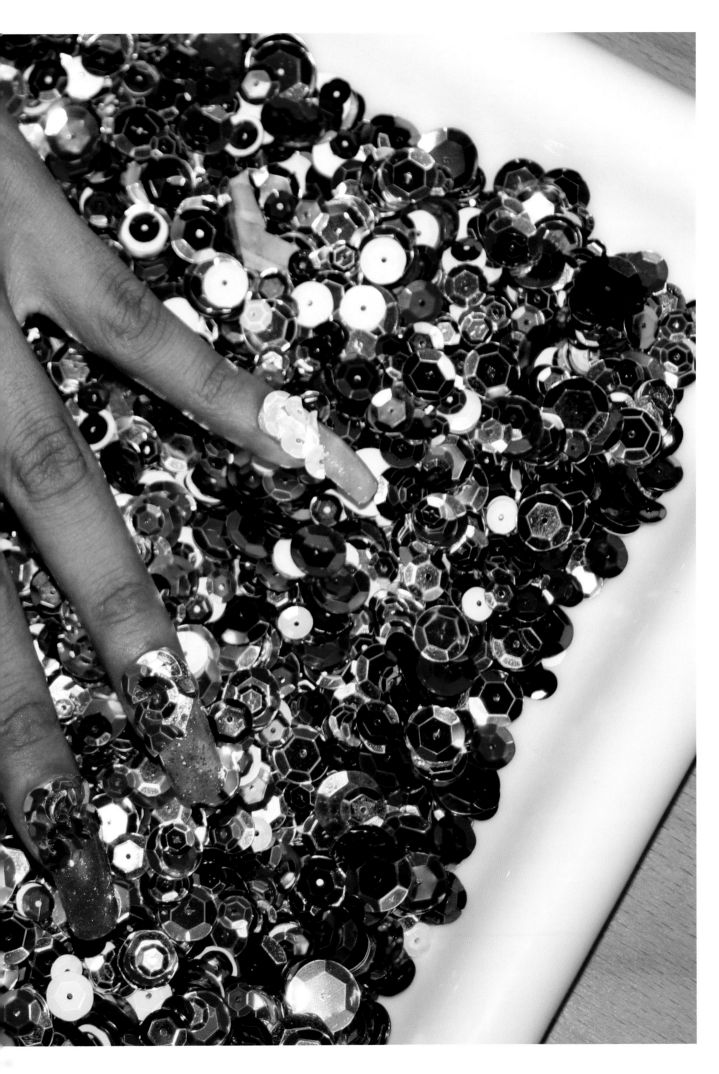

PHOTO/ GABRIELLA
DAVI-KHORASANEE
[CALIFORNIA]

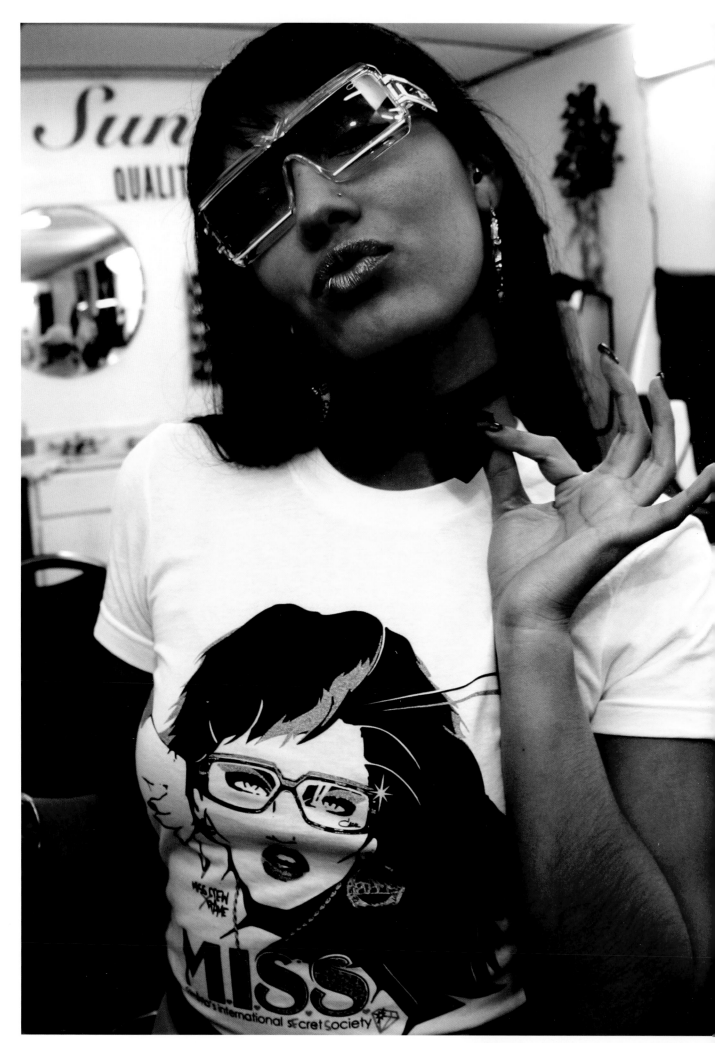

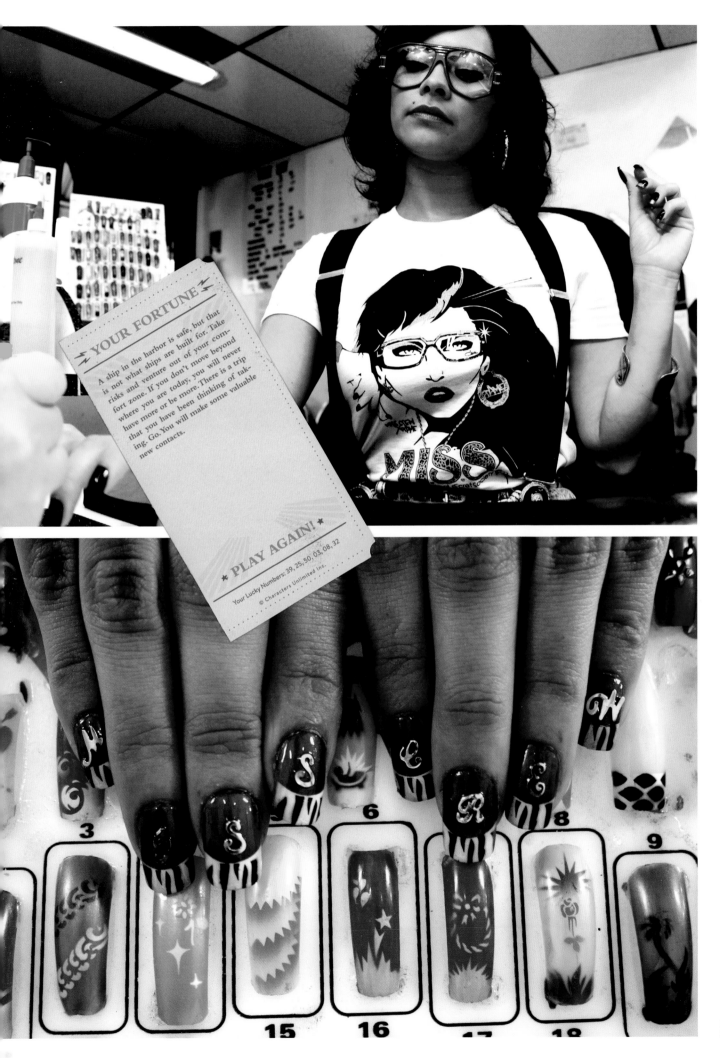

YOUR FORTUNE

A ship in the harbor is safe, but that is not what ships are built for. Take risks and venture out of your comfort zone. If you don't move beyond where you are today, you will never have more or be more. There is a trip that you have been thinking of taking. Go. You will make some valuable new contacts.

★ **PLAY AGAIN!** ★

Your Lucky Numbers: 39, 25, 50, 03, 08, 32

© Characters Unlimited Inc.

PHOTOS/ ALI KHORASANEE
[CALIFORNIA]

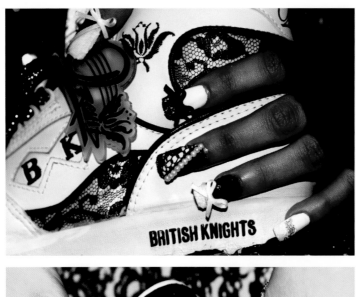
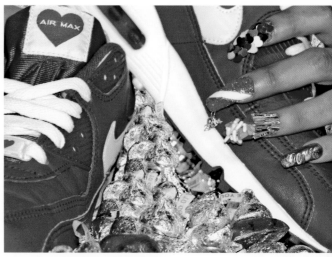

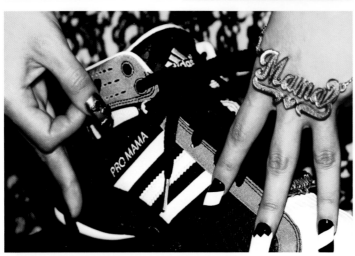
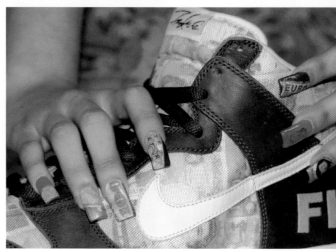

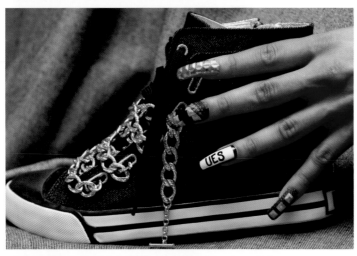
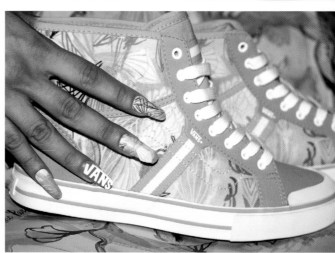

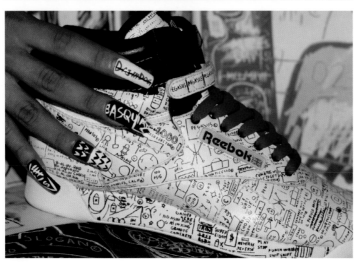
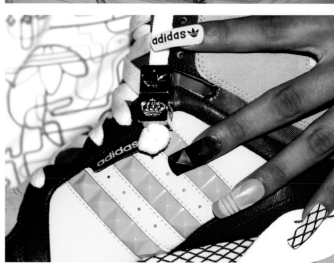

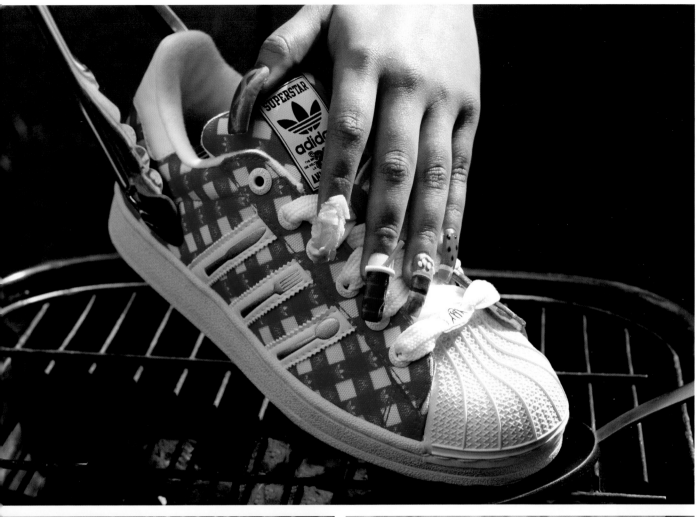

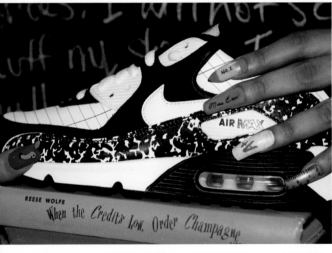

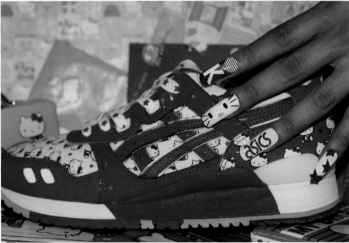

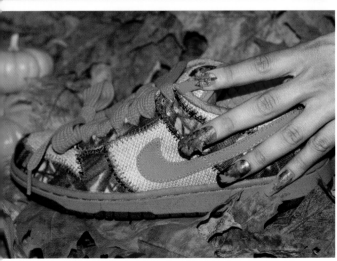

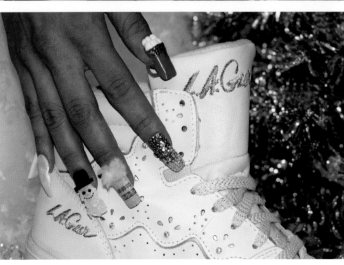

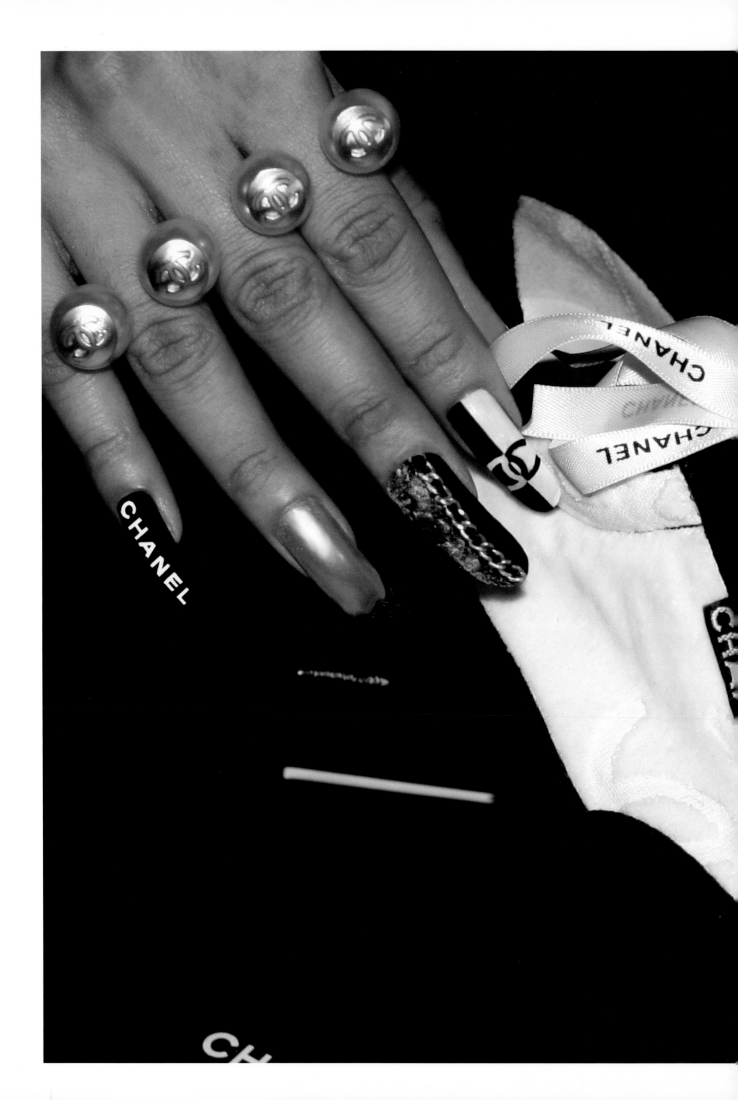

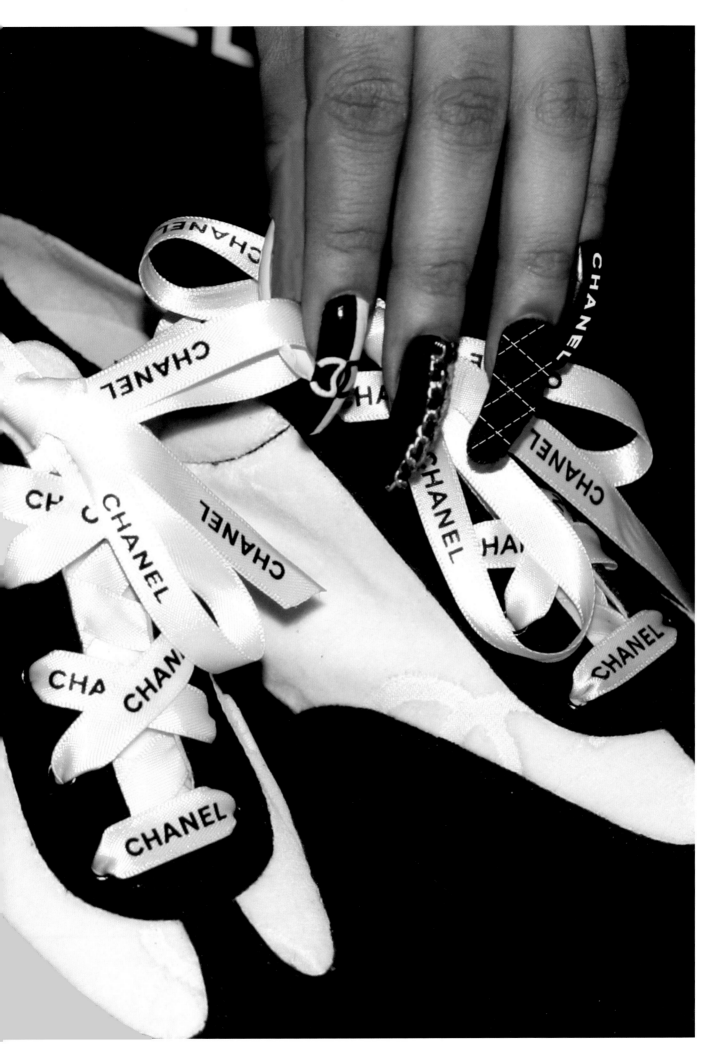

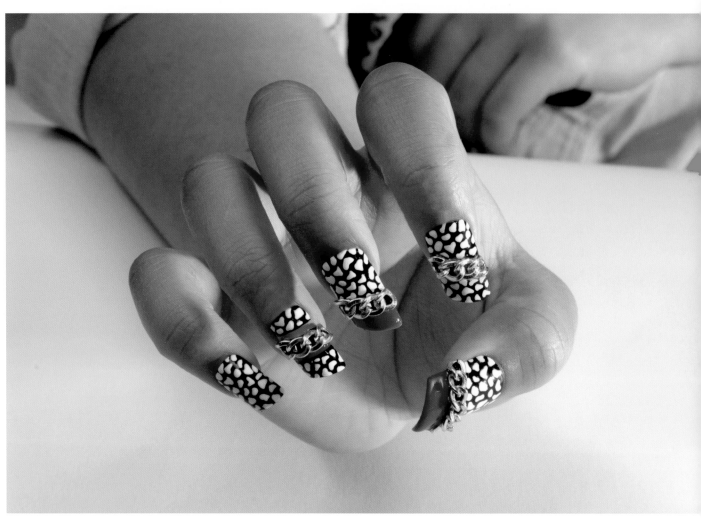

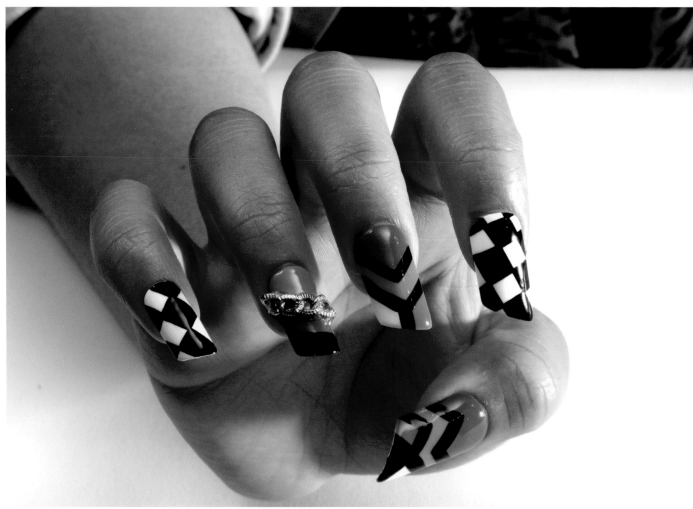

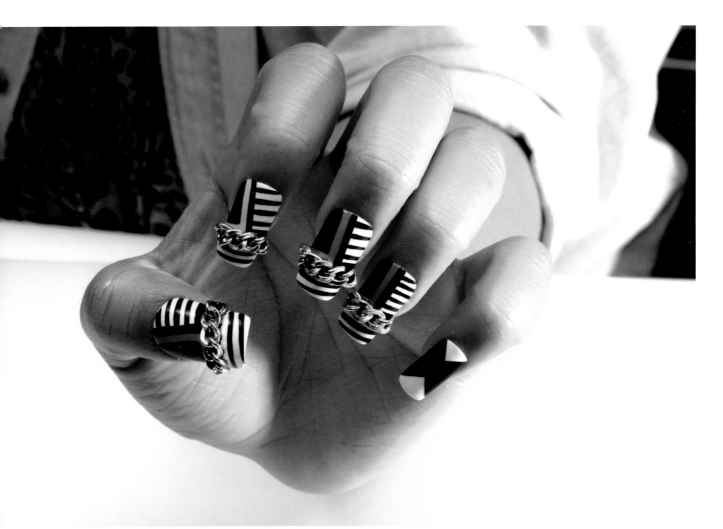

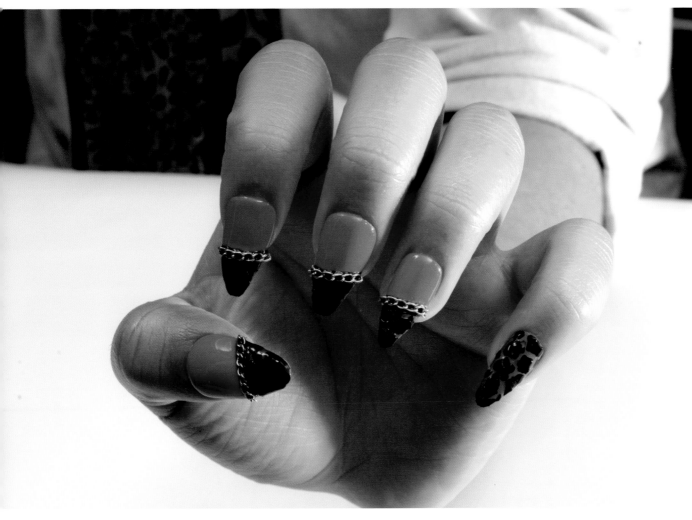

PHOTOS/ DOMINIQUE RENEÉ
[CONNECTICUT]

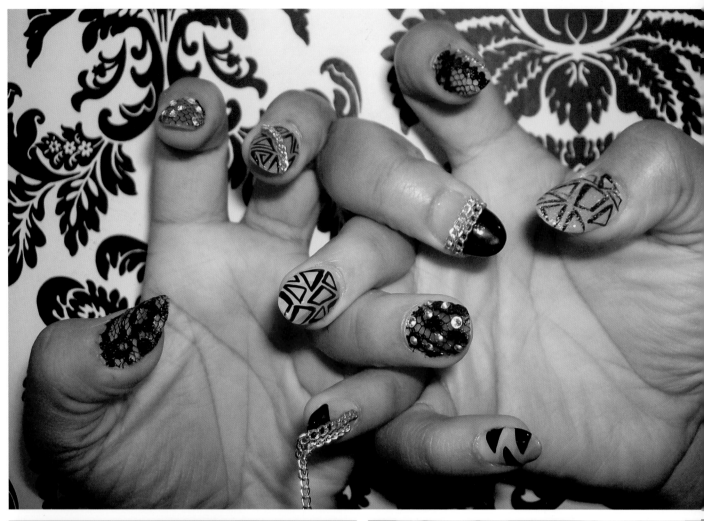

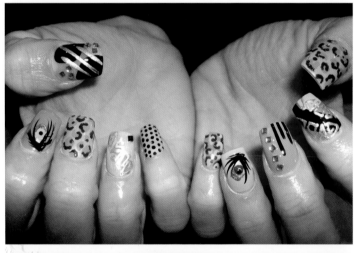

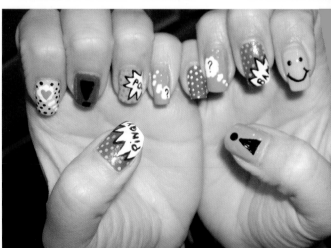

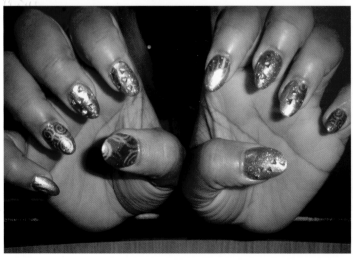

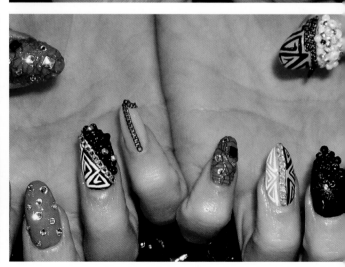

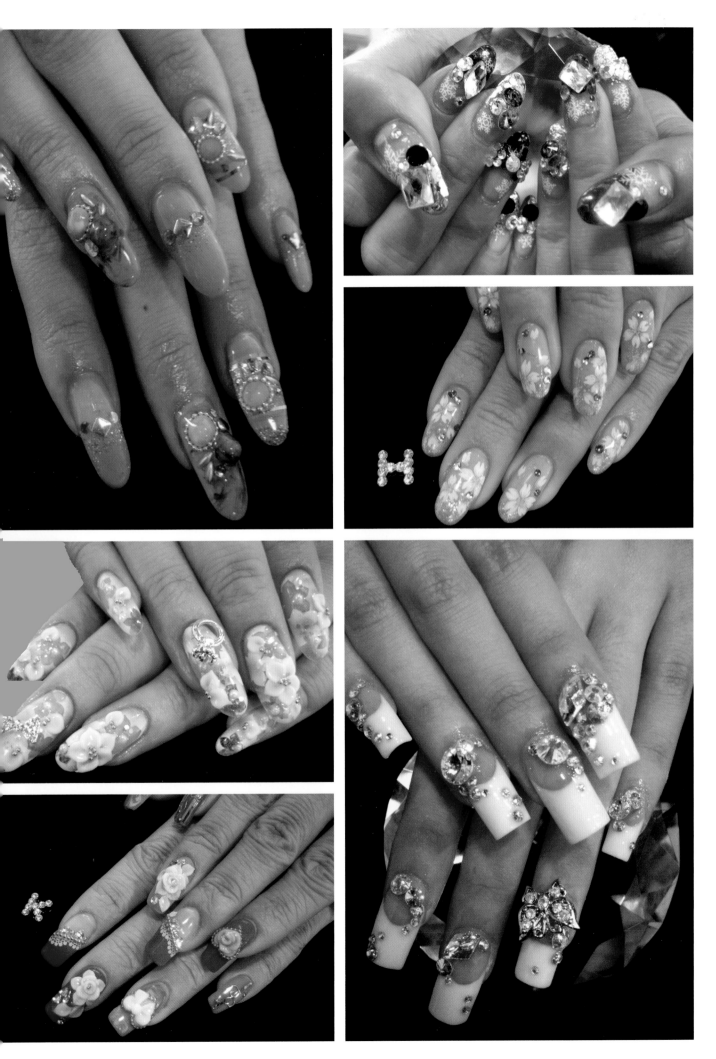

PHOTOS/ KEIKO MATSUI
[BRITISH COLUMBIA]

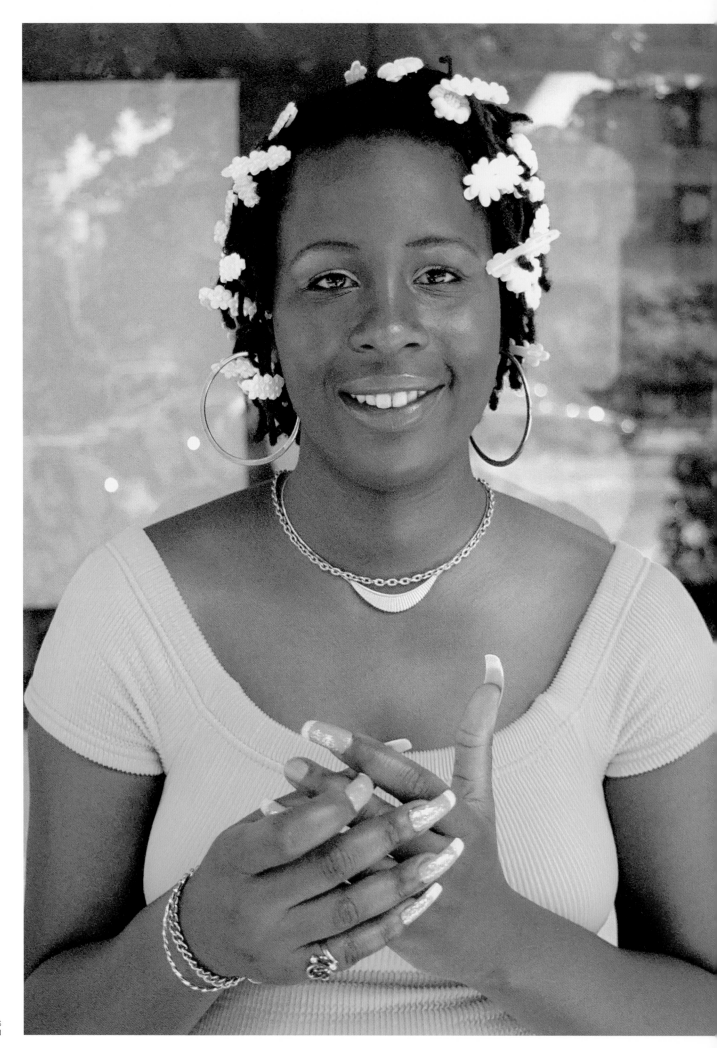

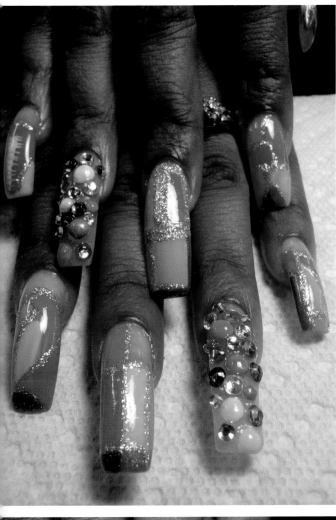
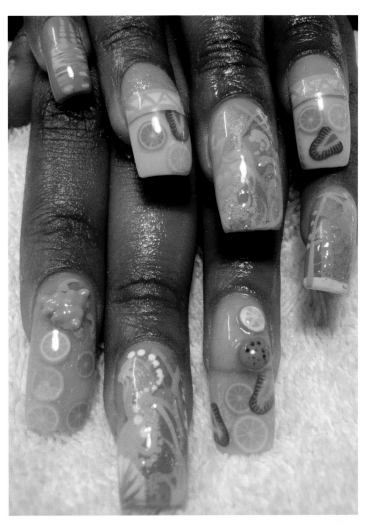
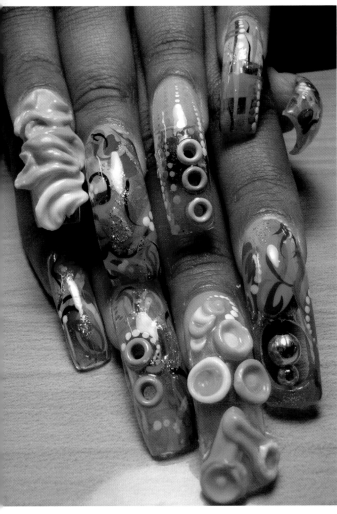
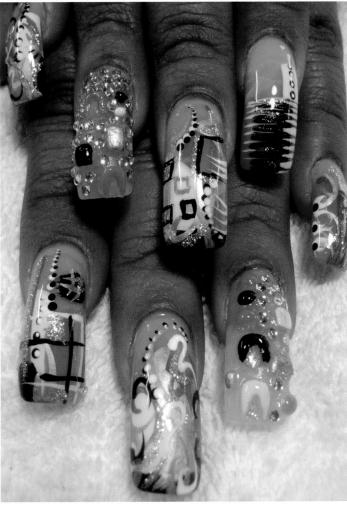

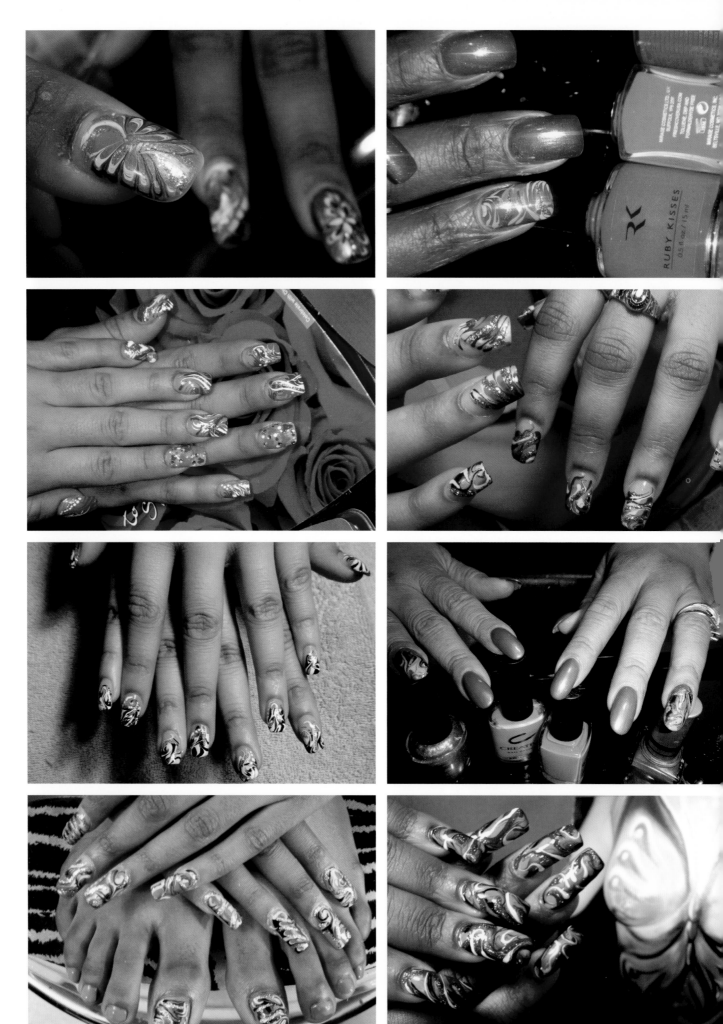

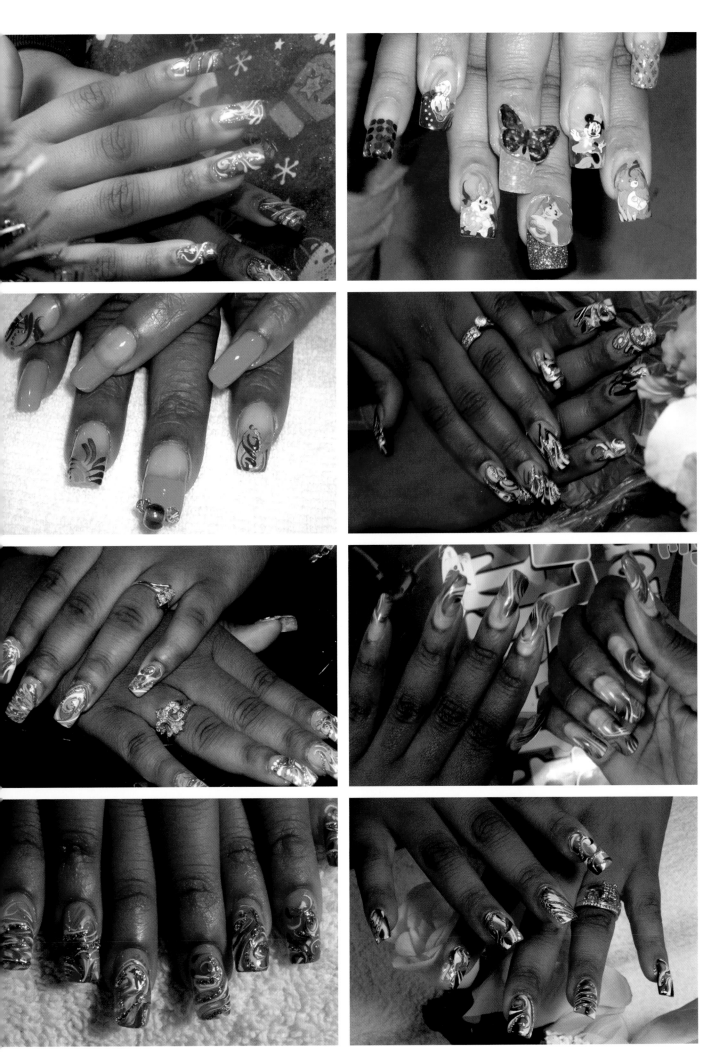

PHOTOS/ CHAWANYA HAYES
[ILLINOIS]

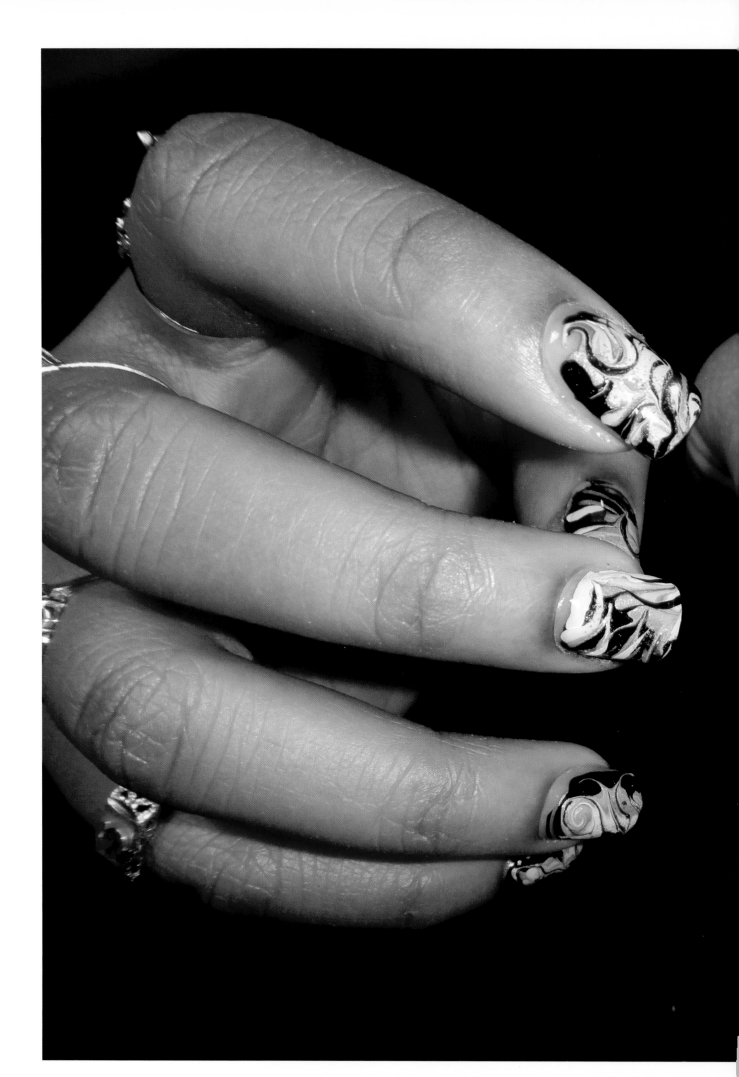

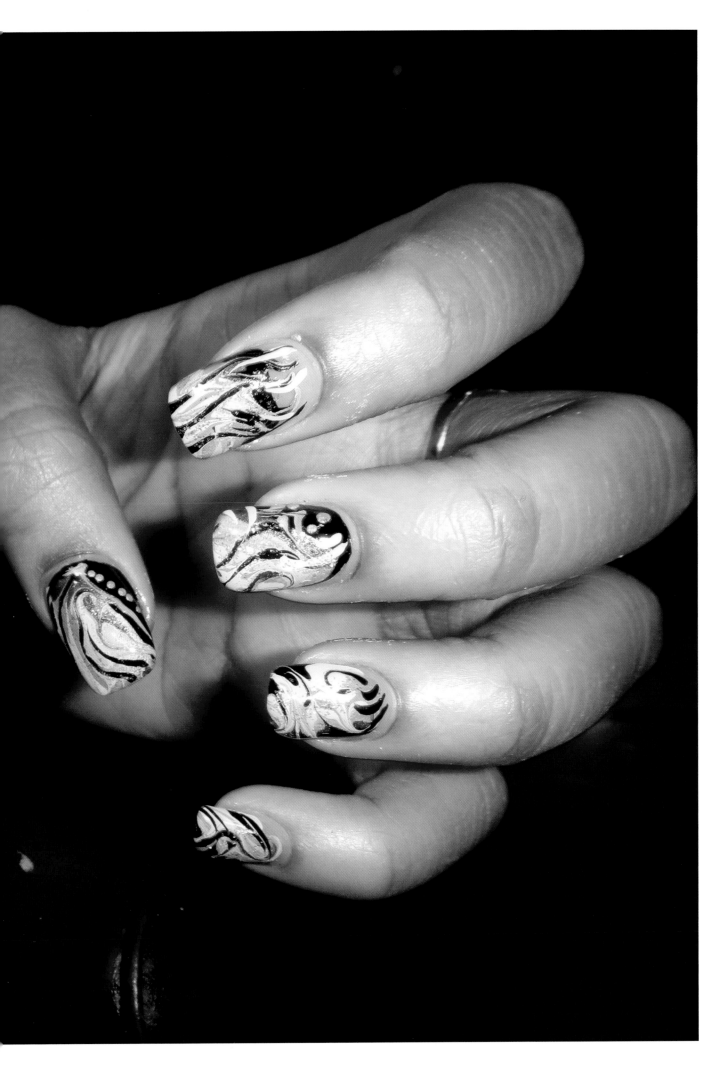

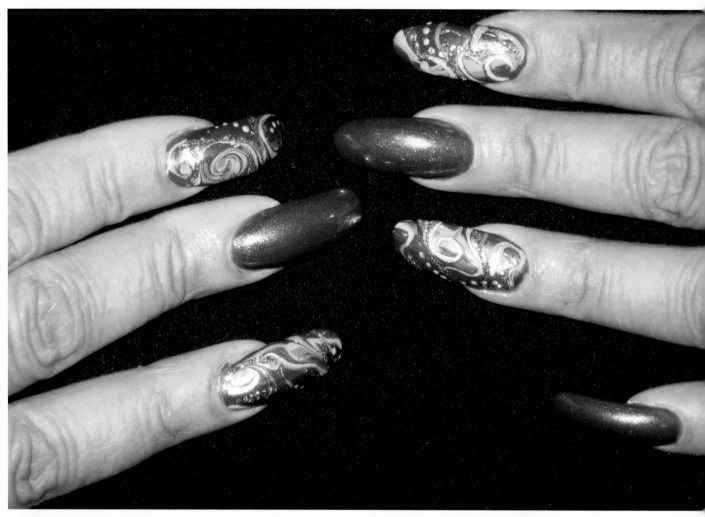

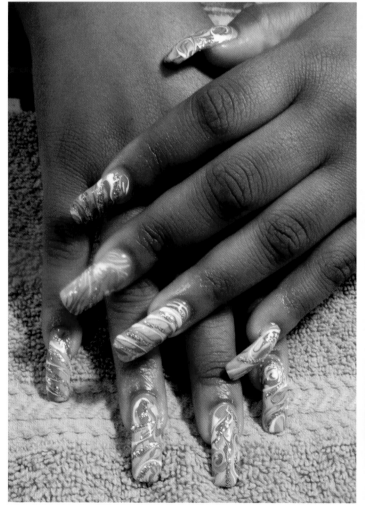

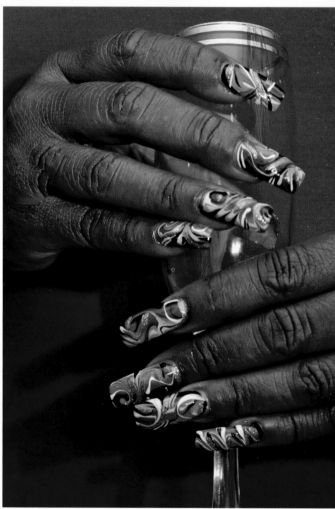

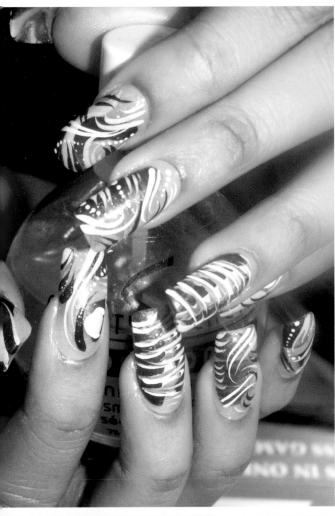
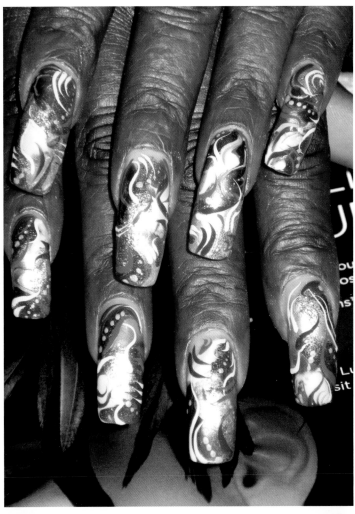
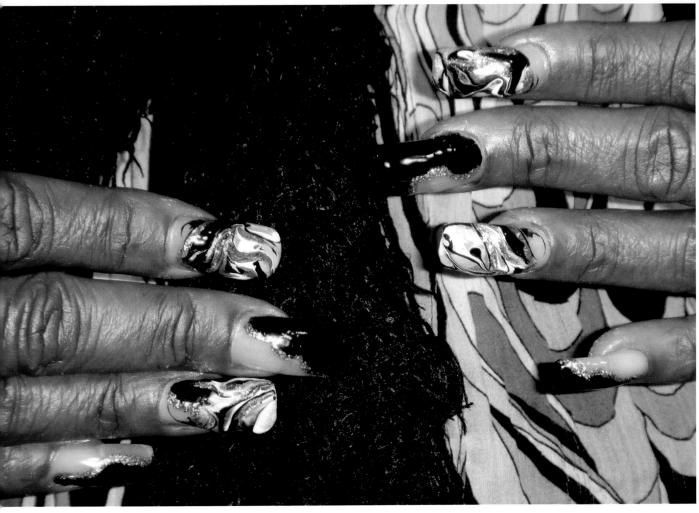

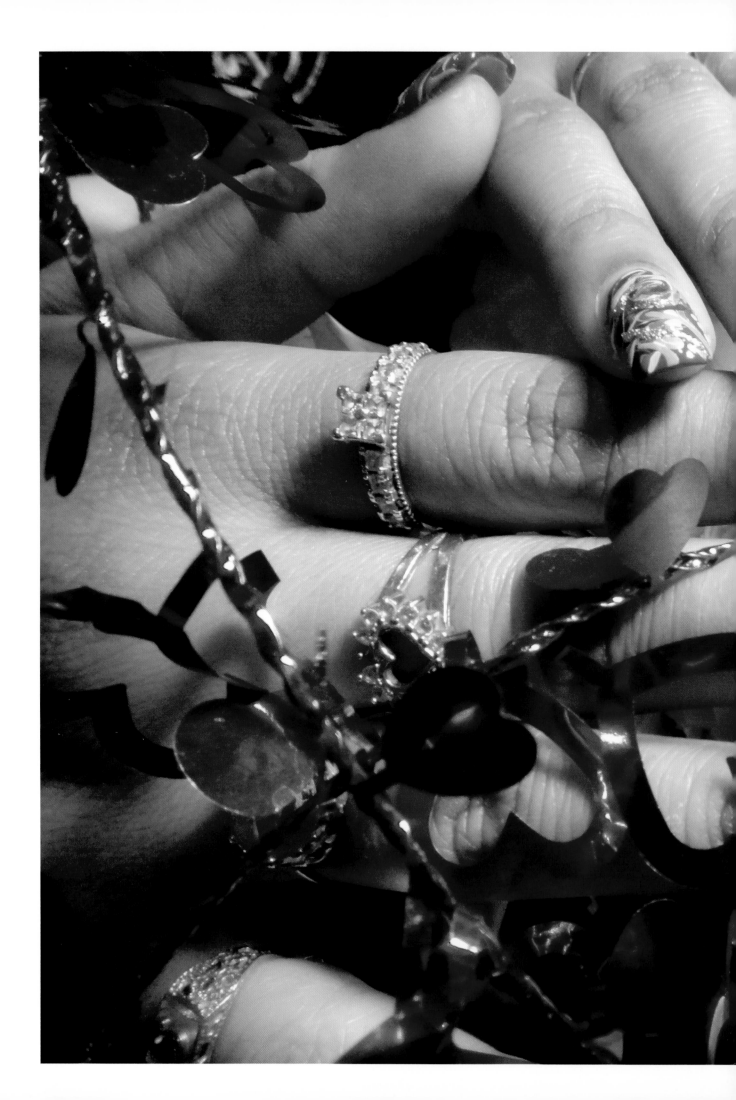

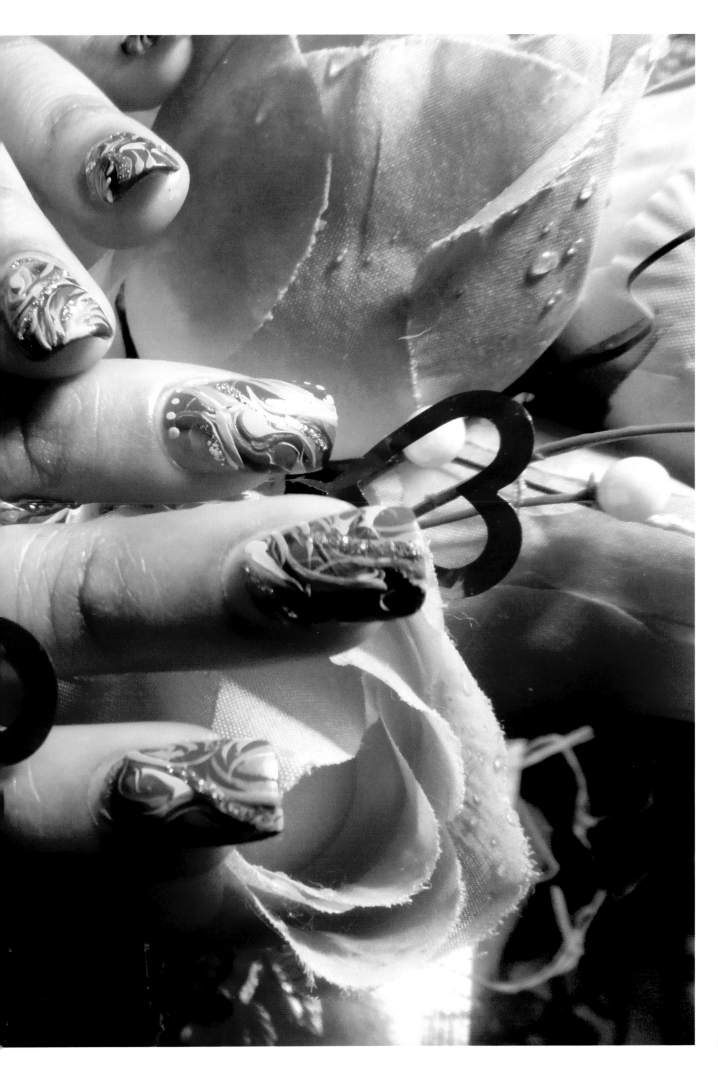

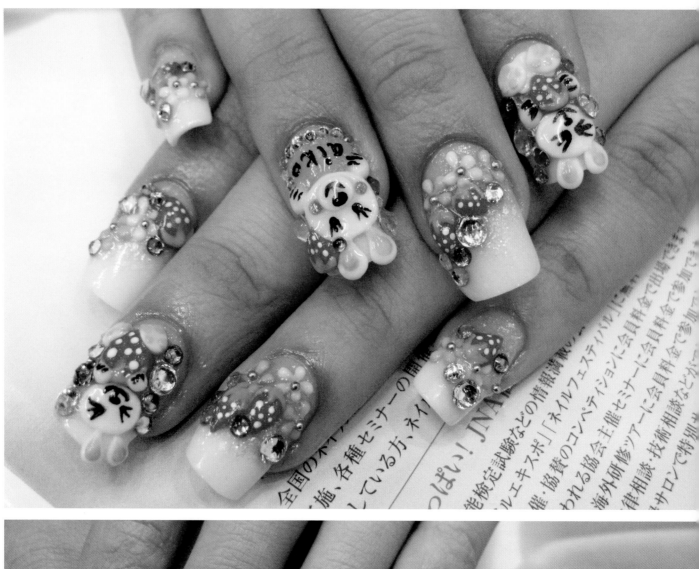

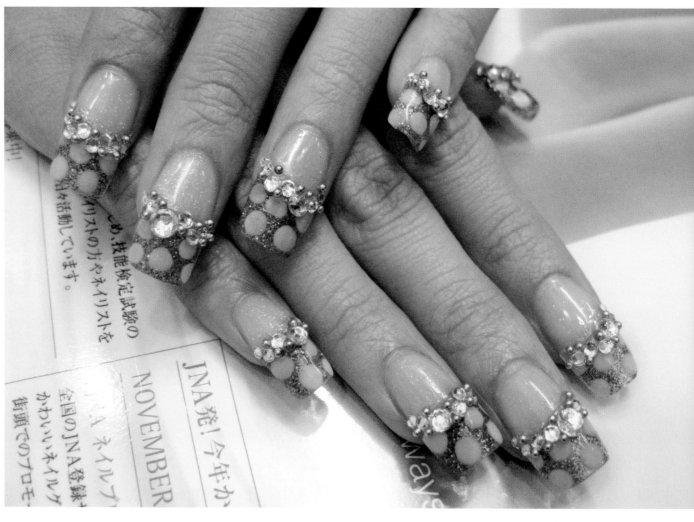

PHOTOS/ DAWN DANIELLE NAH
[SINGAPORE]

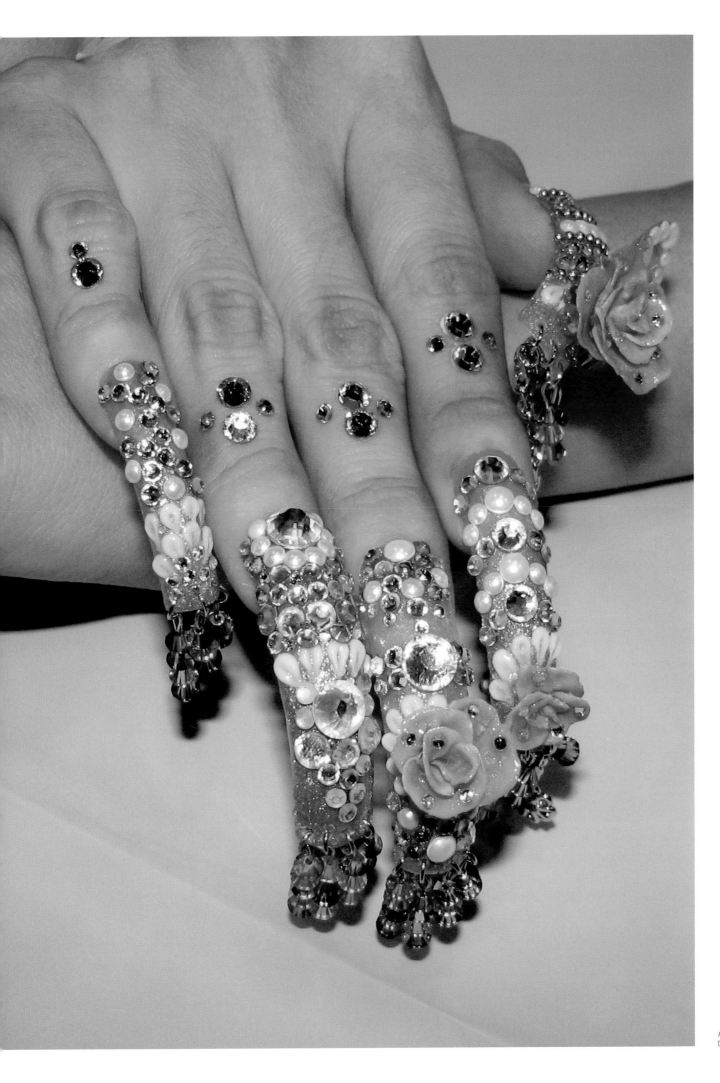

PHOTO/ DAWN DANIELLE NAH
[SINGAPORE]

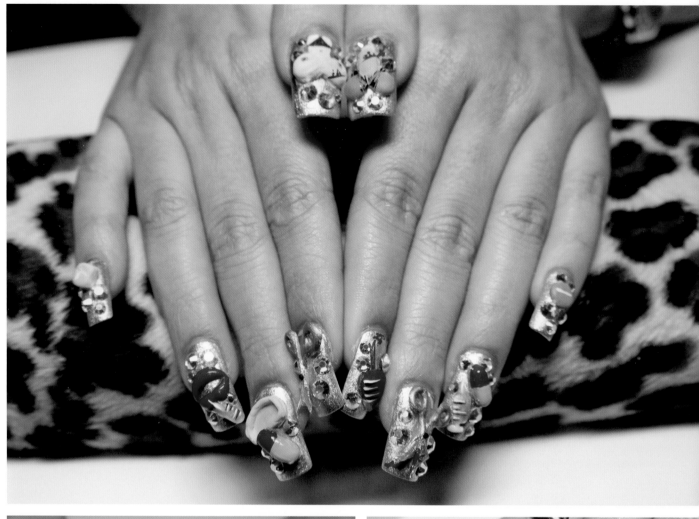

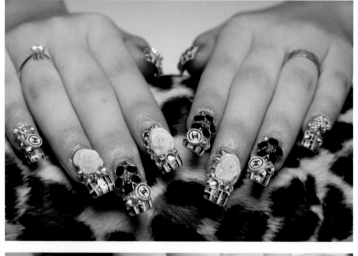

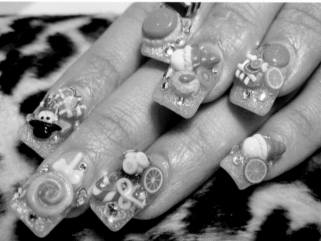

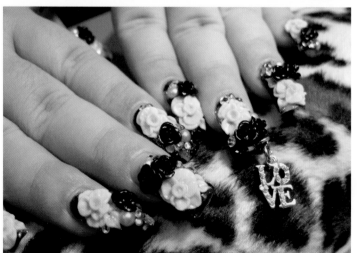

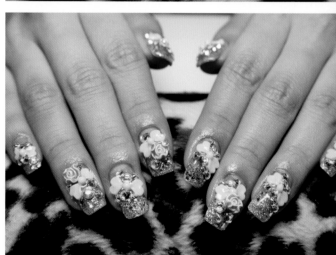

PHOTOS/ DAWN DANIELLE NAH
[SINGAPORE]

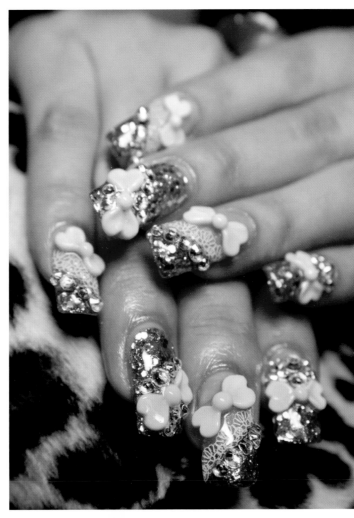

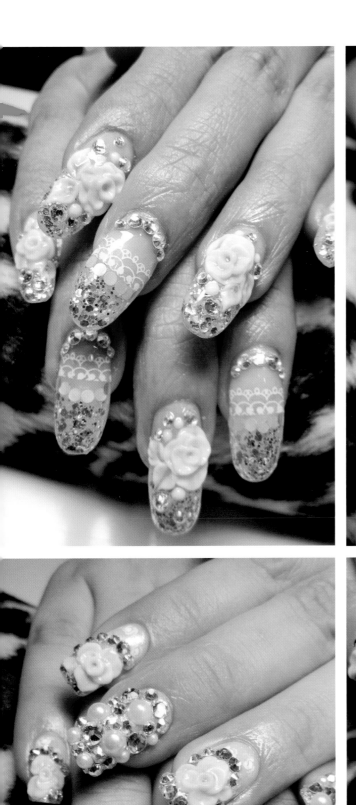

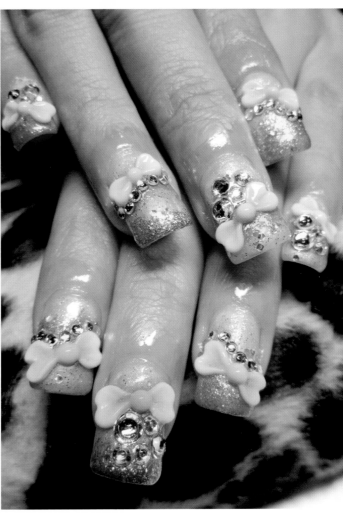

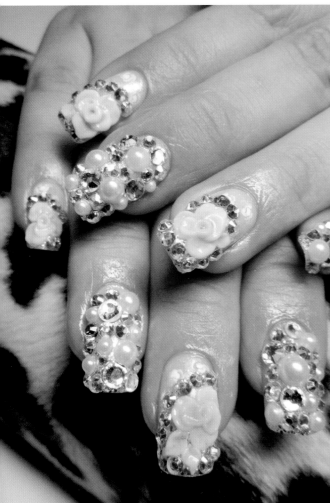

PHOTOS/ DAWN DANIELLE NAH
[SINGAPORE]

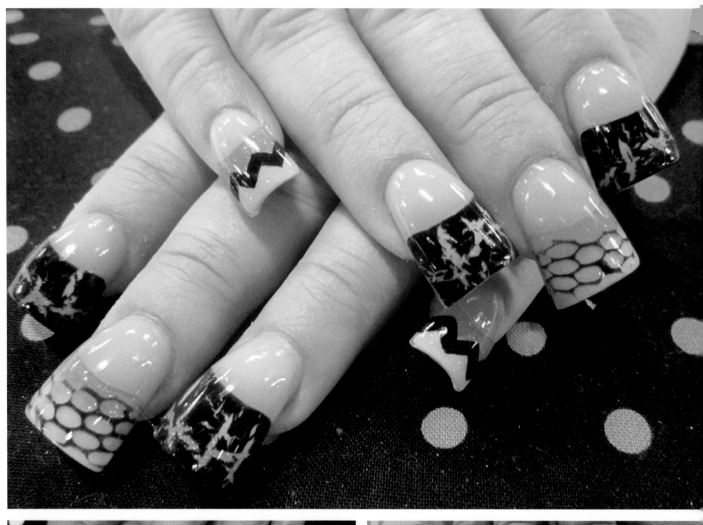

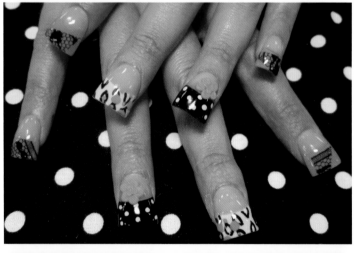

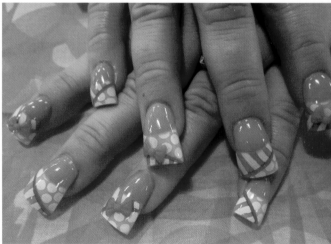

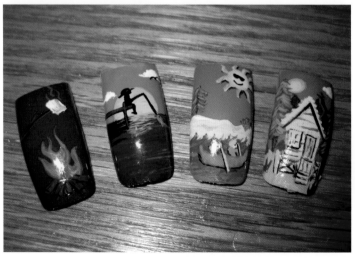

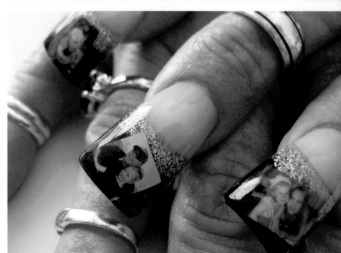

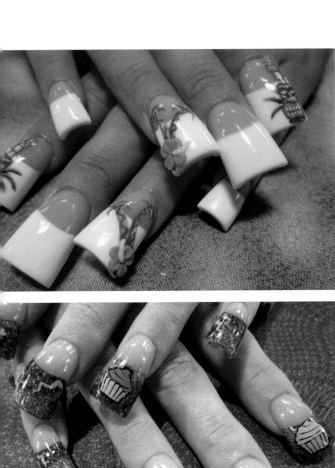
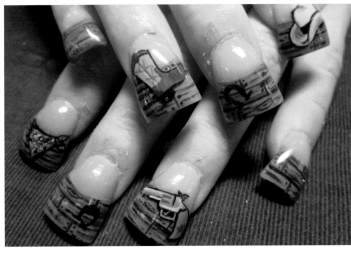
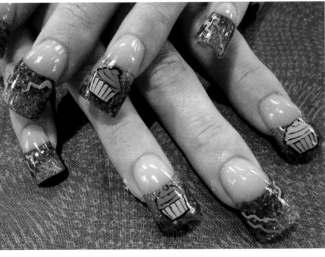
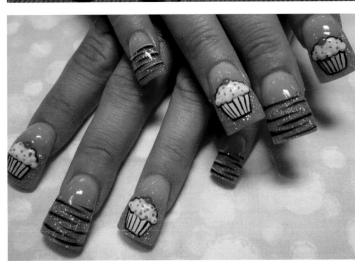
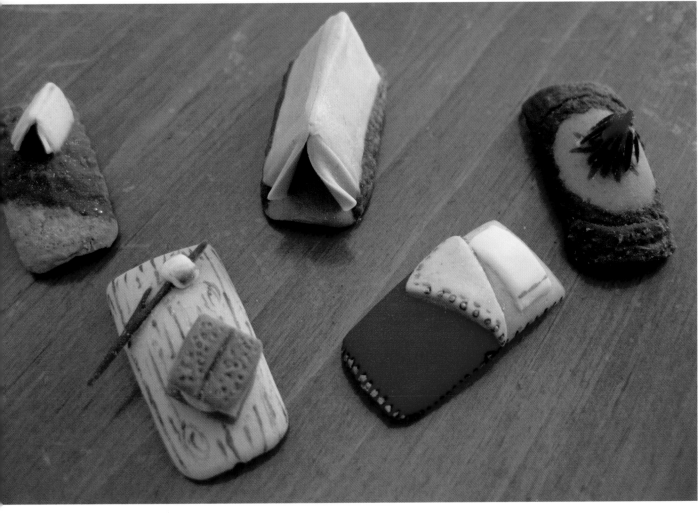

PHOTOS/ OLIVIA GORDON
[CALIFORNIA]

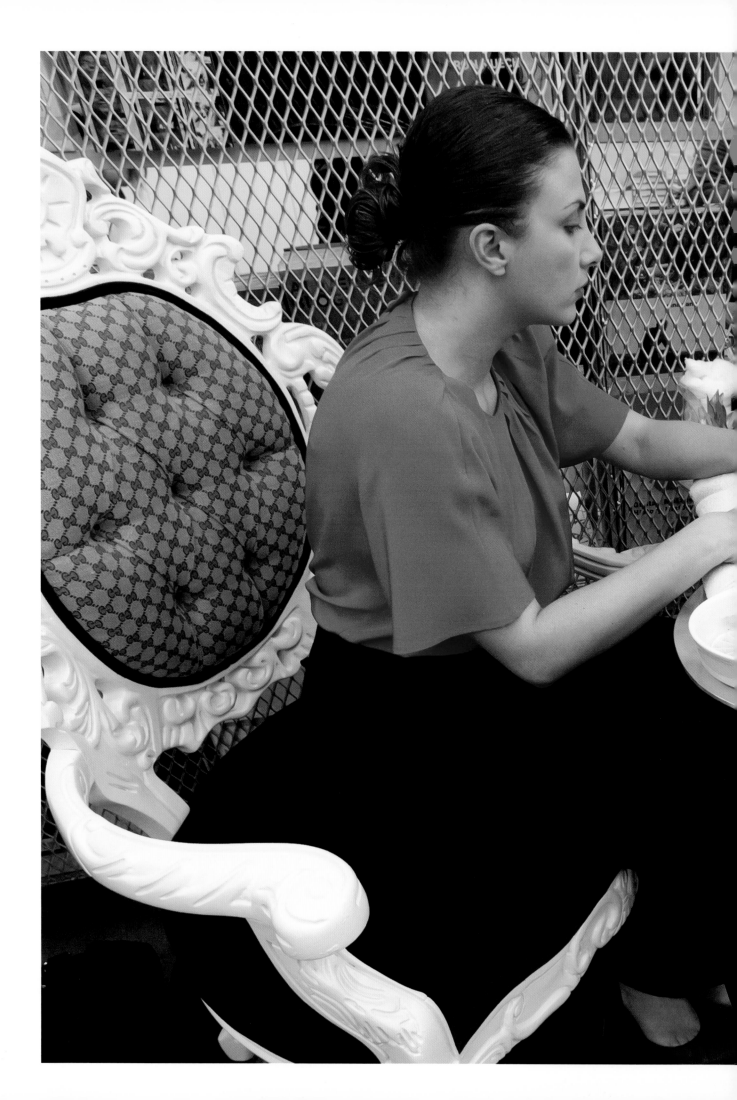

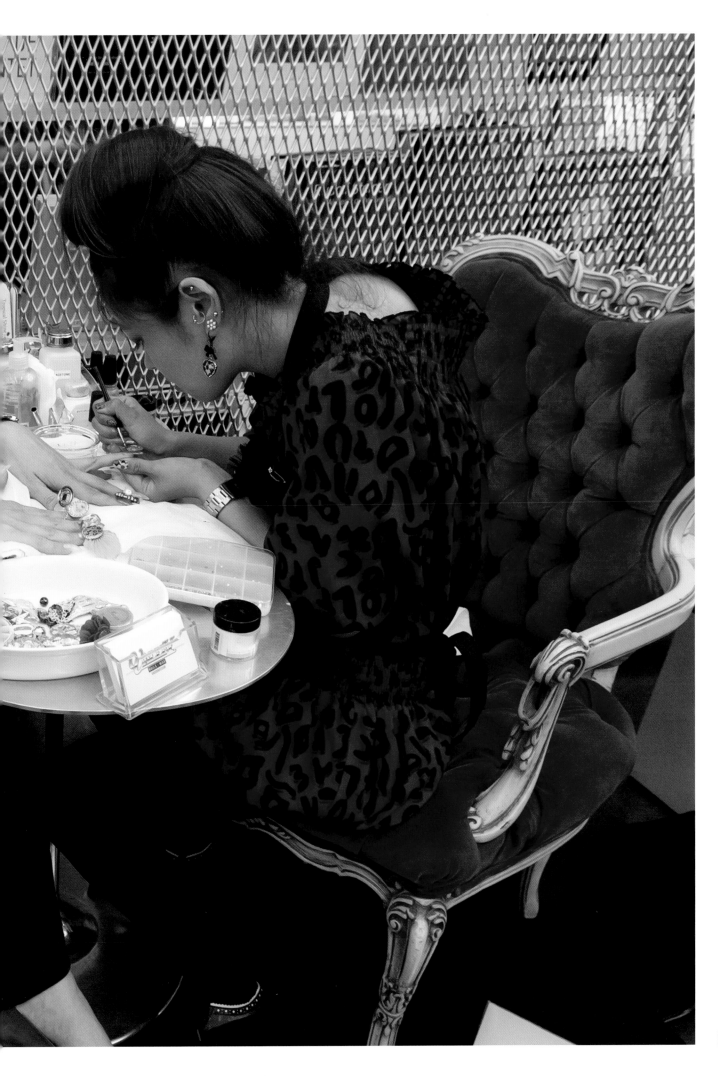

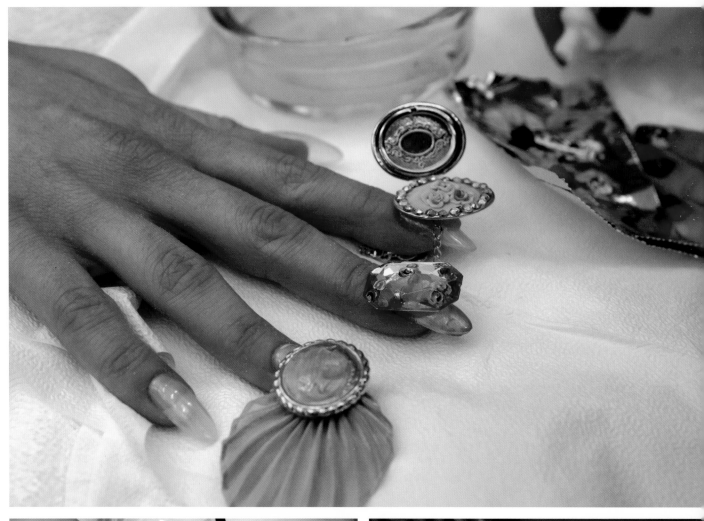
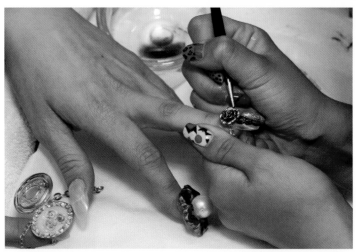
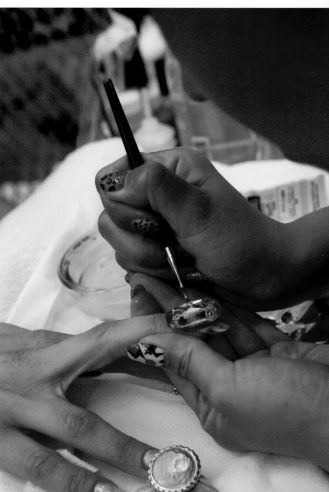
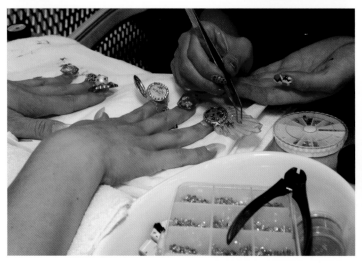

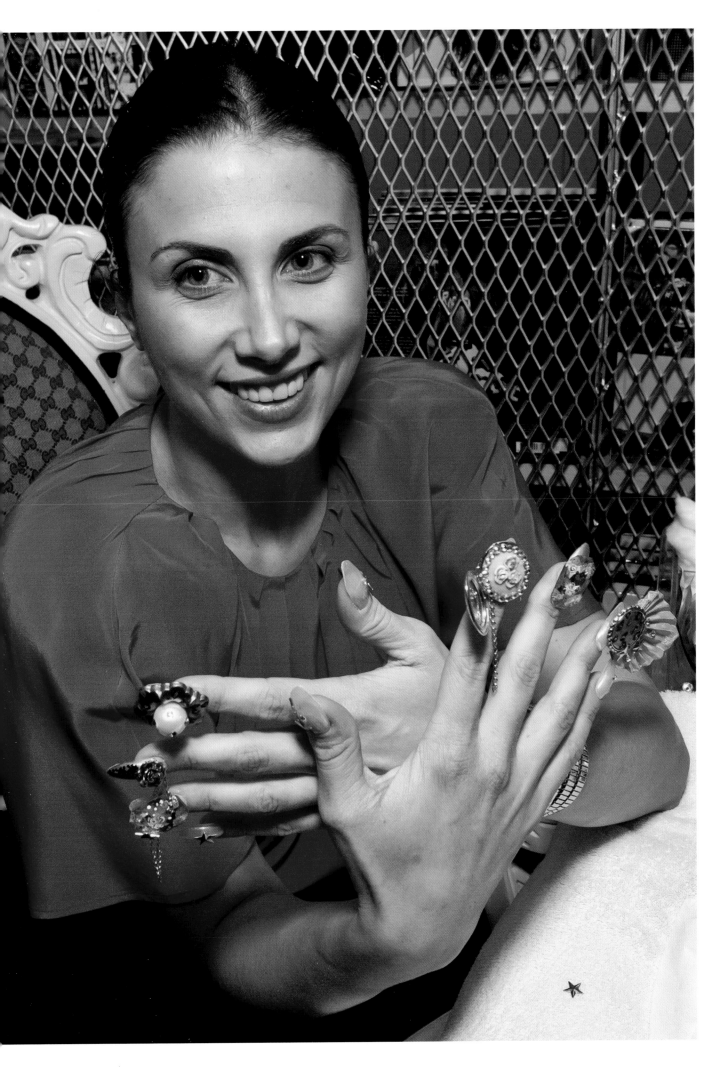

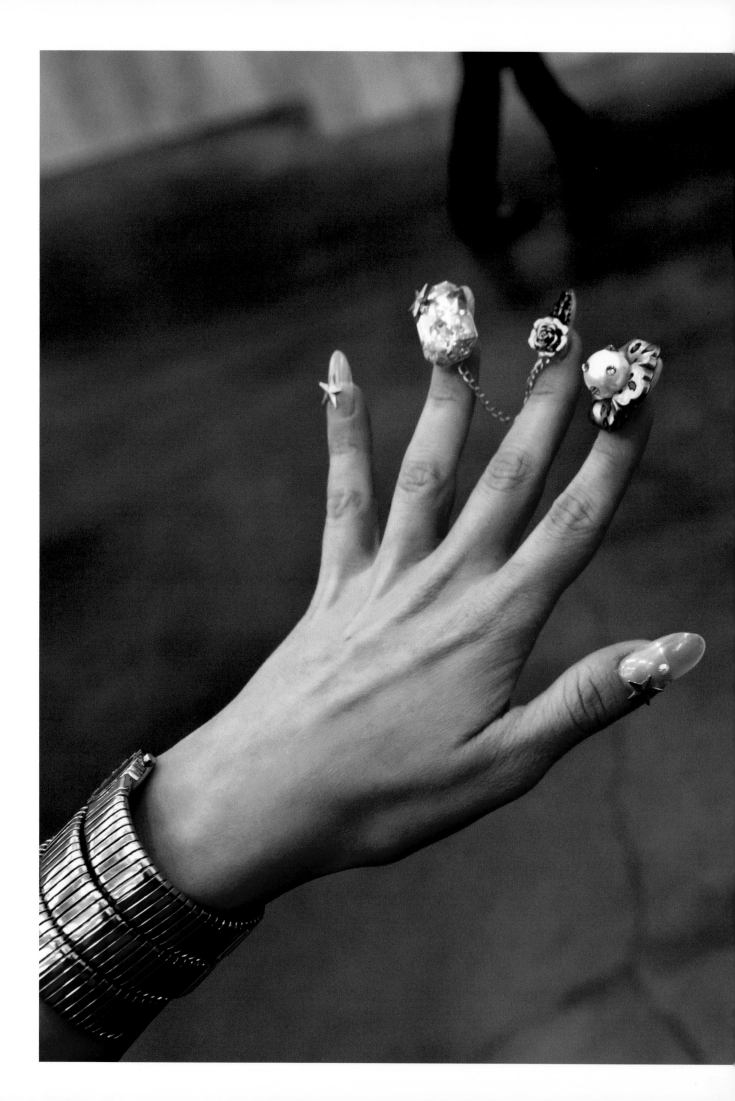

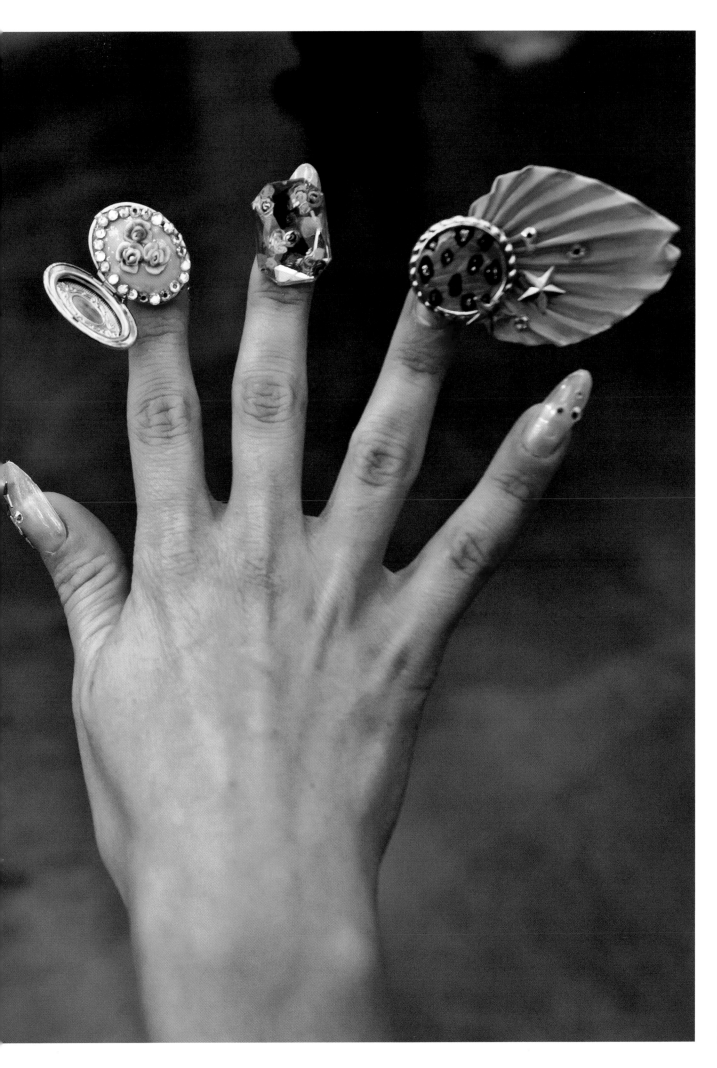

By Kim Hastreiter

Personal style can be a super-exciting language. It is at its most mind-bending when used as a form of communication to express identities boldly and in a very public way through original ideas and not through fashion trends. Often, the most innovative personal style is created in the absence of wealth, and rarely from wearing designer labels bought off the racks. When money is not available, resourcefulness and creativity are required resulting in the greatest imagination and originality. Brilliant ideas don't cost a cent.

In the late 70's and early 80's, I often rode the subways uptown just to see the inspired and amazing looks worn by the kids from the South Bronx who not only came across as visually fierce, but also politically fiercely. Because of their lack of privilege, the streets (not Ivy League universities) honed their intellects. But this didn't make them any less rigorous or intelligent. These young mostly Latino and African American kids would deck themselves out in the most extraordinary styles that were not only amazing to look at but also were provocative and subversive. And smart. The messaging in their looks was complicated, super politically charged and powerful. They'd stride onto the train announcing their arrival immediately through their music with gigantic boom boxes (then called "Ghetto Blasters") hoisted on their shoulders blaring their heroes' tracks that in the day included Afrika Bambaata and Run DMC. They would dress in ways that not so subtly commented on wealthy white society with great humor and irony riffing on these status symbols in hilarious ways. Huge gold Mercedes Benz logos were worn as pendants on thick gold chains dangling on top of a Harvard University sweatshirt with a super preppy LL Bean-style puffy down vest thrown over it, accessorized with studious horn rimmed spectacles (sans lenses) and white Adidas sneakers laced loosely with extremely exaggerated thick laces. Other kids would wear sweat suits, fishing jackets, sneakers and baseball caps plastered with Gucci or Louis Vuitton logos, finished off with medallions of big gold dollar-sign medallions.

It was genius. In one swoop, this knocked both the wind and status out of the worshipped icons of rich white society as if to say, "I may not be able to afford a Gucci bag, but I can print a hundred Gucci logos all over my sweatshirt and look fierce doing it. And it was not an accident that the moment Tom Ford took over the house of Gucci over a decade later that he paid tribute to this early street style moment, designing the bling-iest possible suits, sweats, sneakers and caps all covered in GG logos for his pricey luxury collection. This then became coveted by the status brand's new luxury customer base: the (now) super wealthy hip-hop entertainment community. It all then went on to become bootleg knock-off merchandise sold surreptitiously uptown on 125th Street. (The irony never ends).

Personalization and customization is, of course, the other great benchmark of style identity that has always gone hand in hand with expressing powerful ideas through style. This is the magic that inspires the artist and author of this book, Carlos Rolon aka Dzine, who has for many years made work that has crossed the line between style, cultural anthropology and fine art. (He refers to it as "Kustom Kulture"). Yes, taking a baseball cap and screening a Chanel logo on it or applying Fendi logos to a pair of Nike sneakers is one way to express individuality and politics through customization. But tricking out your car, bicycle, laptop or skateboard is yet another. As a young art student in California in 1974, I painted a dragon on the side of my brand new half-ton pickup truck accompanied with Chinese-styled lettering that said "Dragon Wagon"! I used to proudly drive it down to Hollywood Boulevard on weekends to watch the Cholos from East LA parade their customized cars up and down all night long showing off the glittering airbrushed metallic paint designs, deluxe and crazy interiors--and the sparks that would fly as their low cars dragged along the pavement. Mesmerized, I remember thinking "this is art". It is clear that Dzine agrees. His unique and amazing work not only celebrates customization digging down into its relationship to art, subcultures and "self fashioning" but also creates a new and democratic dialogue in the process. For many years, his fascination with custom car and bicycle culture introduced the notion of personalization to the art world: creating radical collaboratively customized vehicles (from cars to bicycles), which he then showed in museums and galleries.

Continuing with his strongly-held belief that " art is everywhere", Dzine has recently been flirting with one of the most daring and radical personalization ideas in the name of style --- decorative customization applied to one's very own body. Personal customization--whether created temporarily (outrageous hair sculpting, henna body-painting, ornately decorated finger and toe nails) or permanently (tattooing, piercing, or even inlaying a gold dollar sign into one's front tooth)-- is not for the timid. Although extreme creative body decoration has existed for centuries, it is more common these days than ever. Is it art? Is it a subculture? Is it fashion? Lines are being blurred. Tattoo masters work has lately been appearing on everything from luxury fashion accessories and customized ice cream trucks to the faces of extreme male models on the Paris runways and in recent fashion ad campaigns. Even the over-the-top "hair entertainers" from Detroit who compete tirelessly for trophies in the famous Hair Wars competition ended up at Jeffrey Deitch's gallery in New York a few years ago. One Hairwars winner walked her outrageous hairdo to the end of the runway, pushed a button and it began to fly around the room (she called it the "Hairycopter") while another winner pulled a live snake out of her enormous grass green updo as the crowd went wild. I mean if that's not art, what is?

Recently one of the most fun, creative cultural phenomenon bubbling under the radar has been the proliferation of nail artists all over the country. And Dzine, recognizing the brilliant extreme innovations of the underground nail art movement has celebrated and embraced this as an artform. He has taken it to another level through his latest project, designing remarkable luxe bling-ed out nail ornaments, opening guerilla pop up nail art "salons" in museums and galleries and finally publishing this beautiful book documenting it all.

But whether it's called performance, fashion, beauty or pop culture, or just plain art, for Dzine the labels don't really matter. What does matter to him is celebrating, supporting and making this beauty accessible and leveling the playing field for creators and talents (not to mention lovers of art) no matter what their social status is. In the end, I am so grateful to an artist like Dzine who helps us all to look at and recognize art and its innovators around us in a much more open way. Because art is truly everywhere.

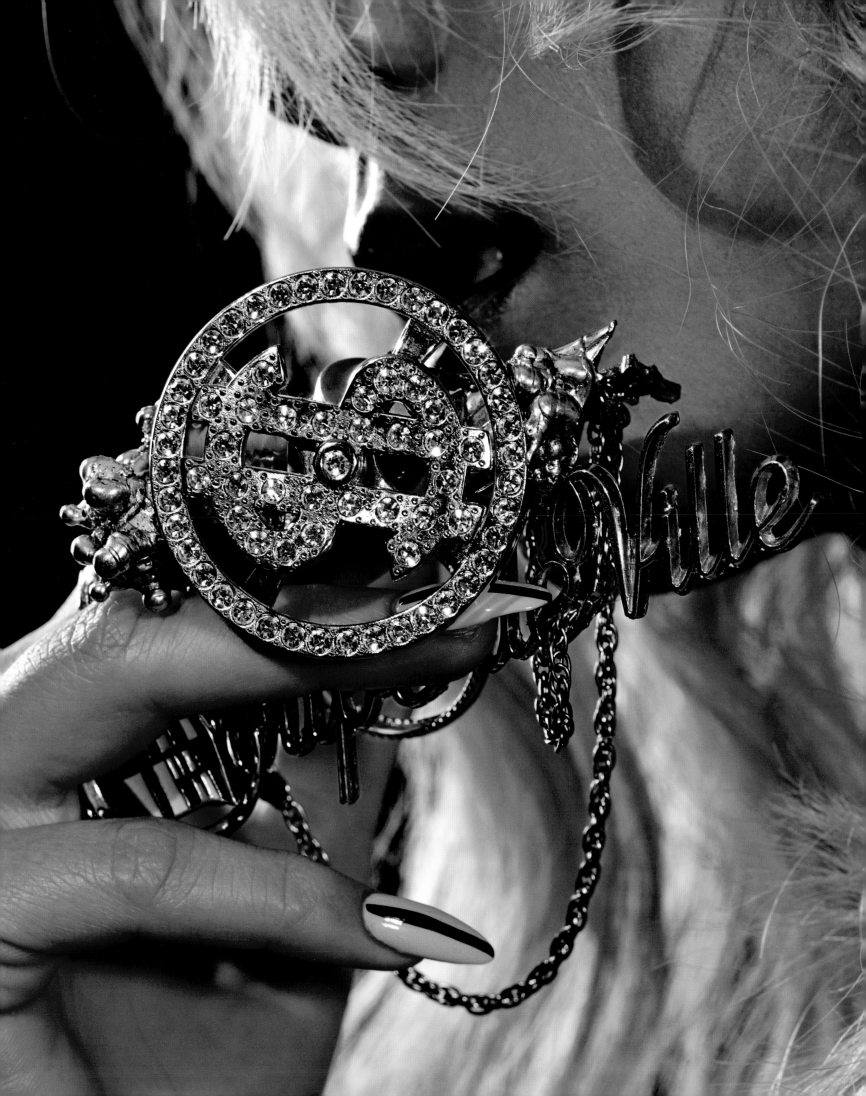

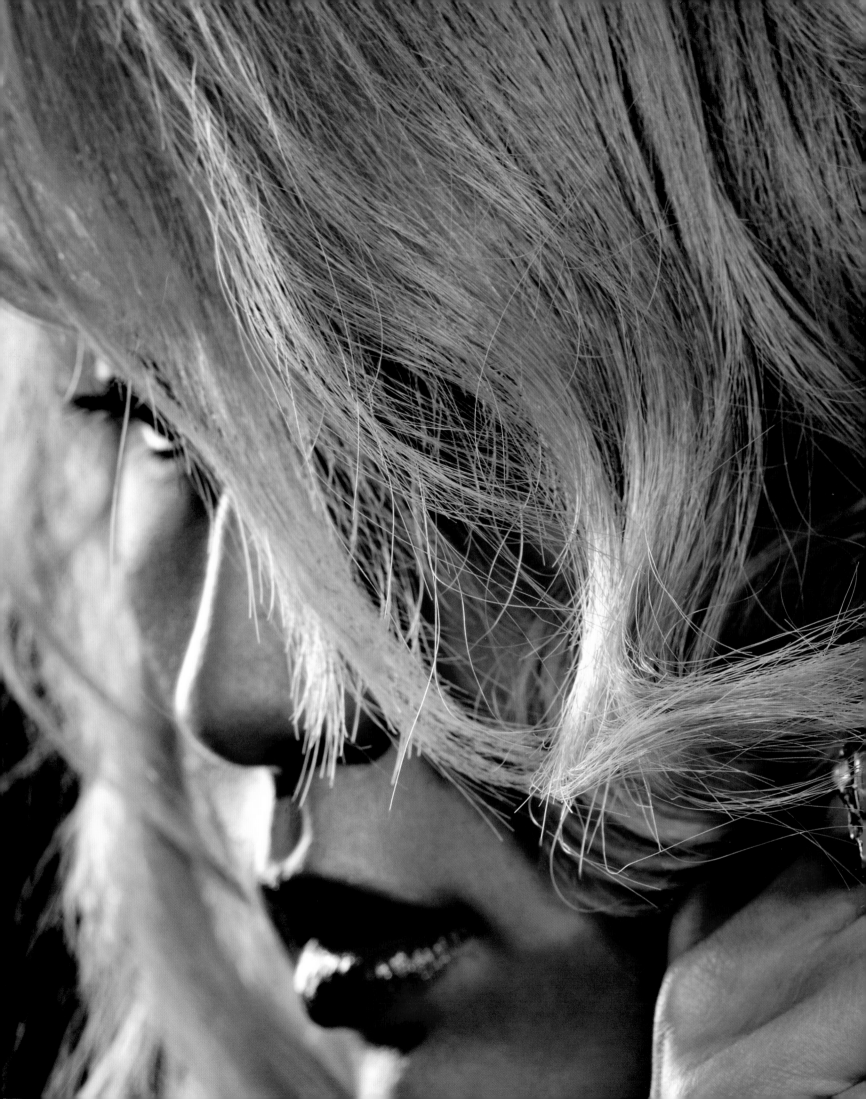

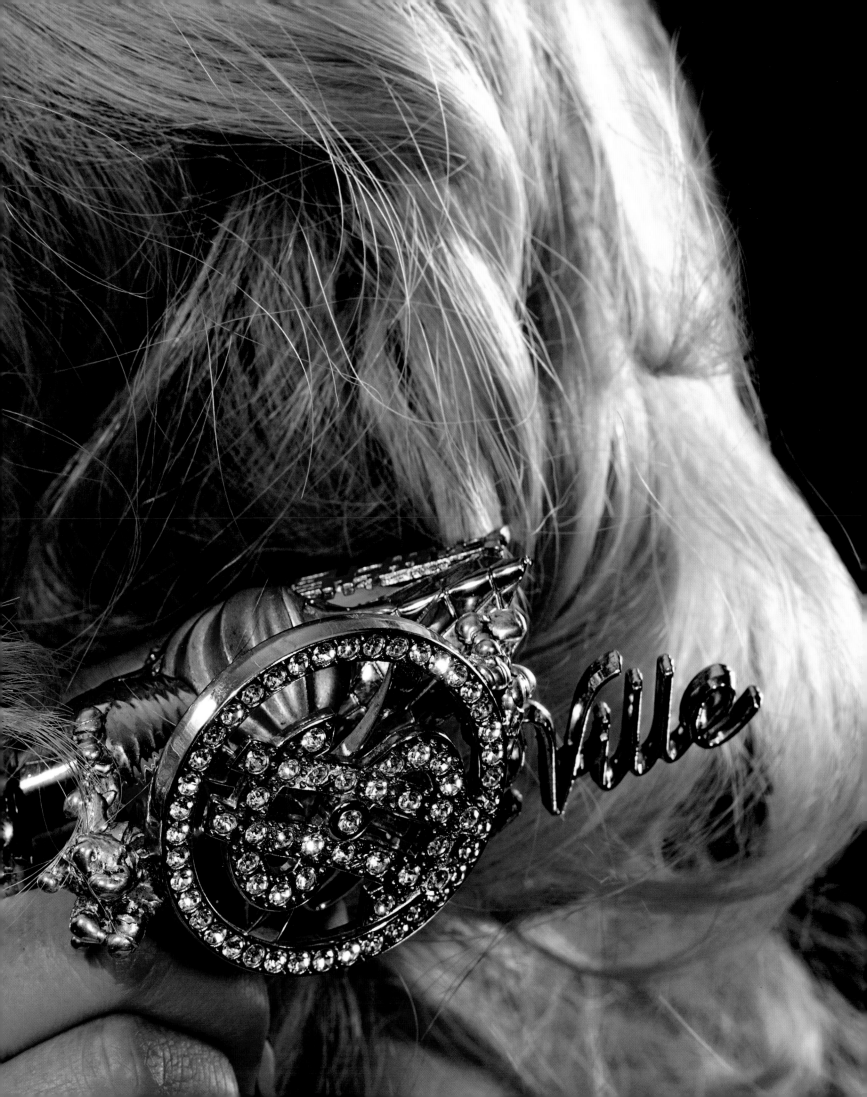

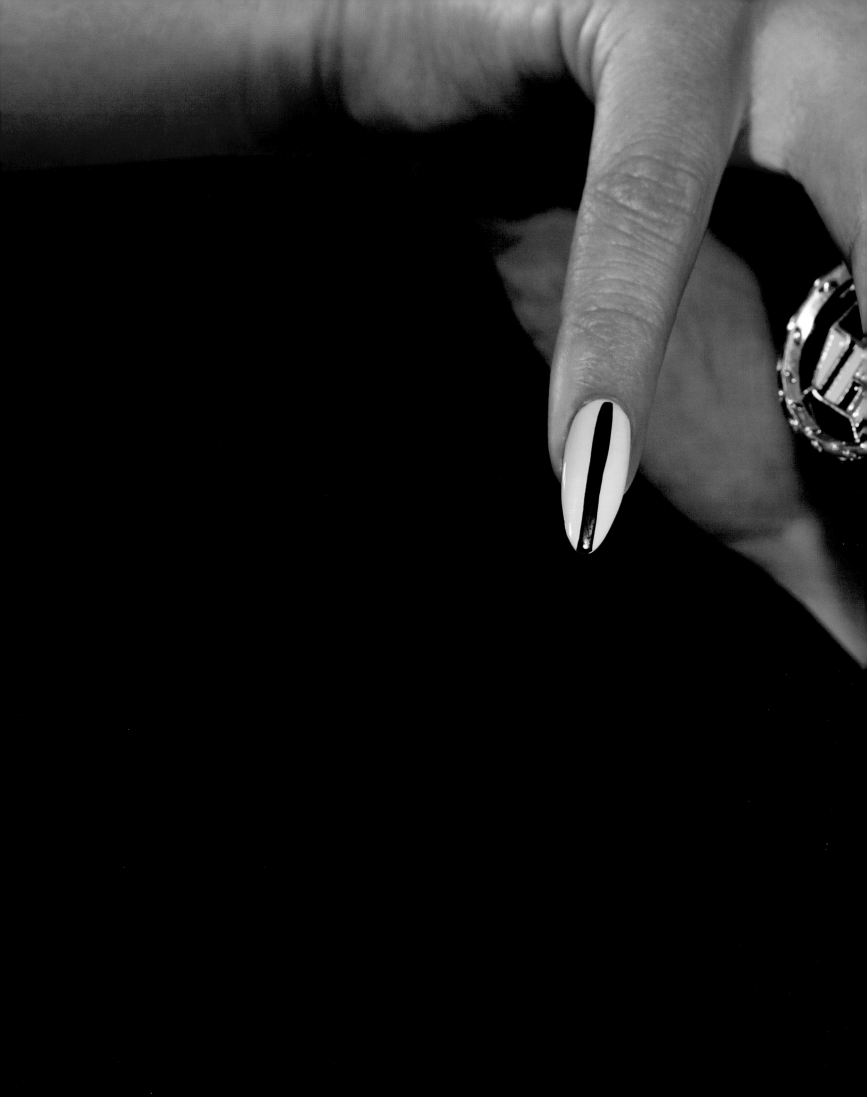

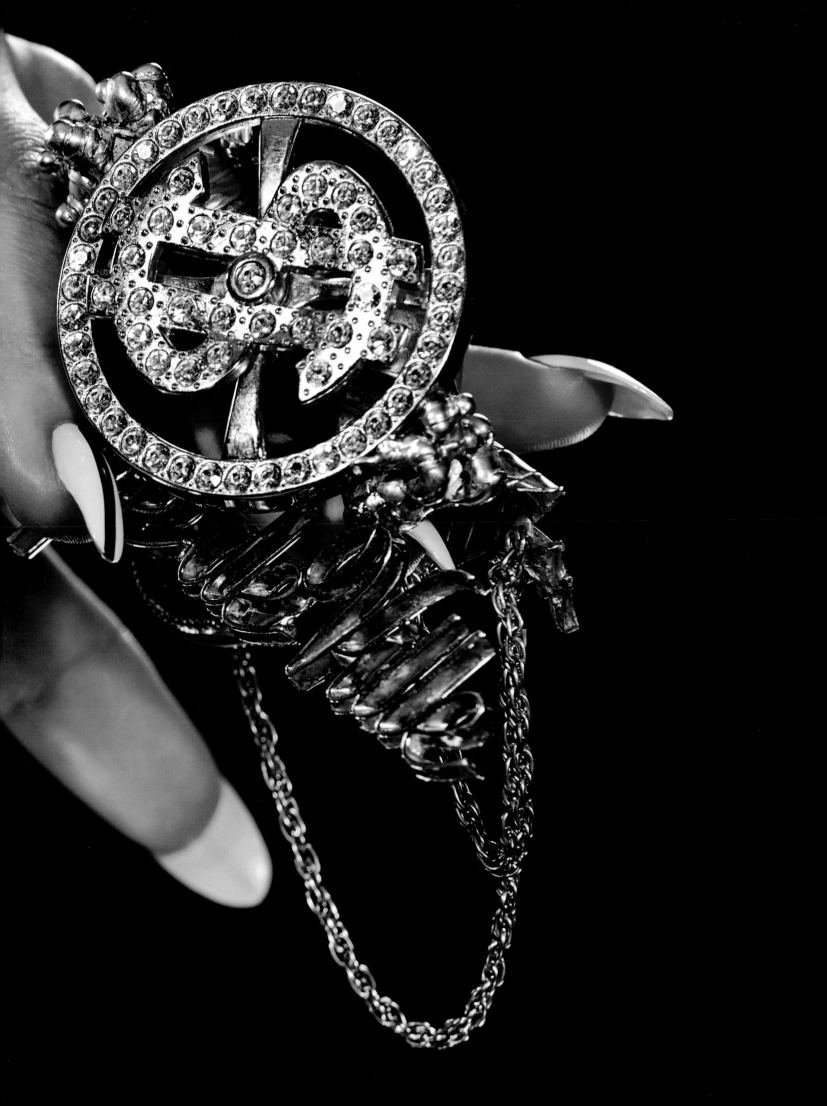

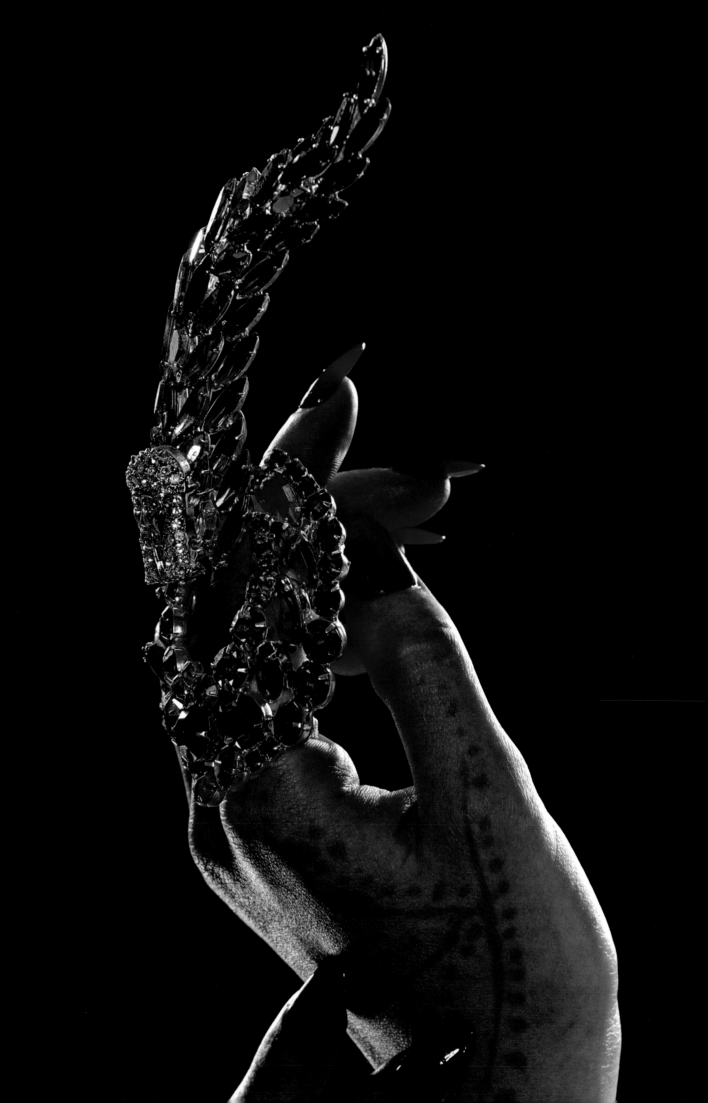

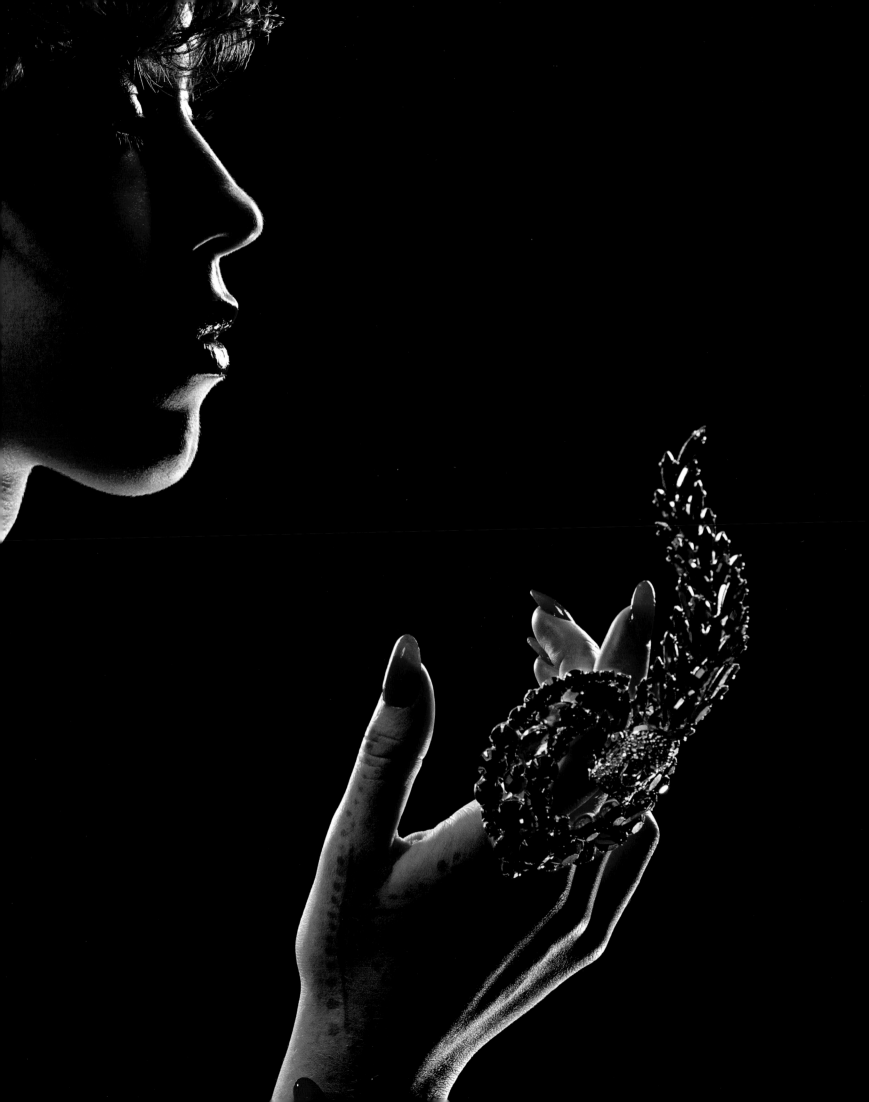

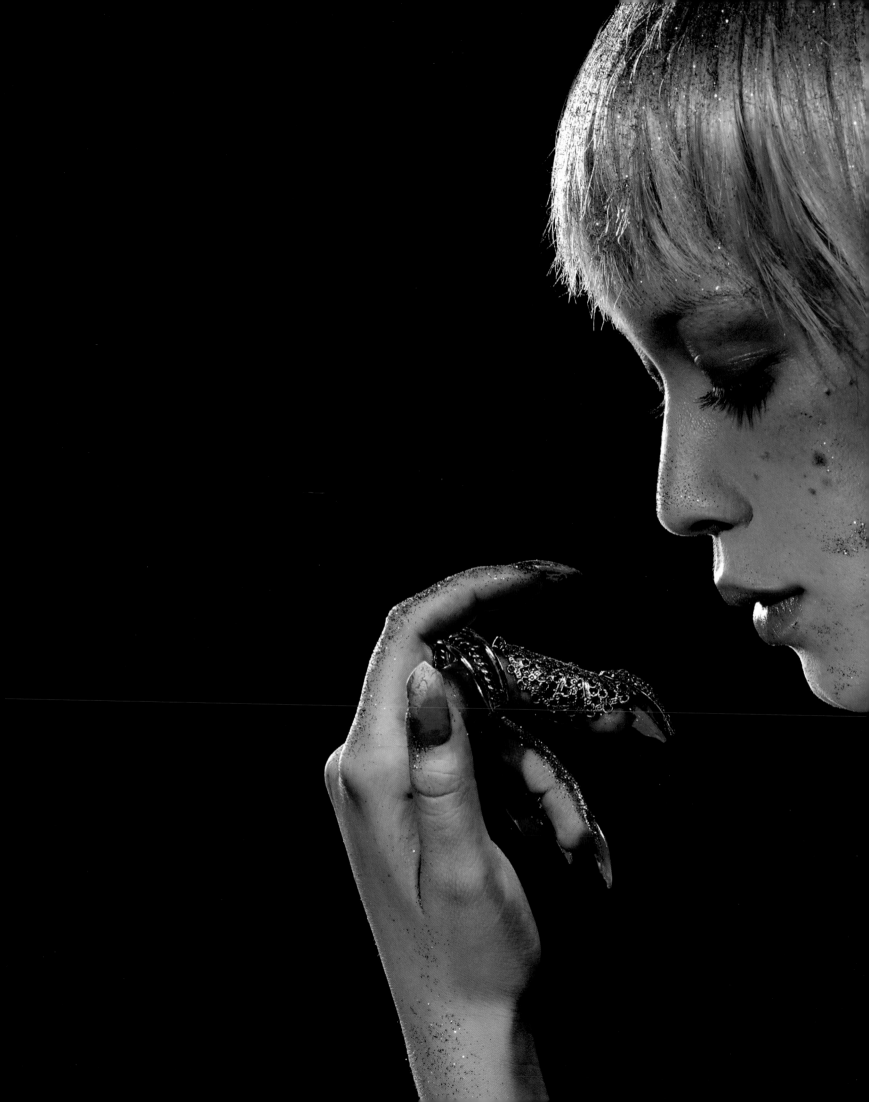

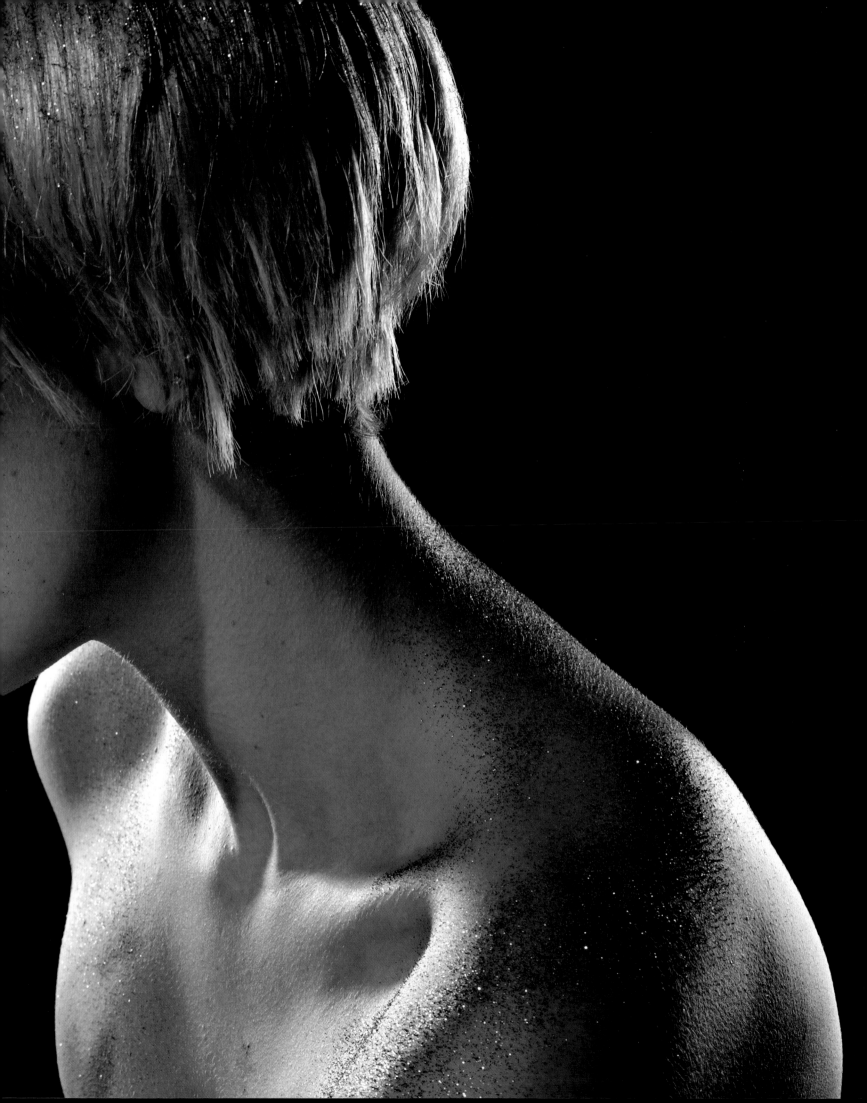

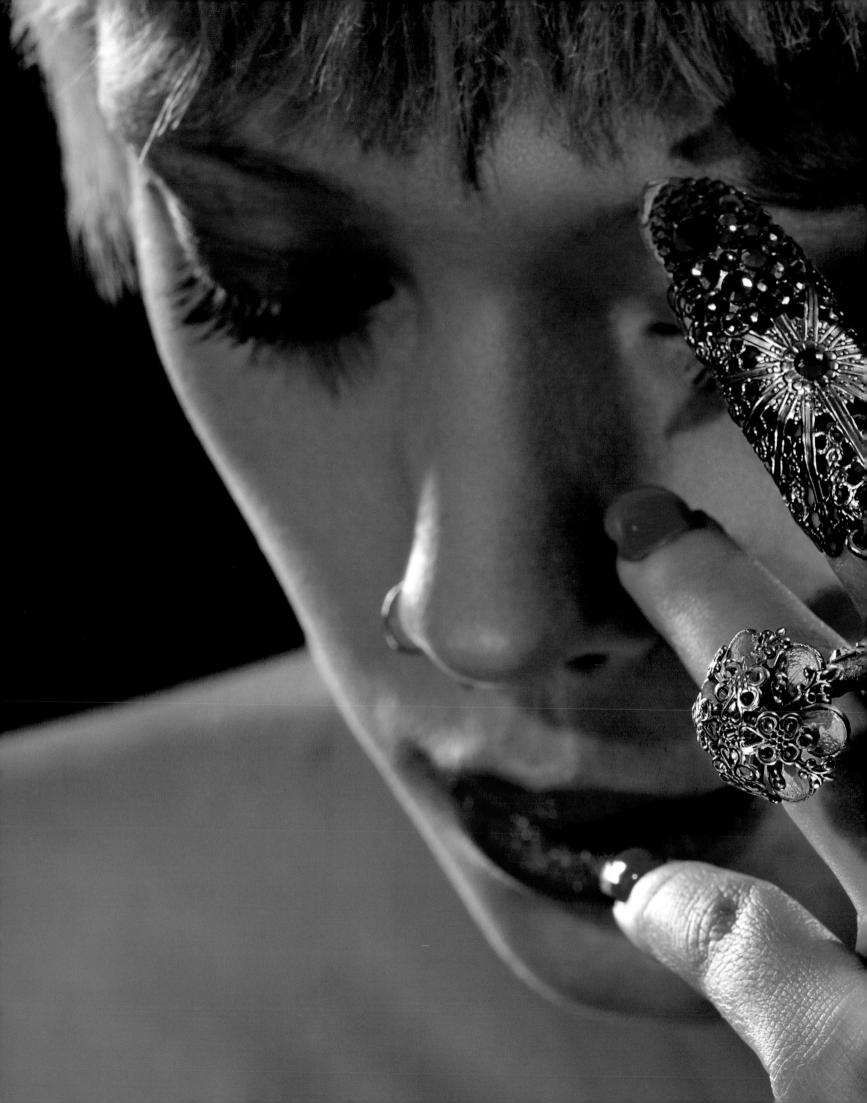

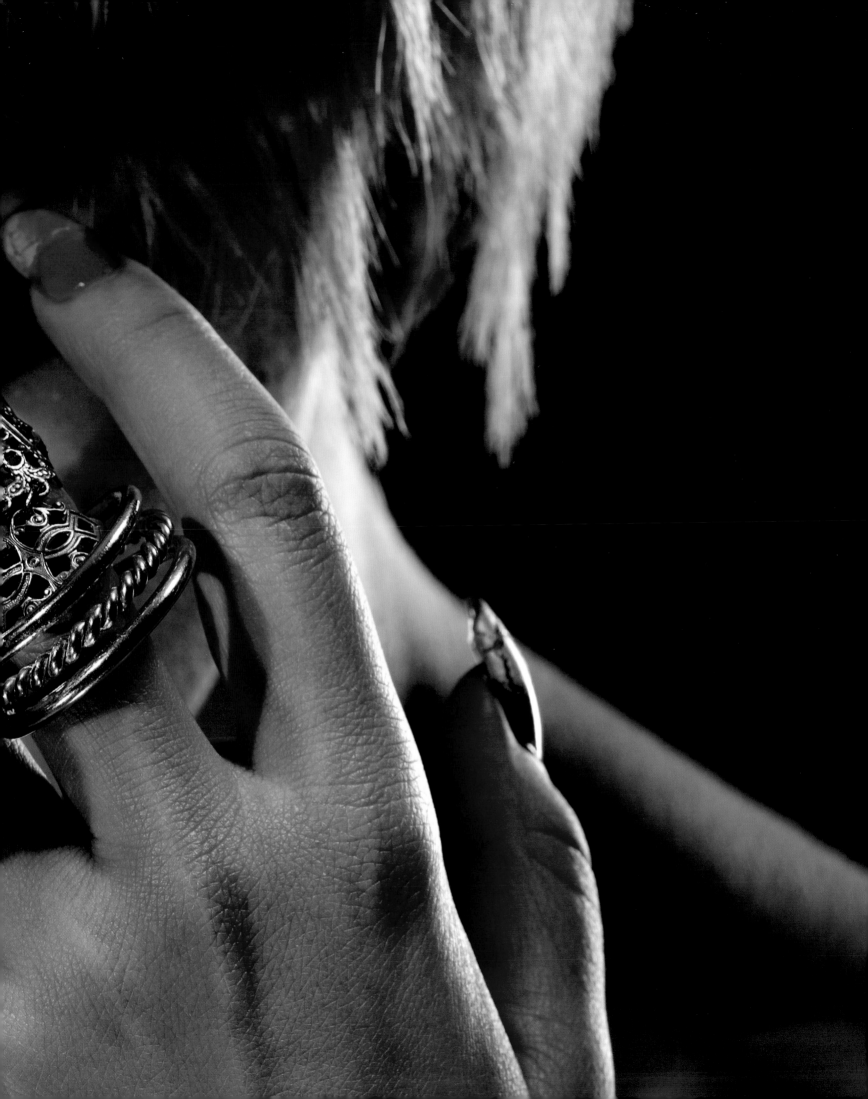

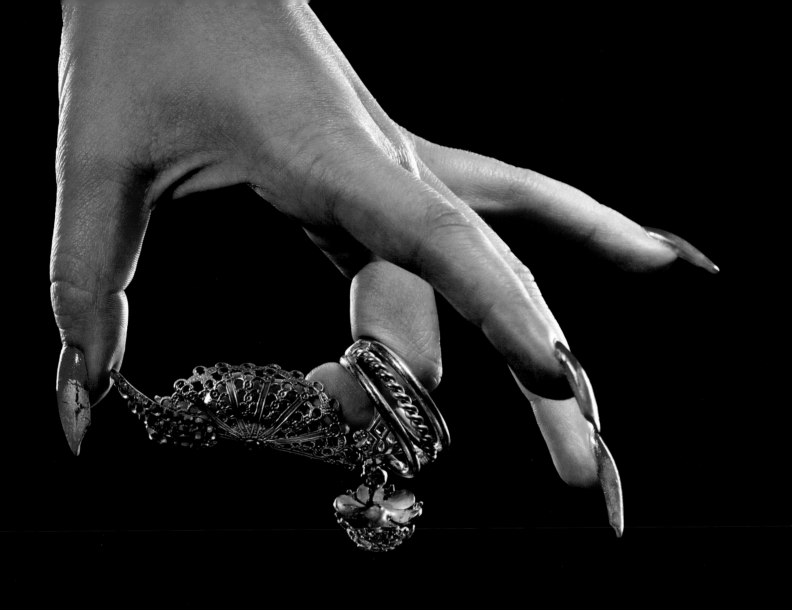

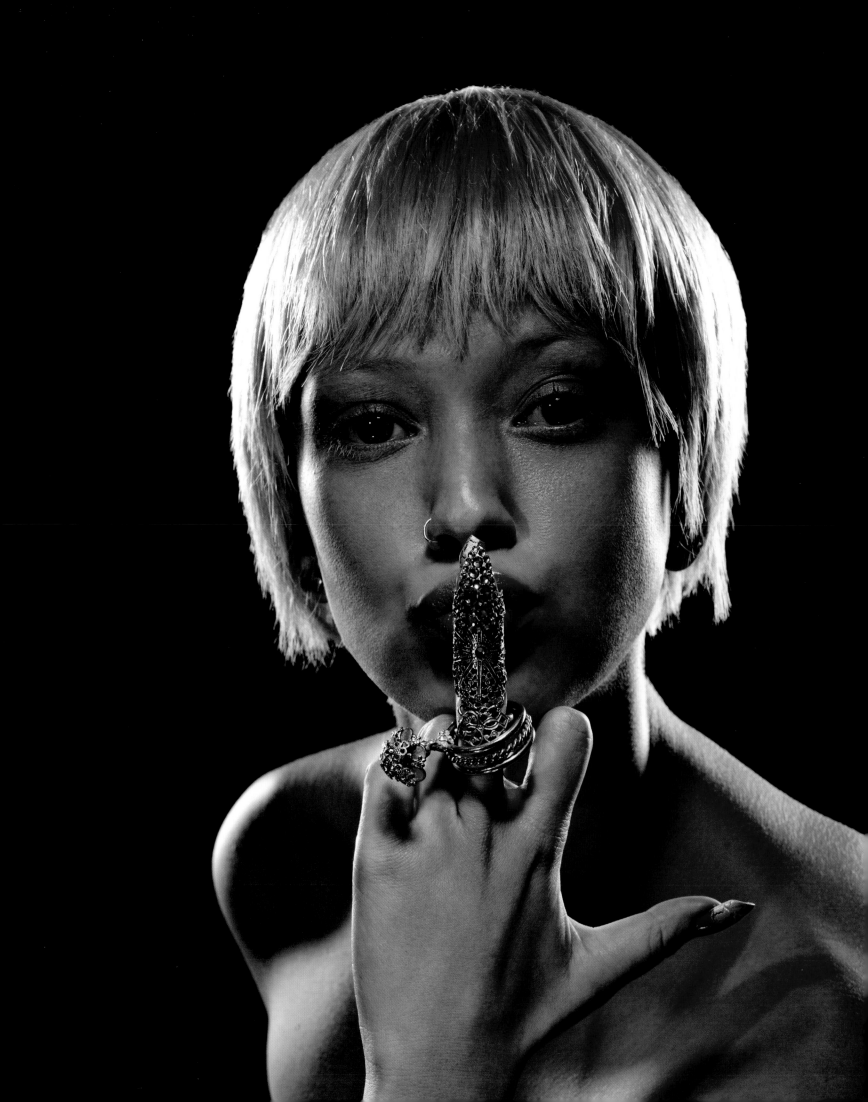

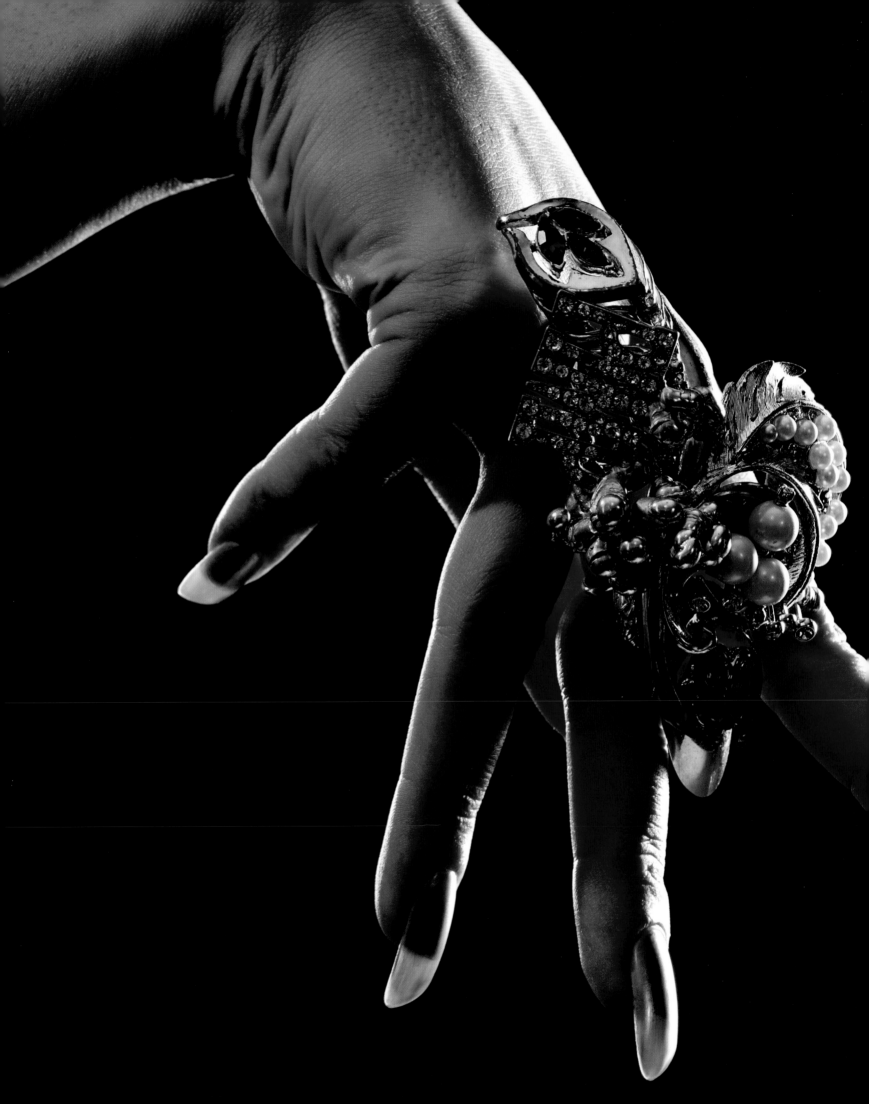

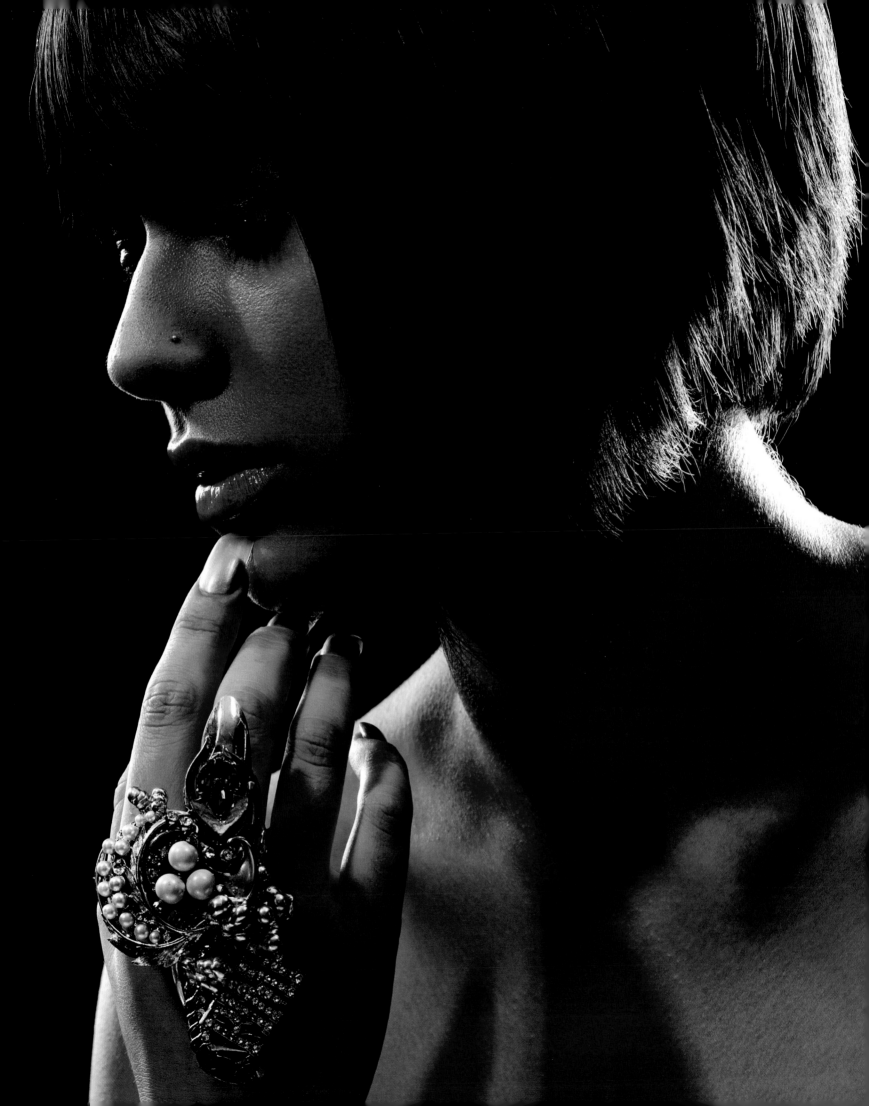

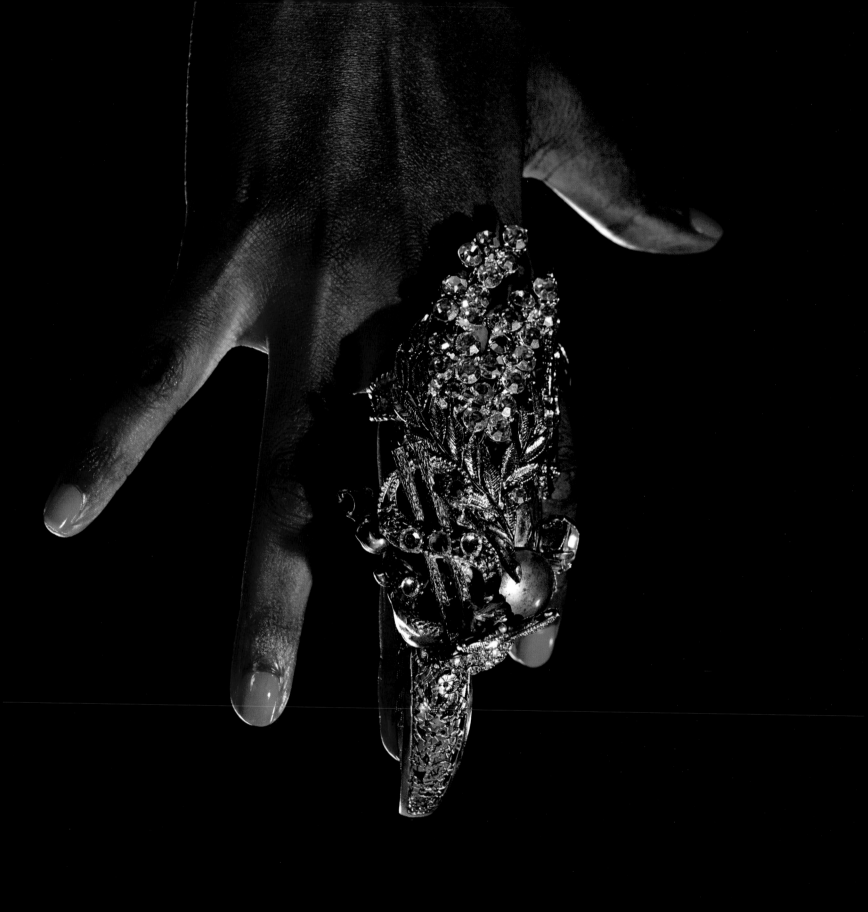

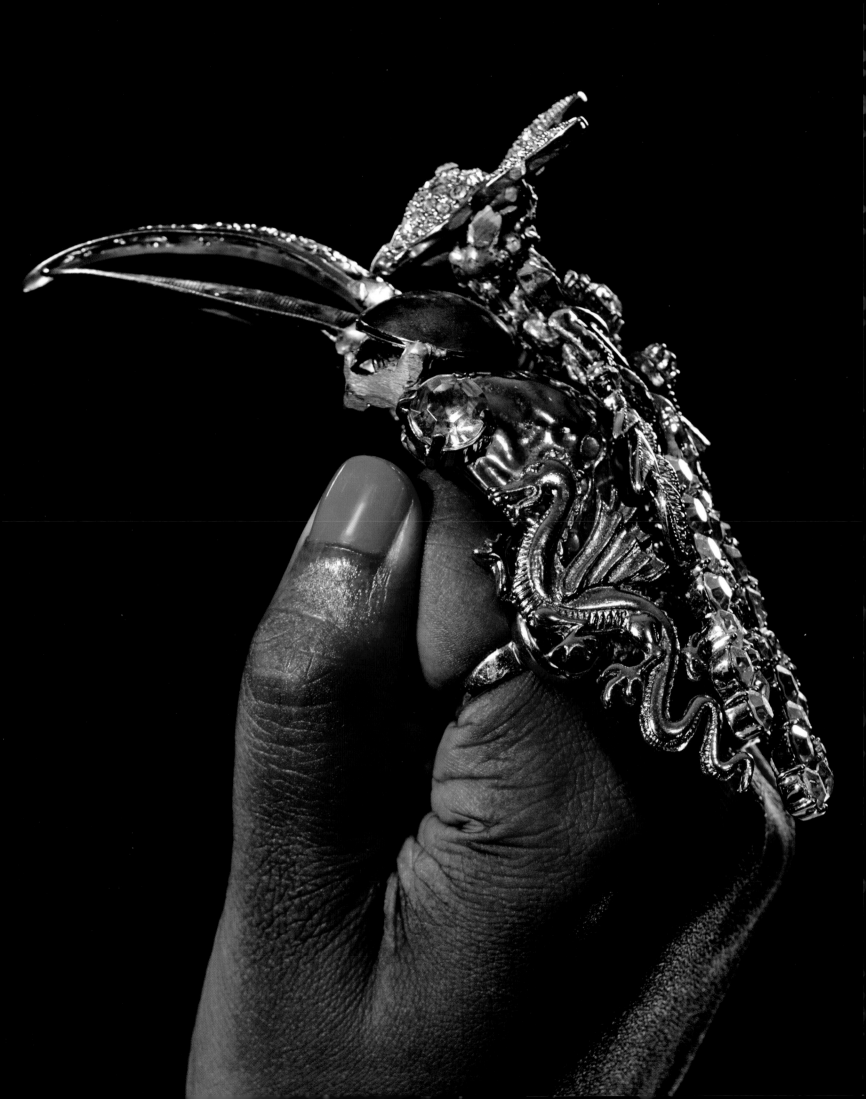

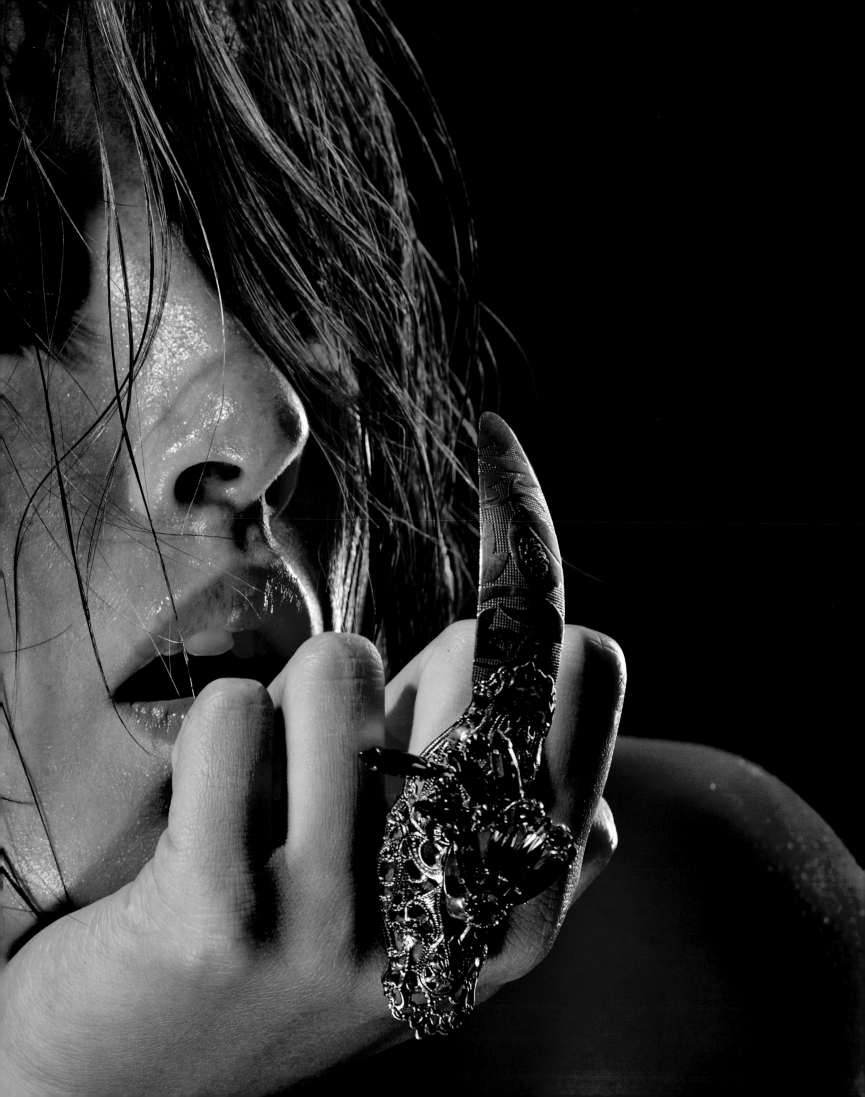

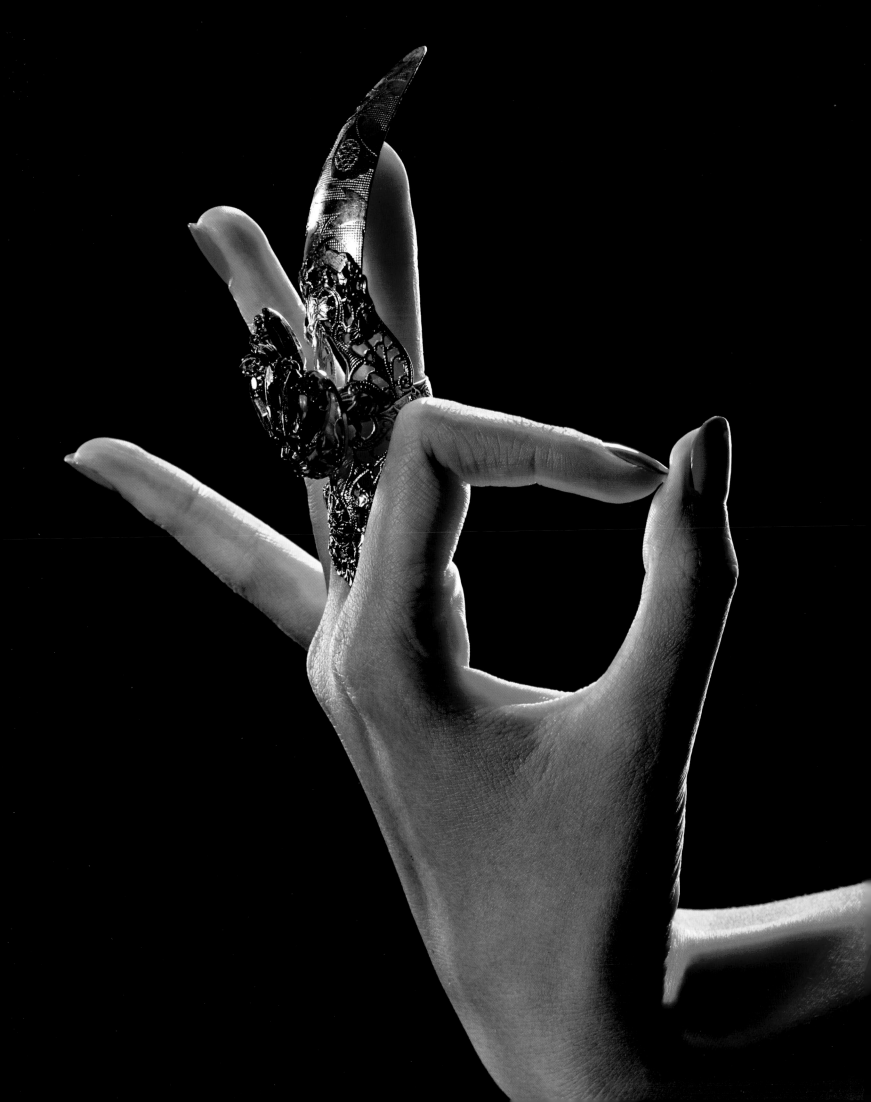

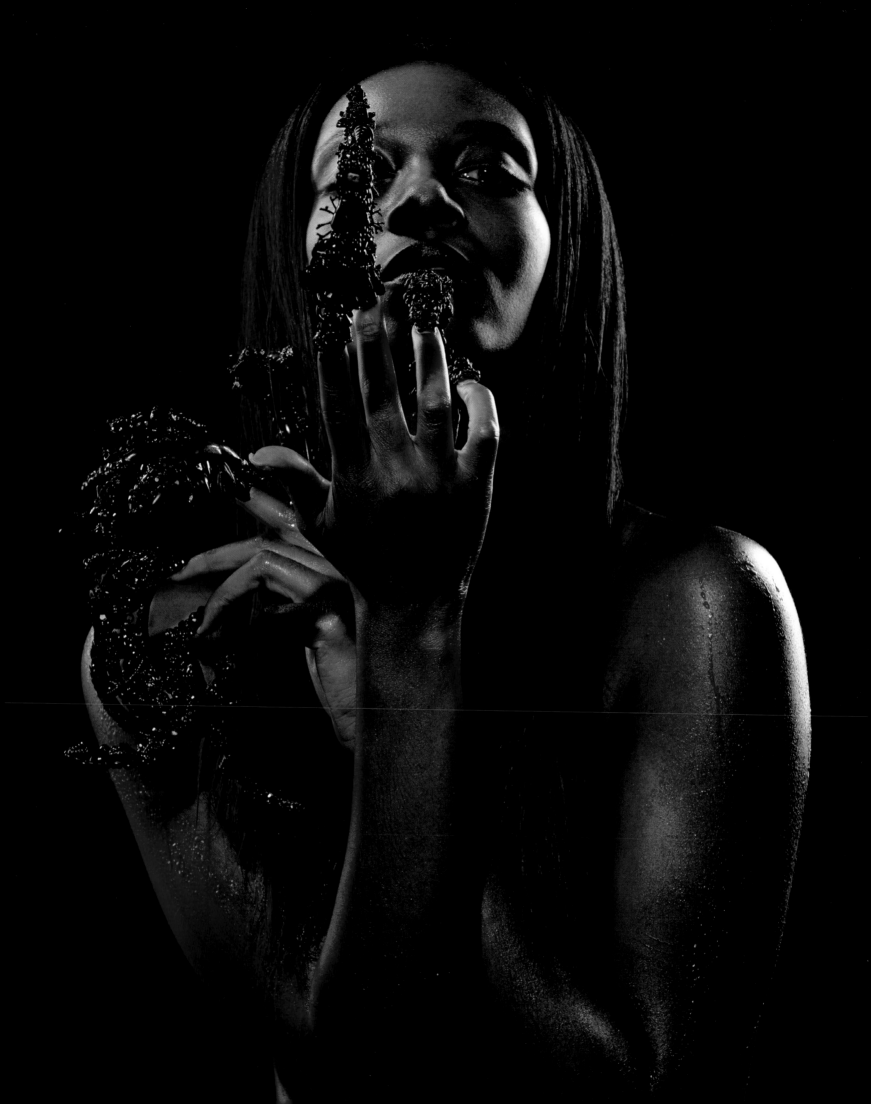

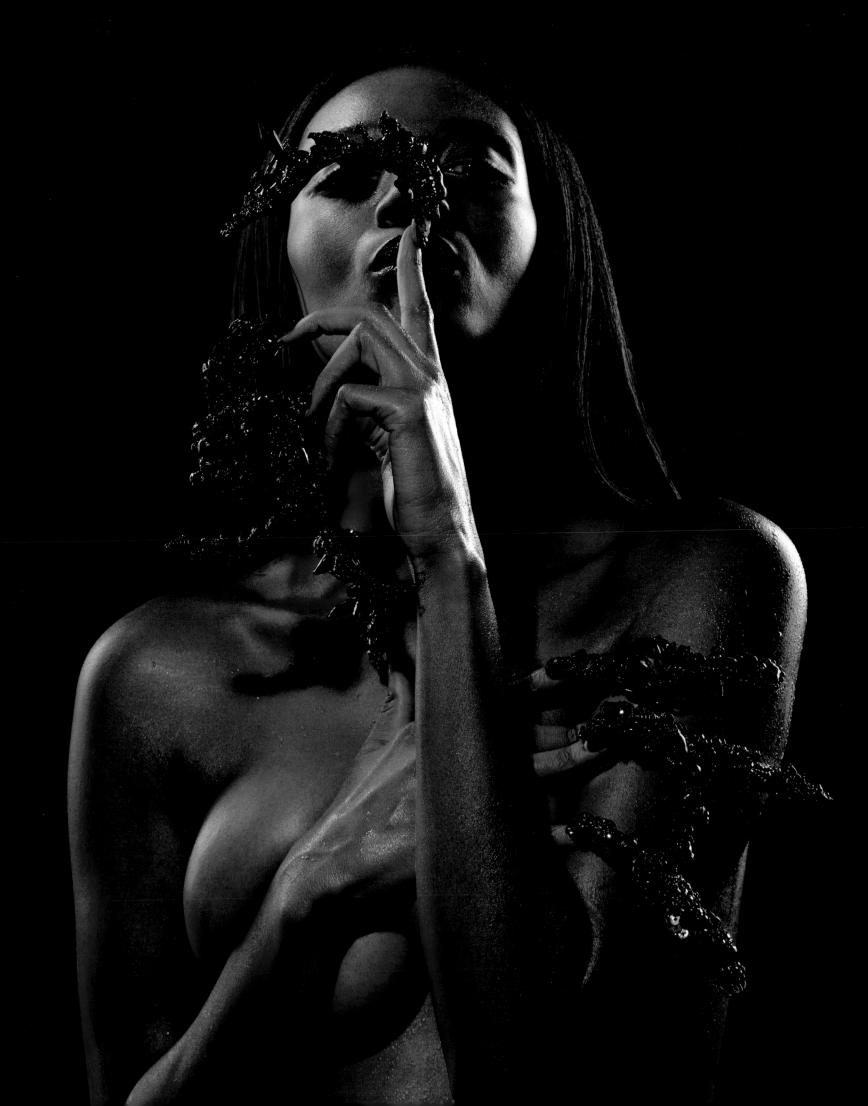

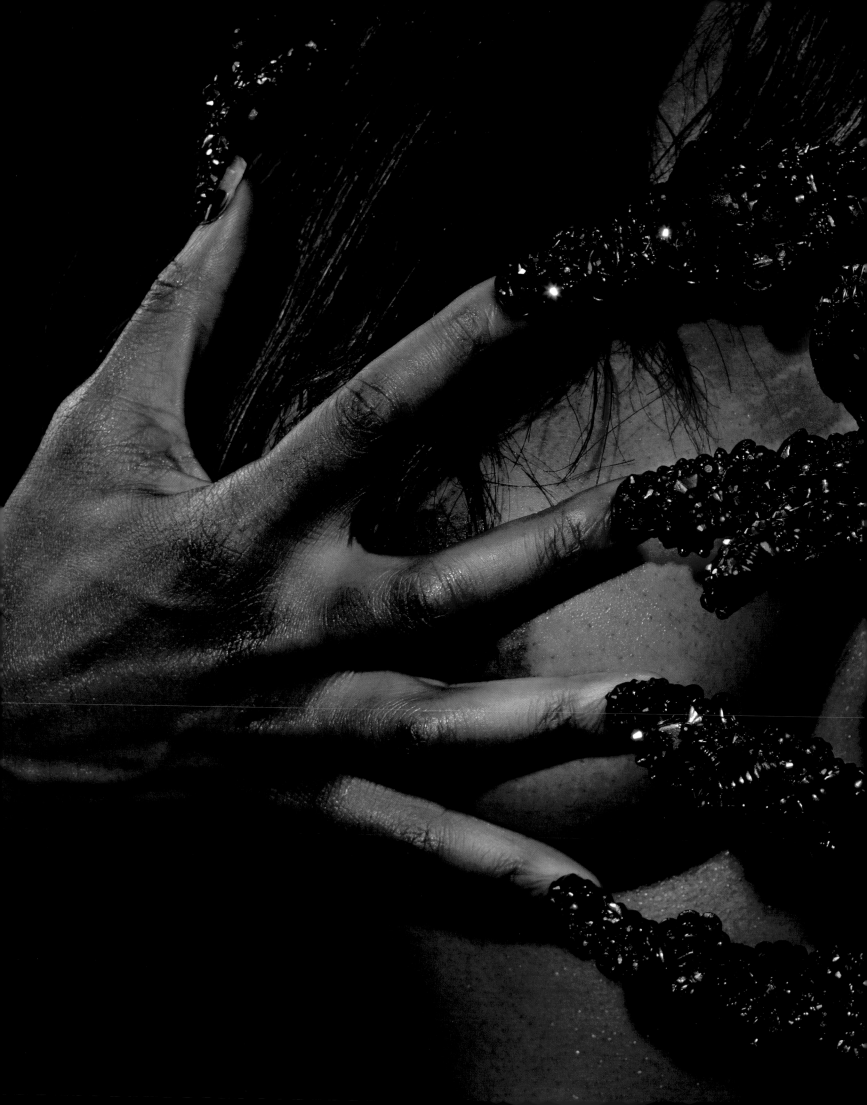

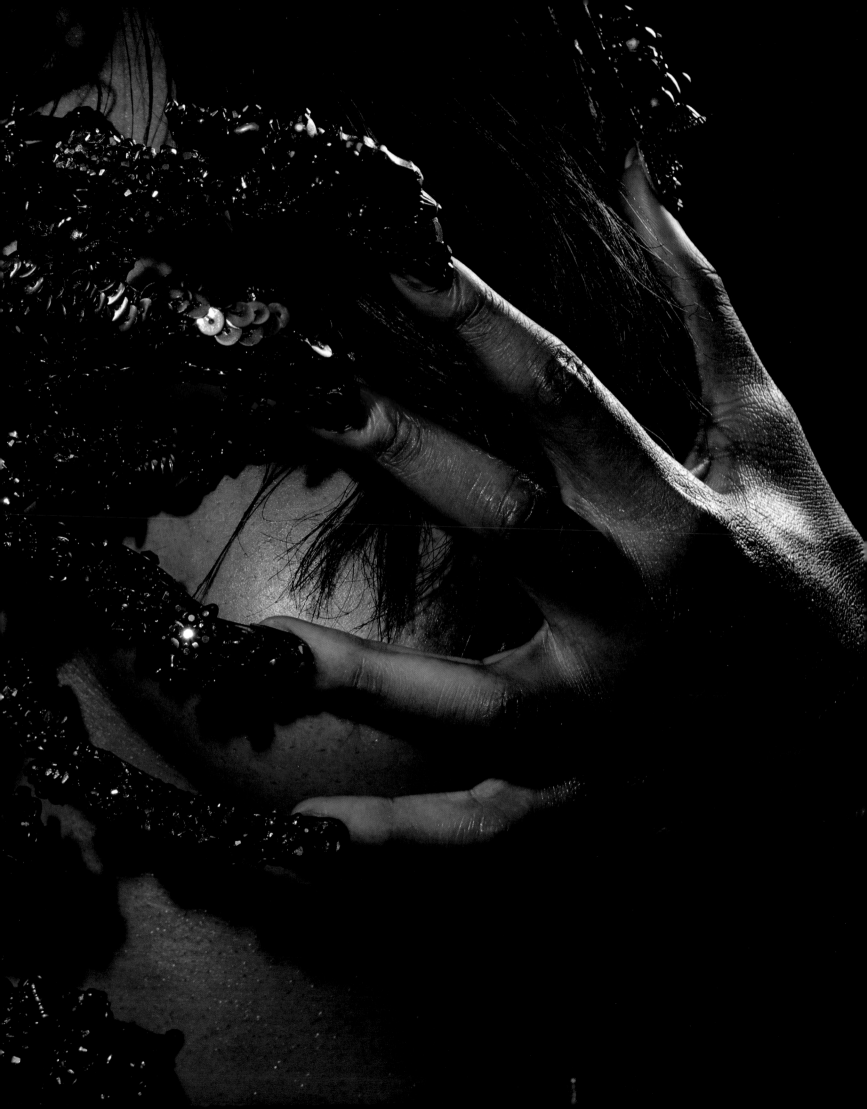

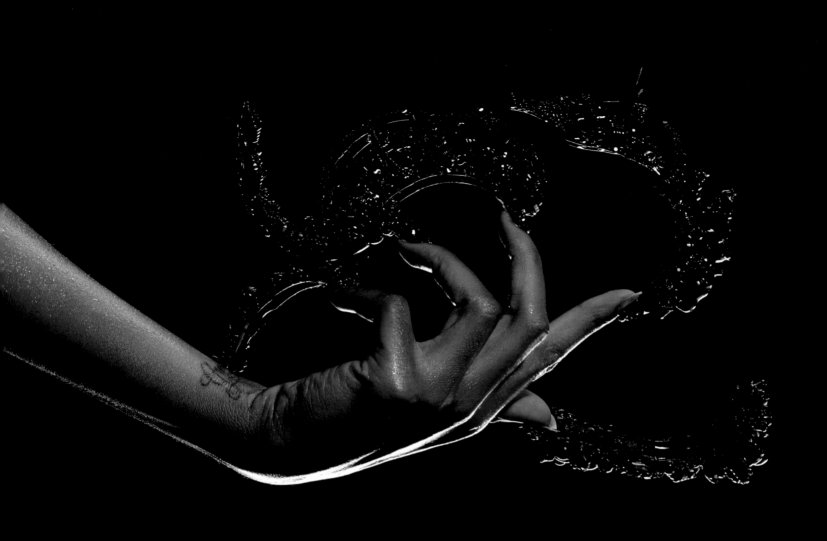

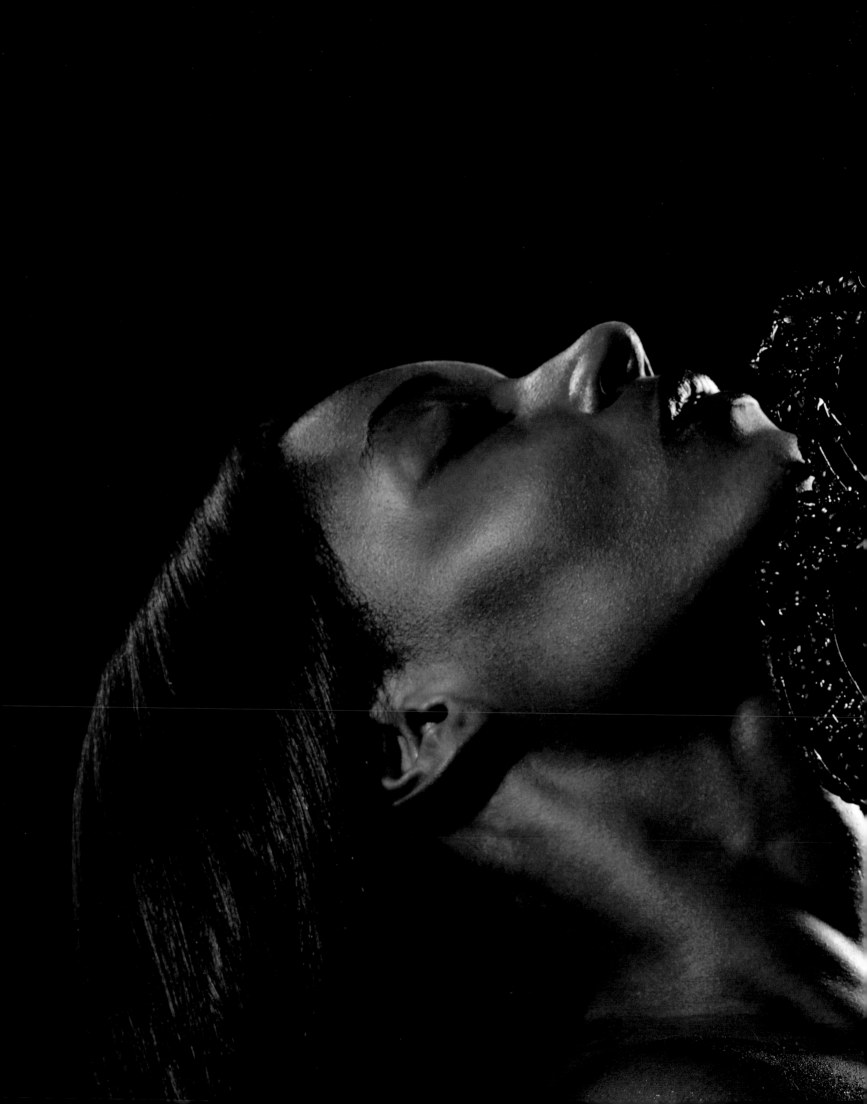

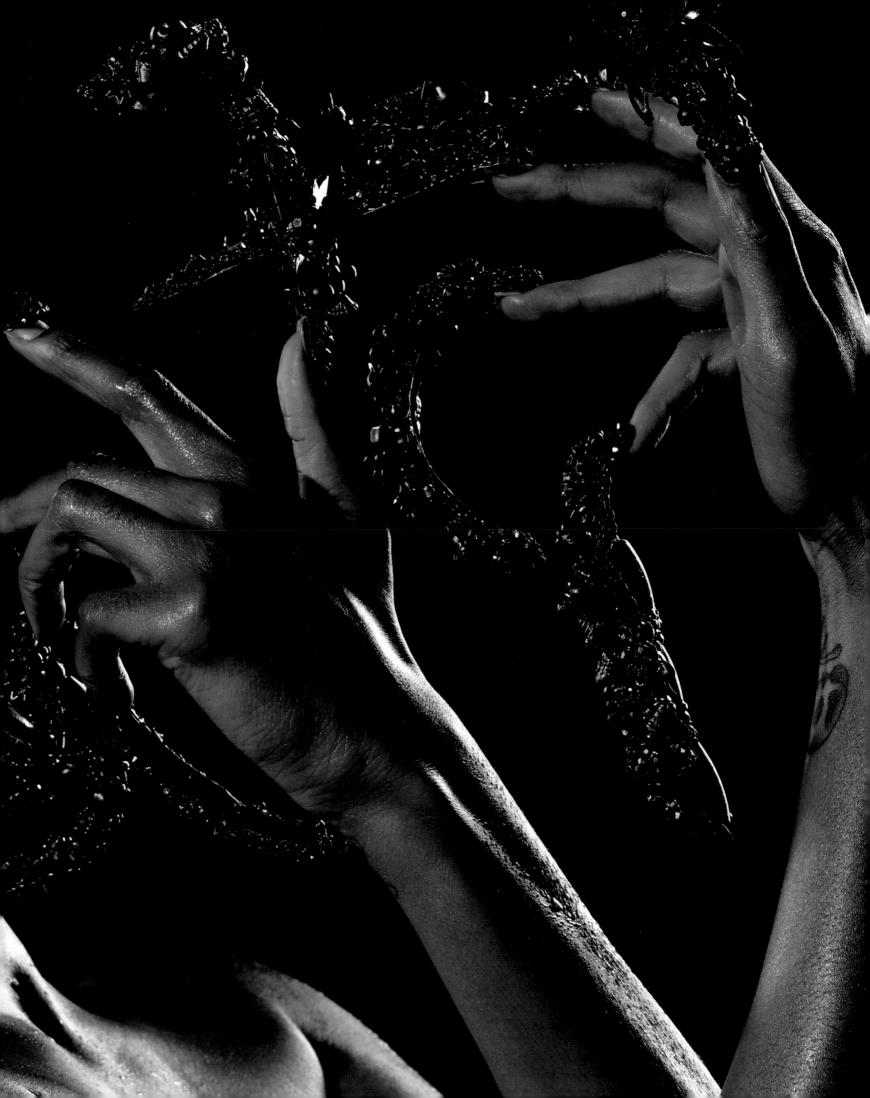

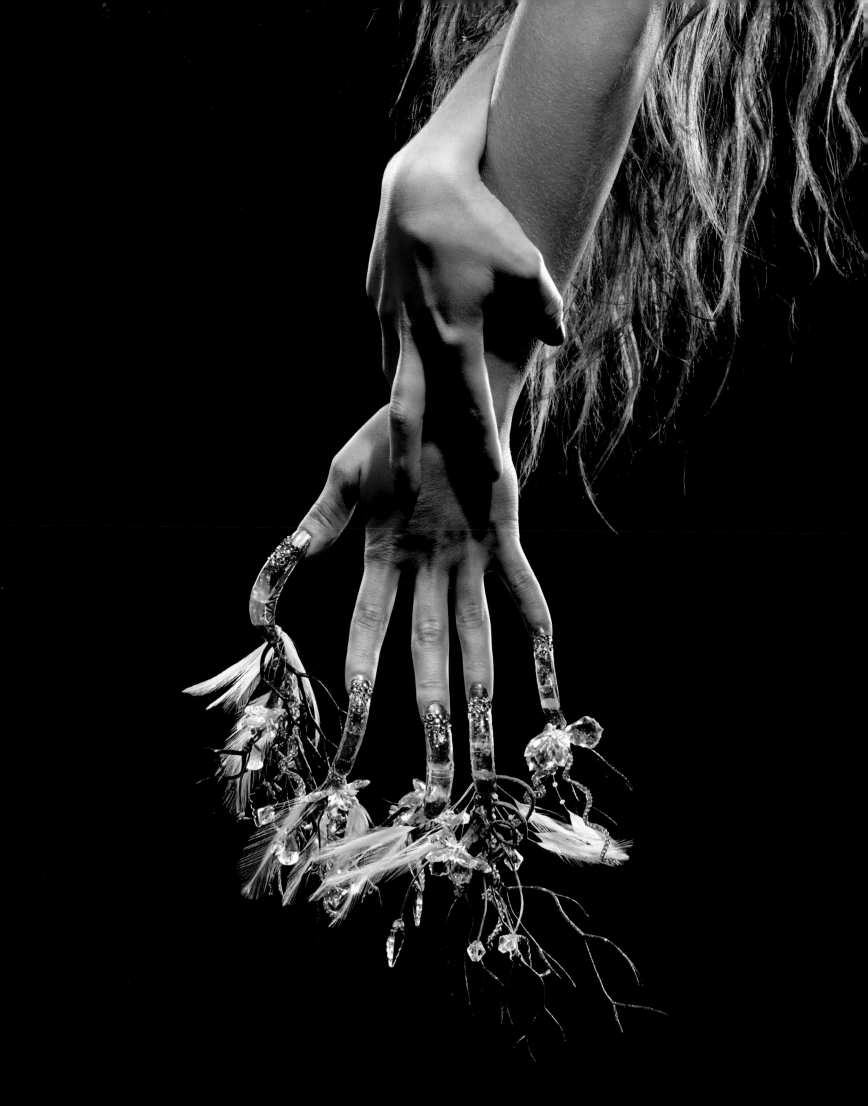

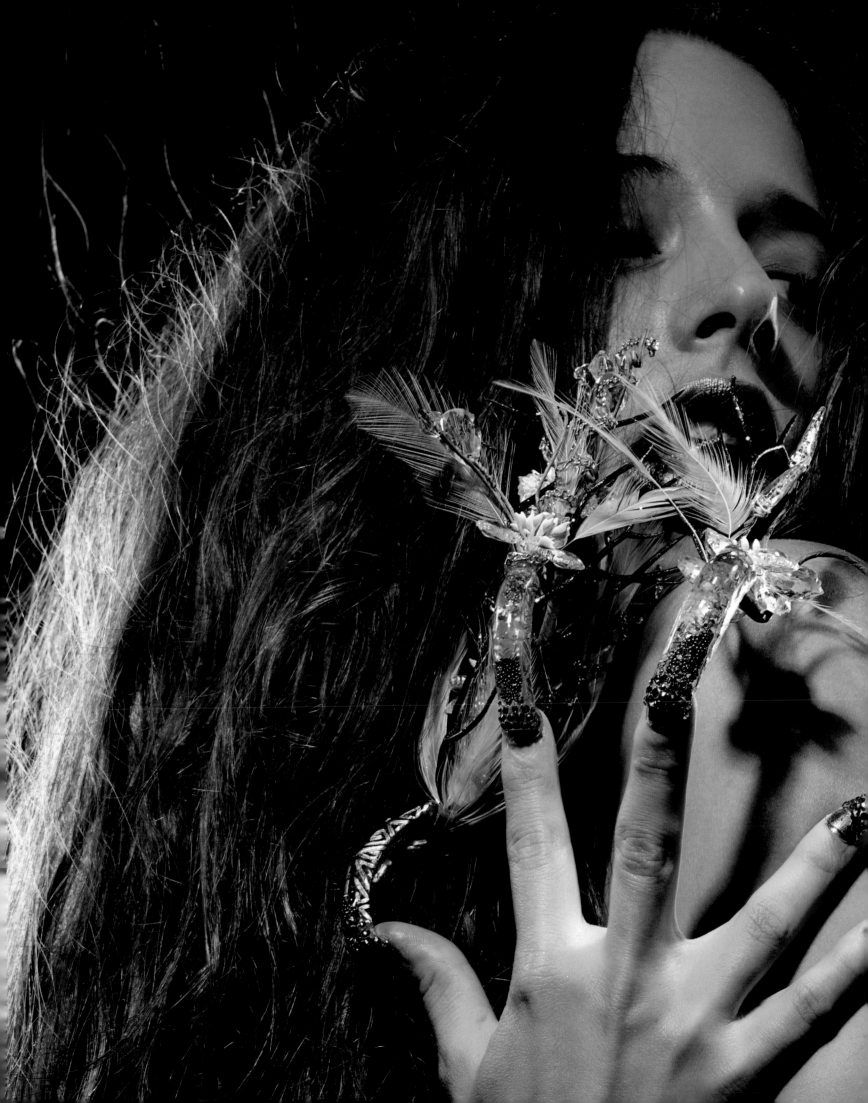

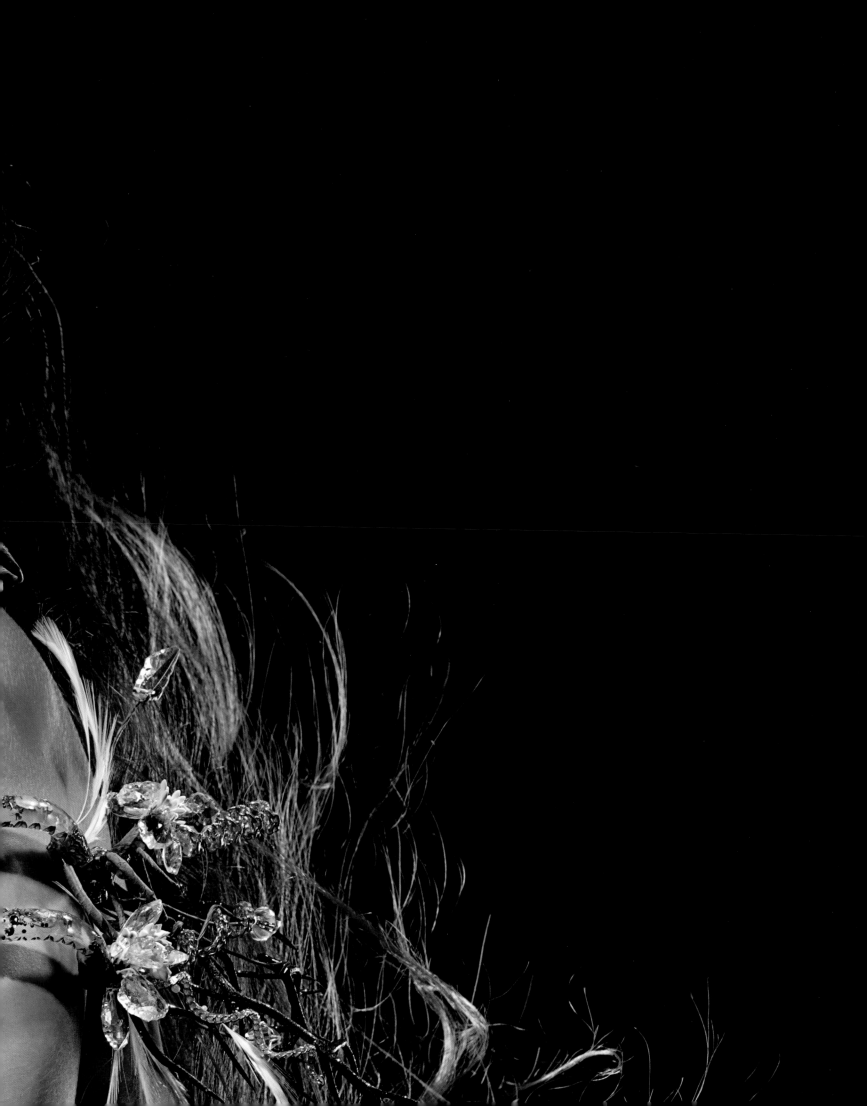

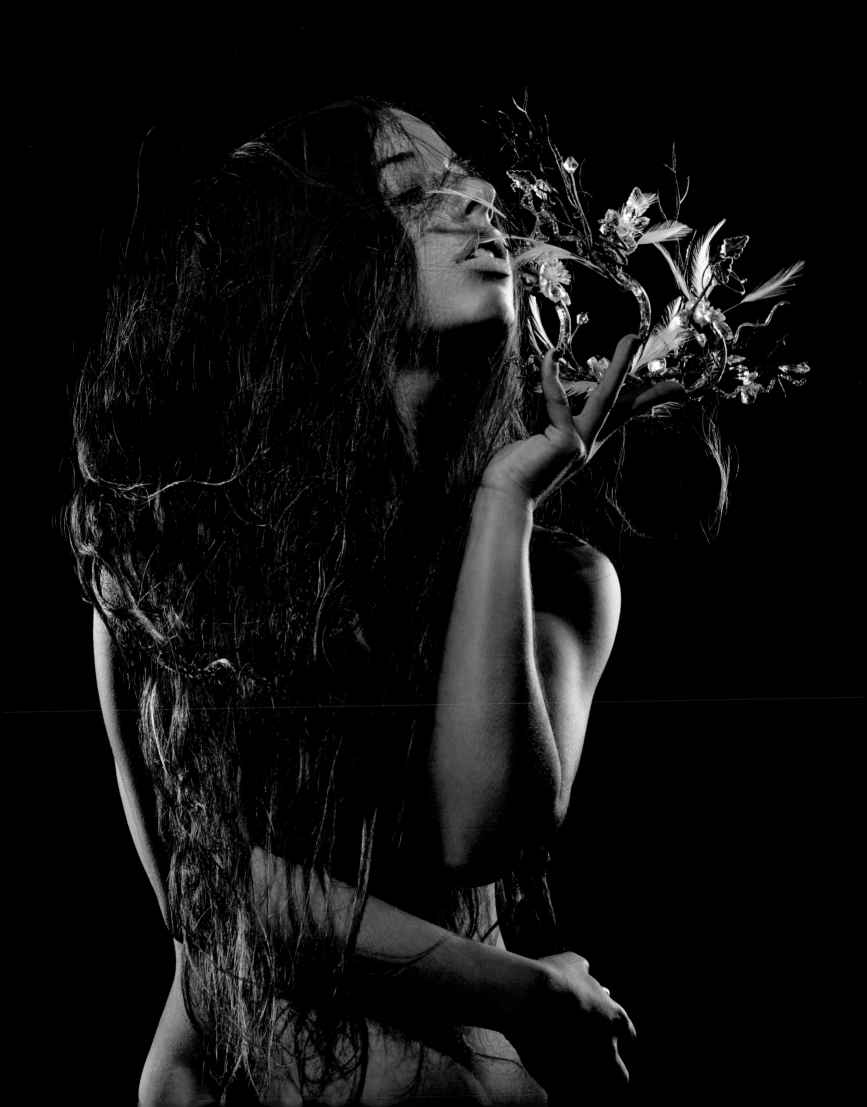

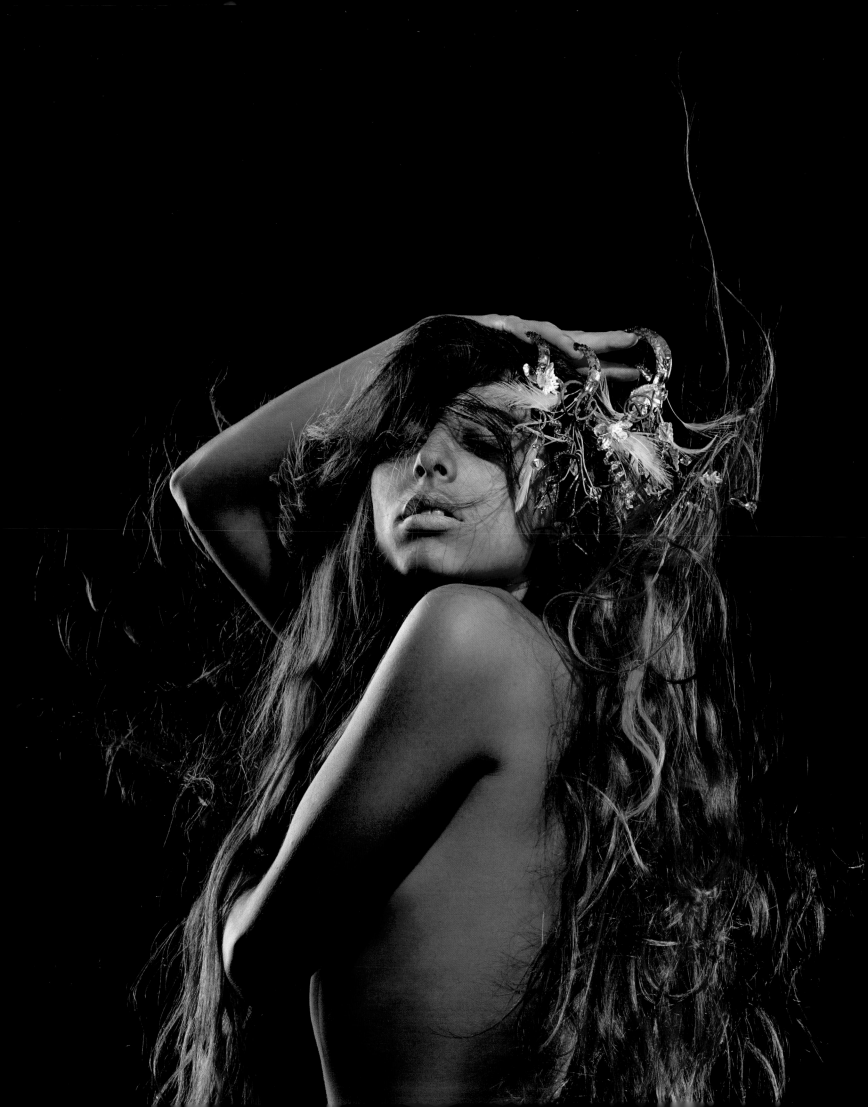

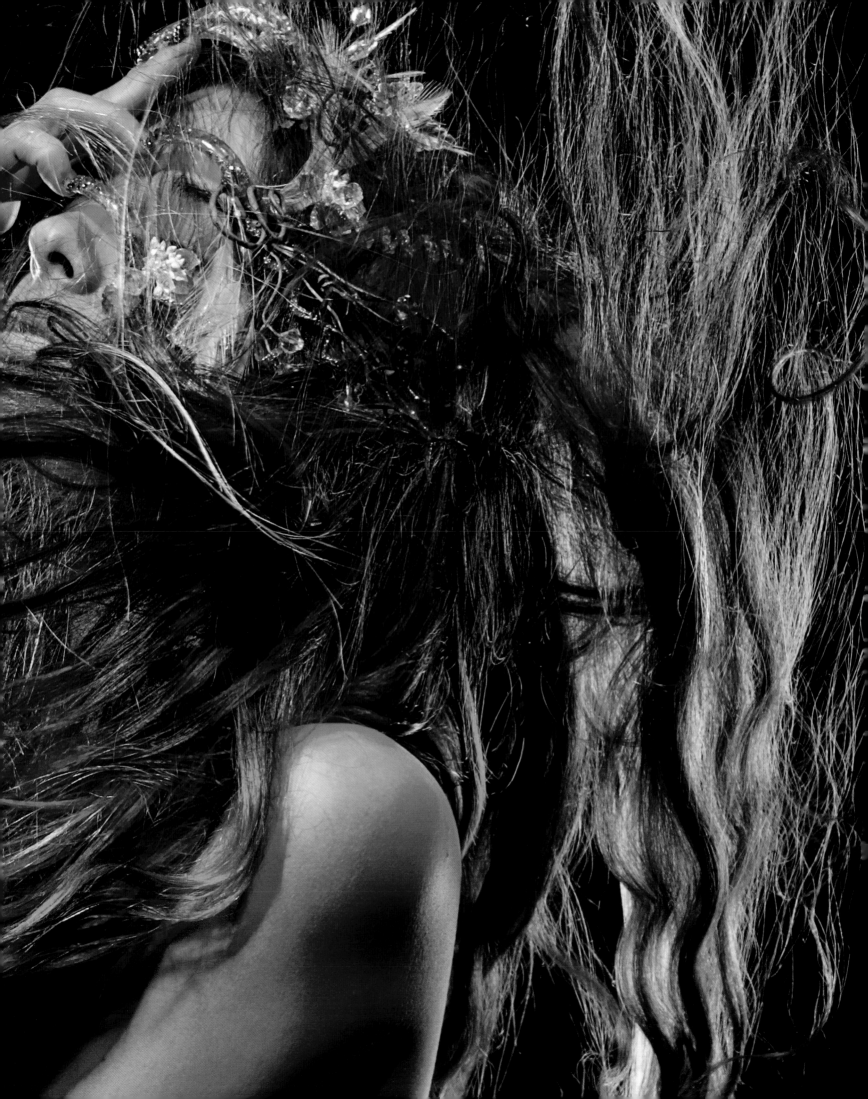

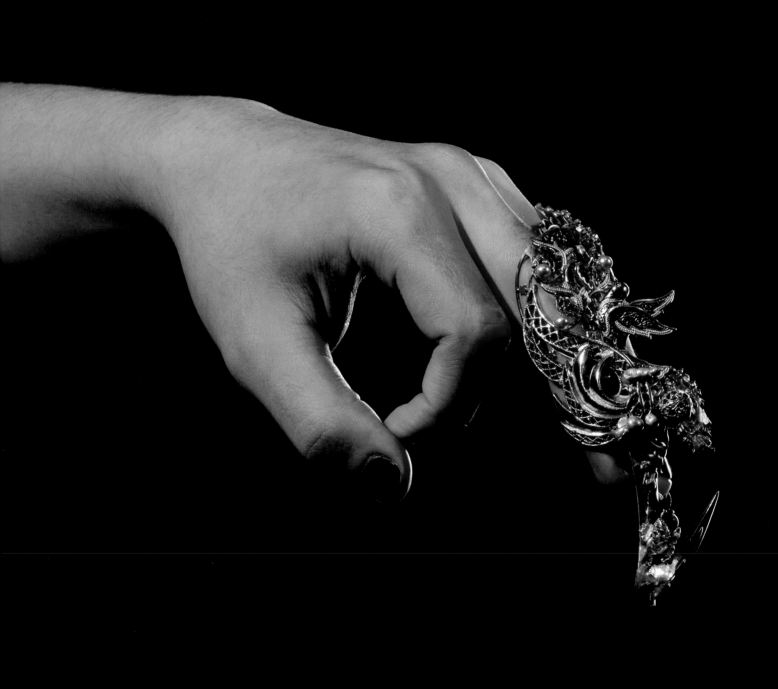

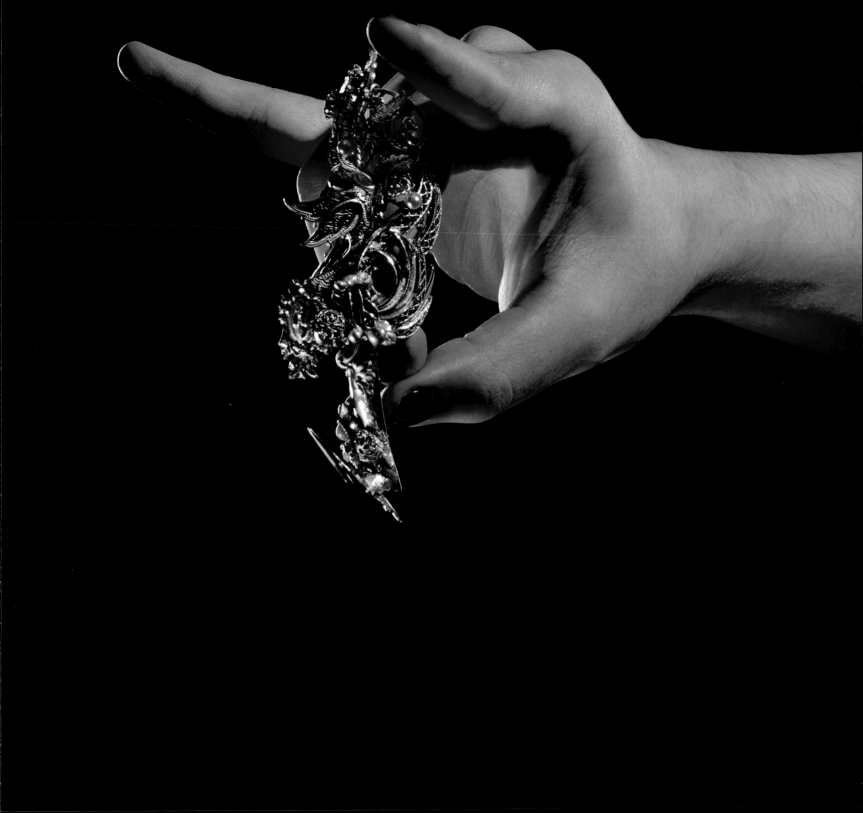

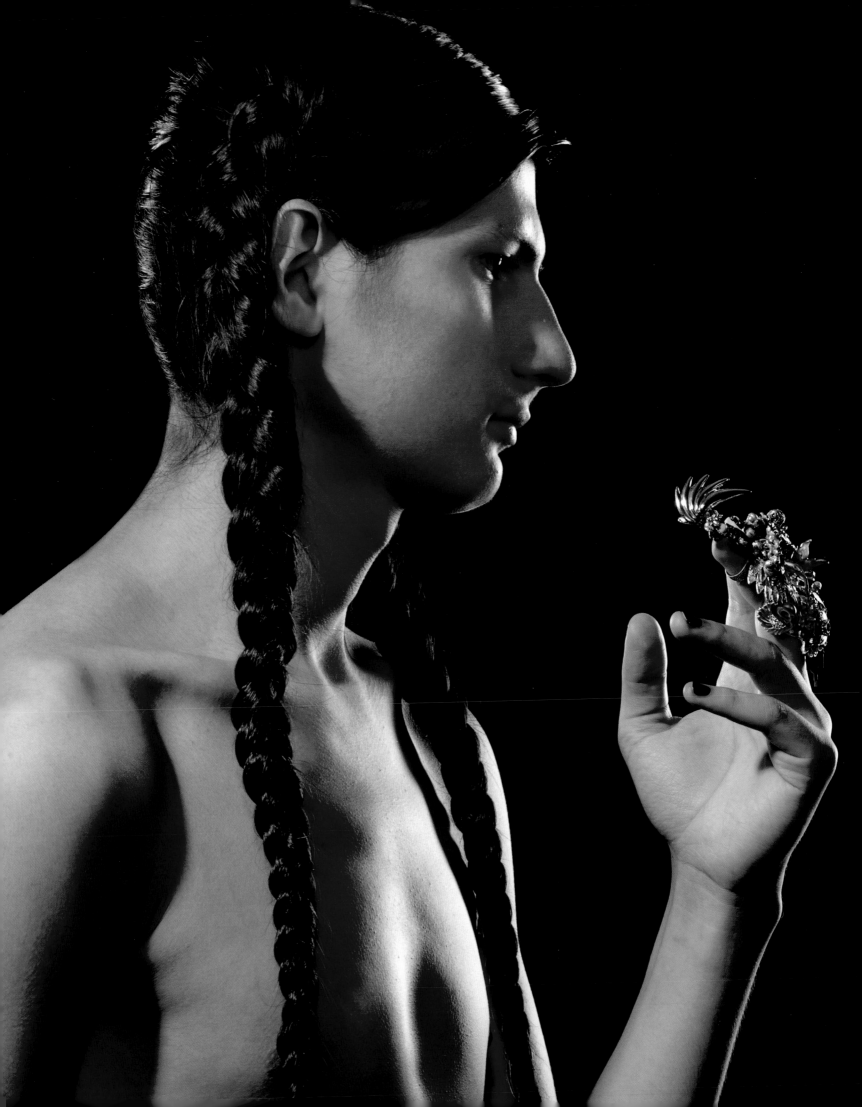

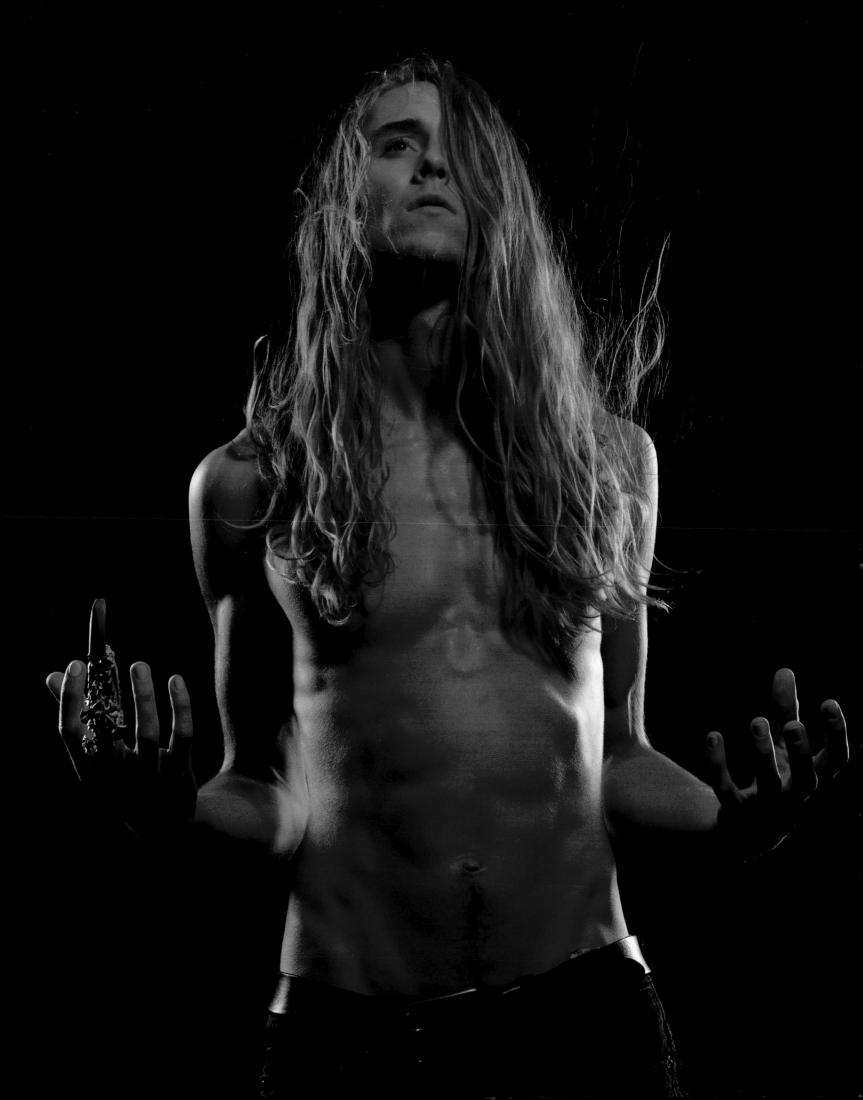

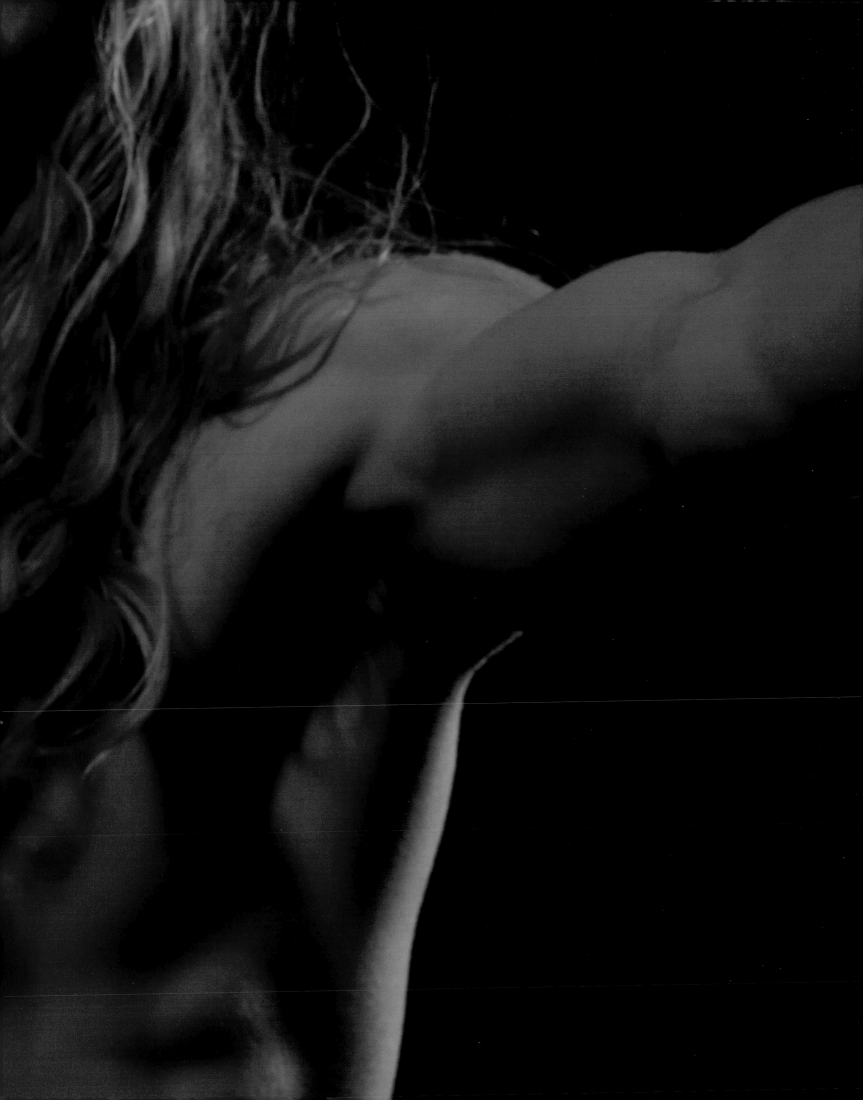

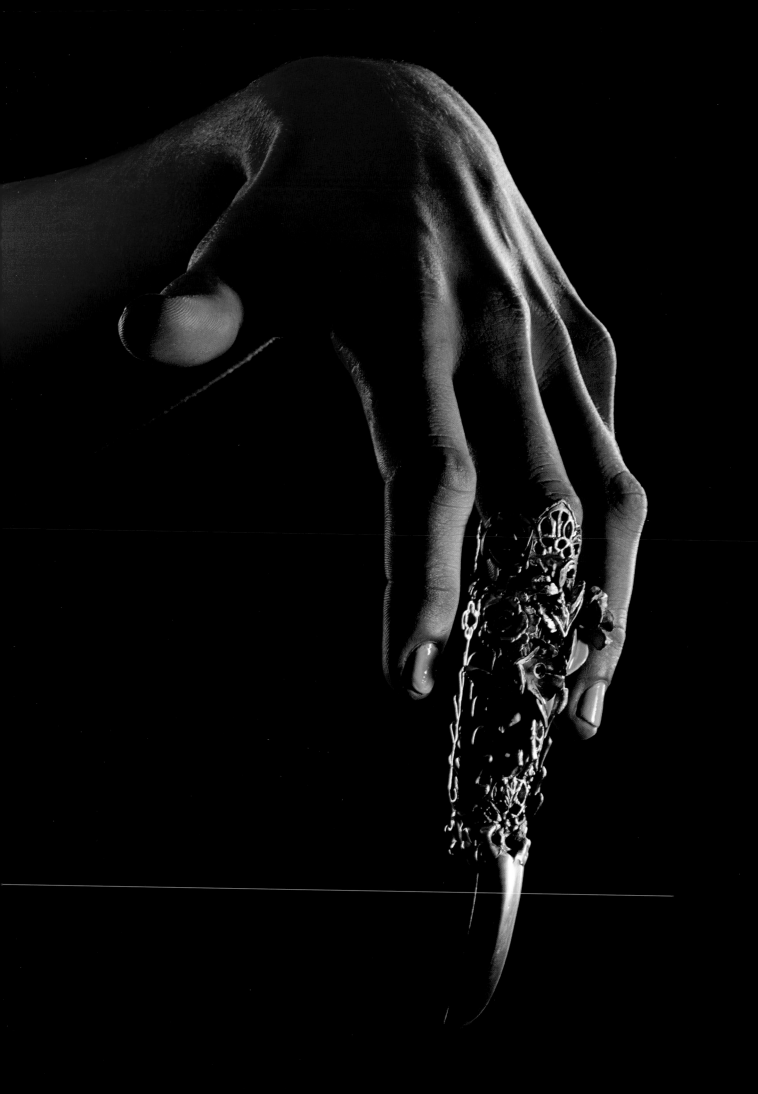

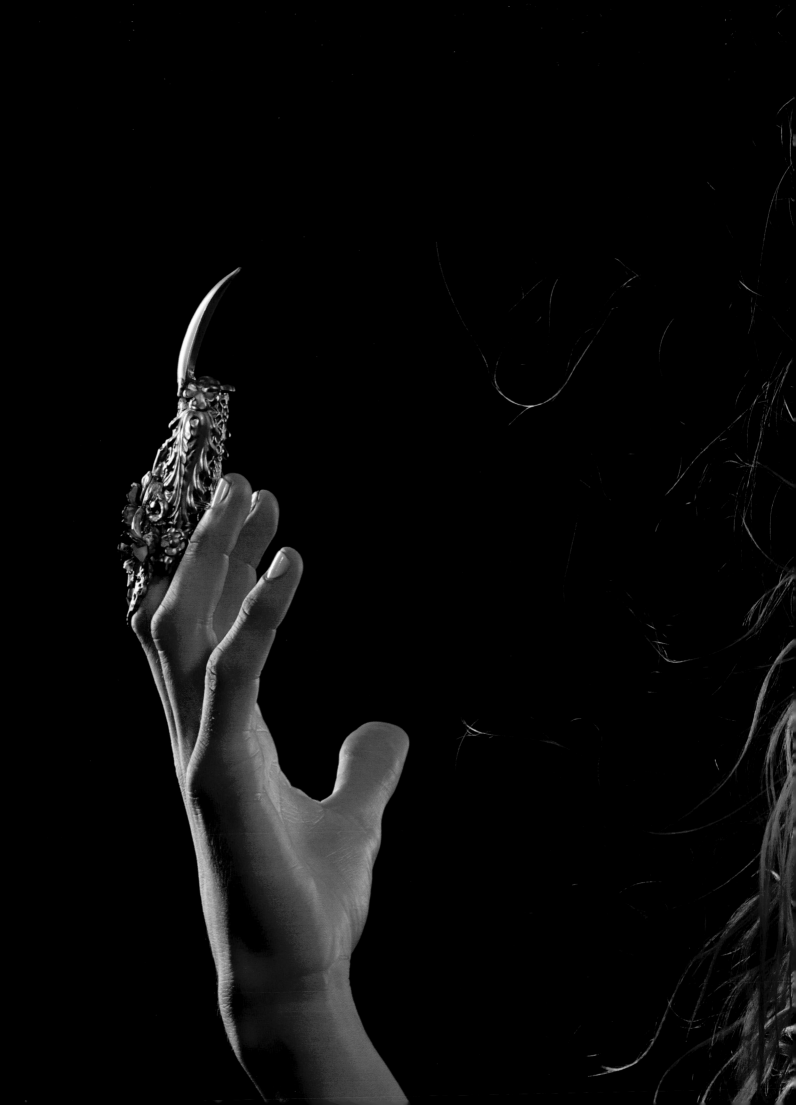

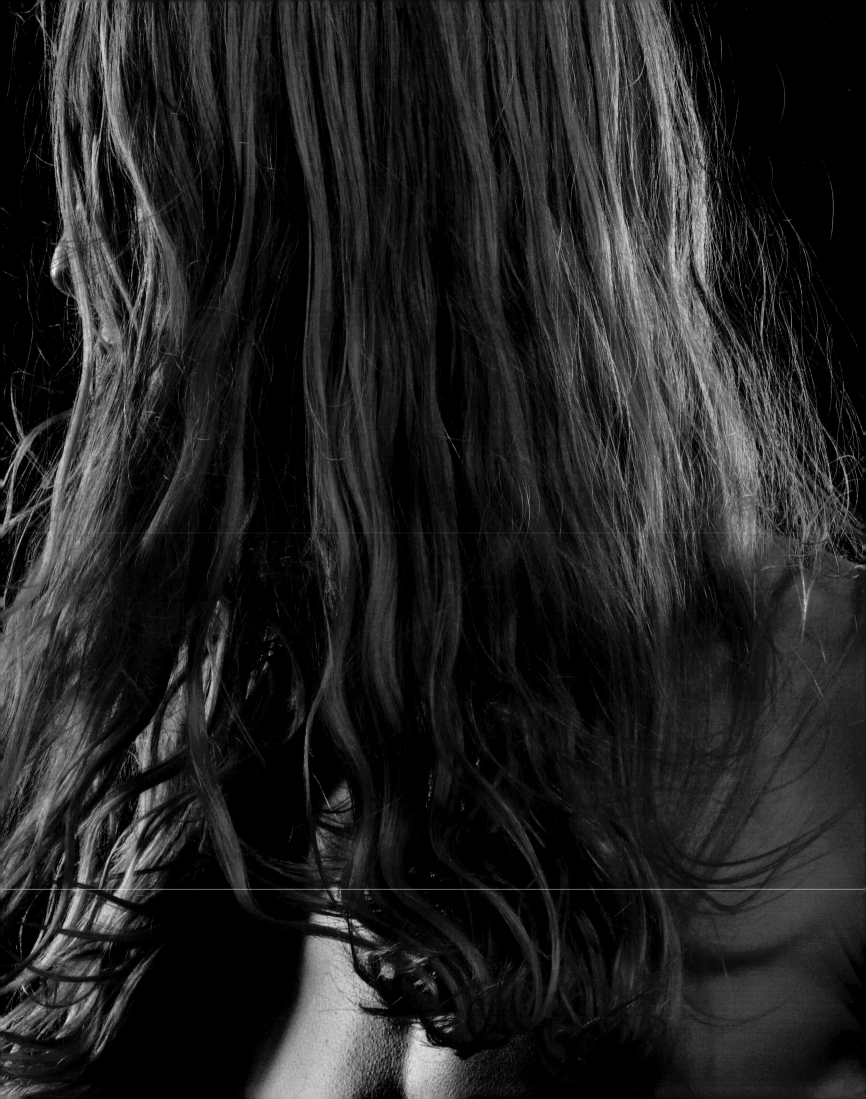

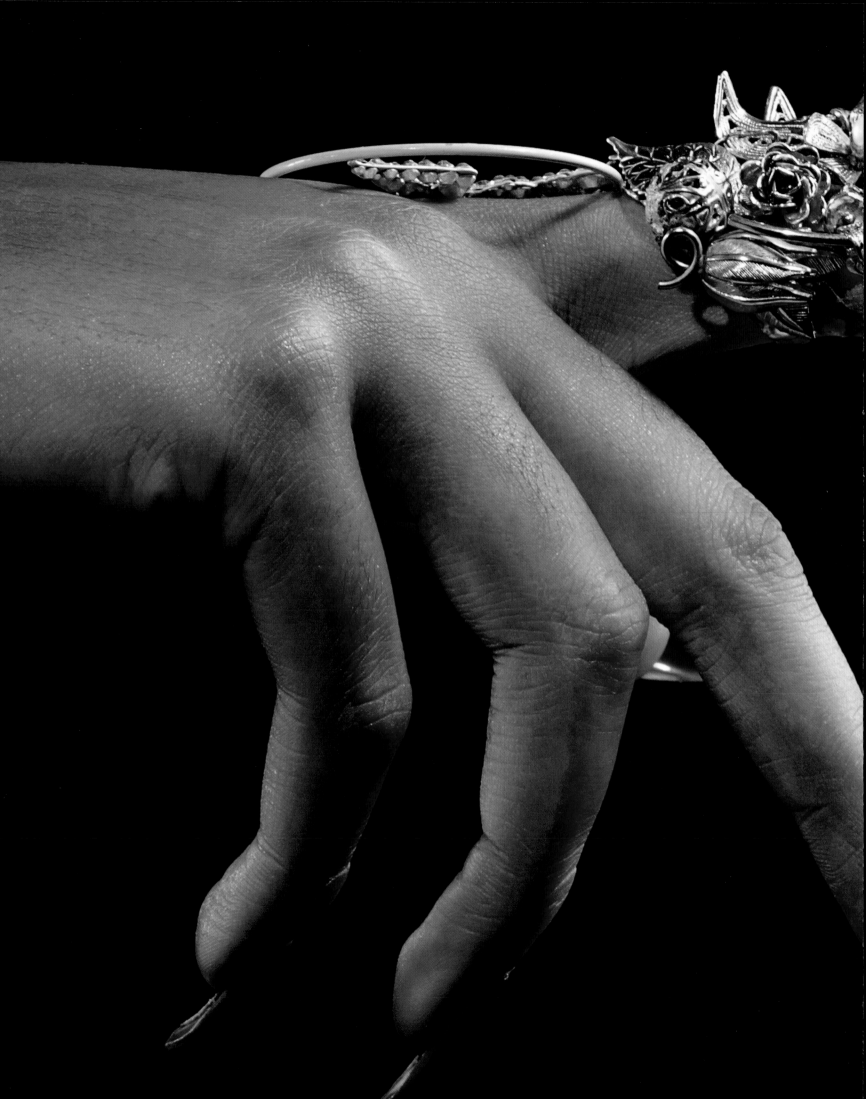

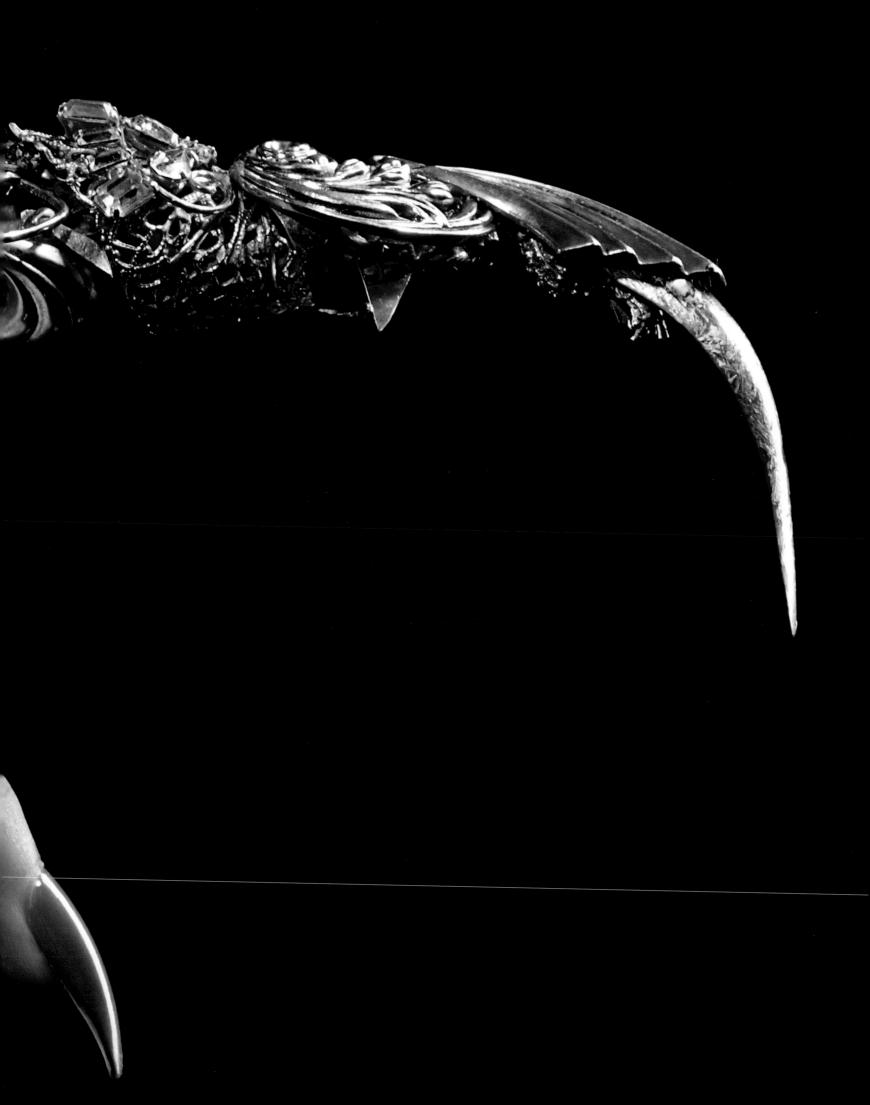

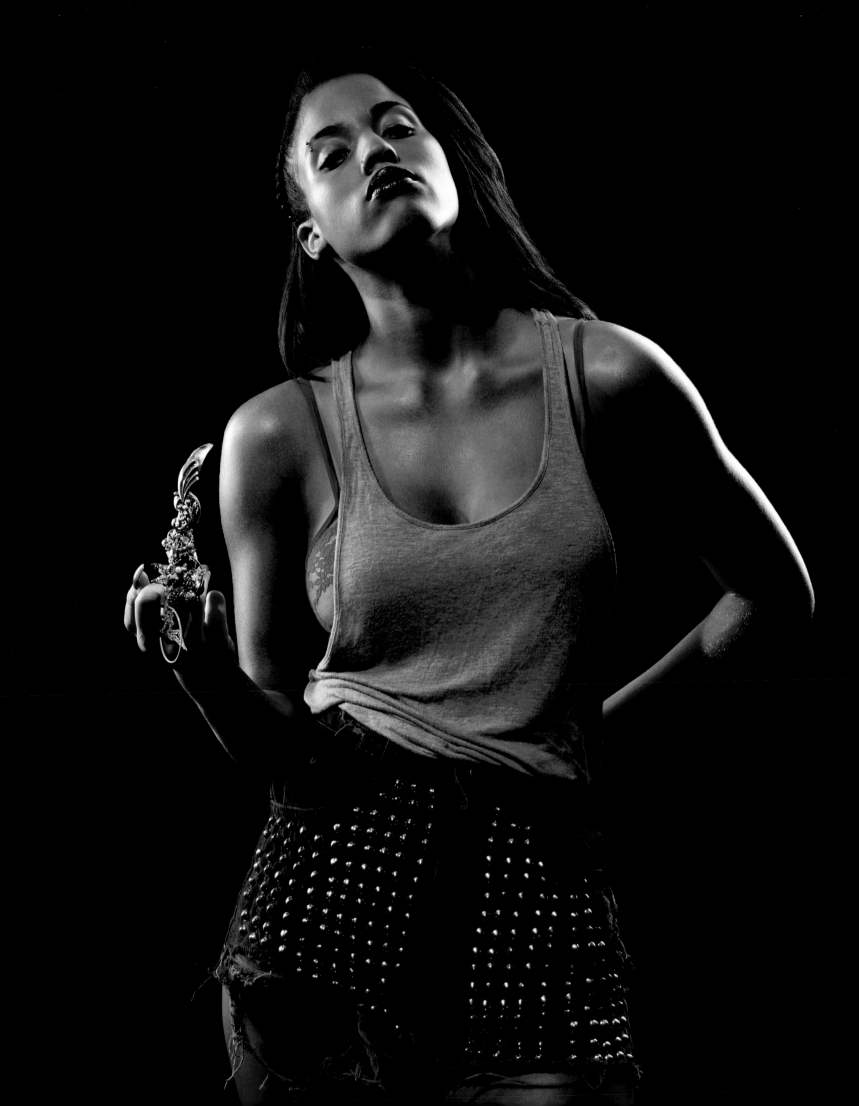

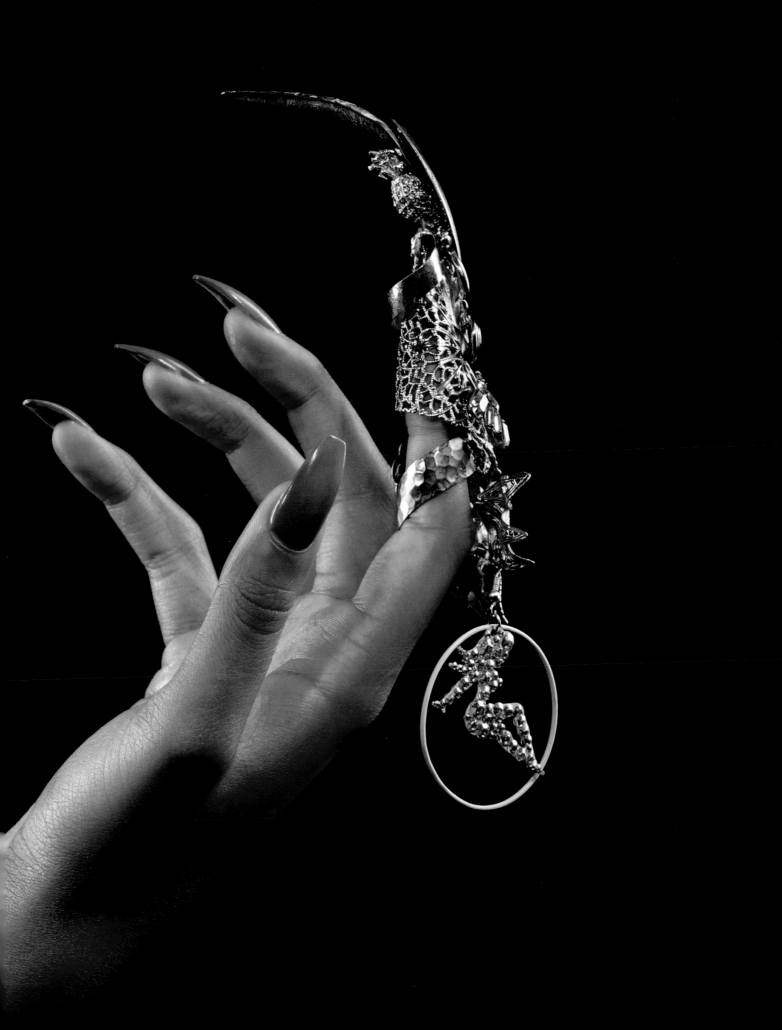

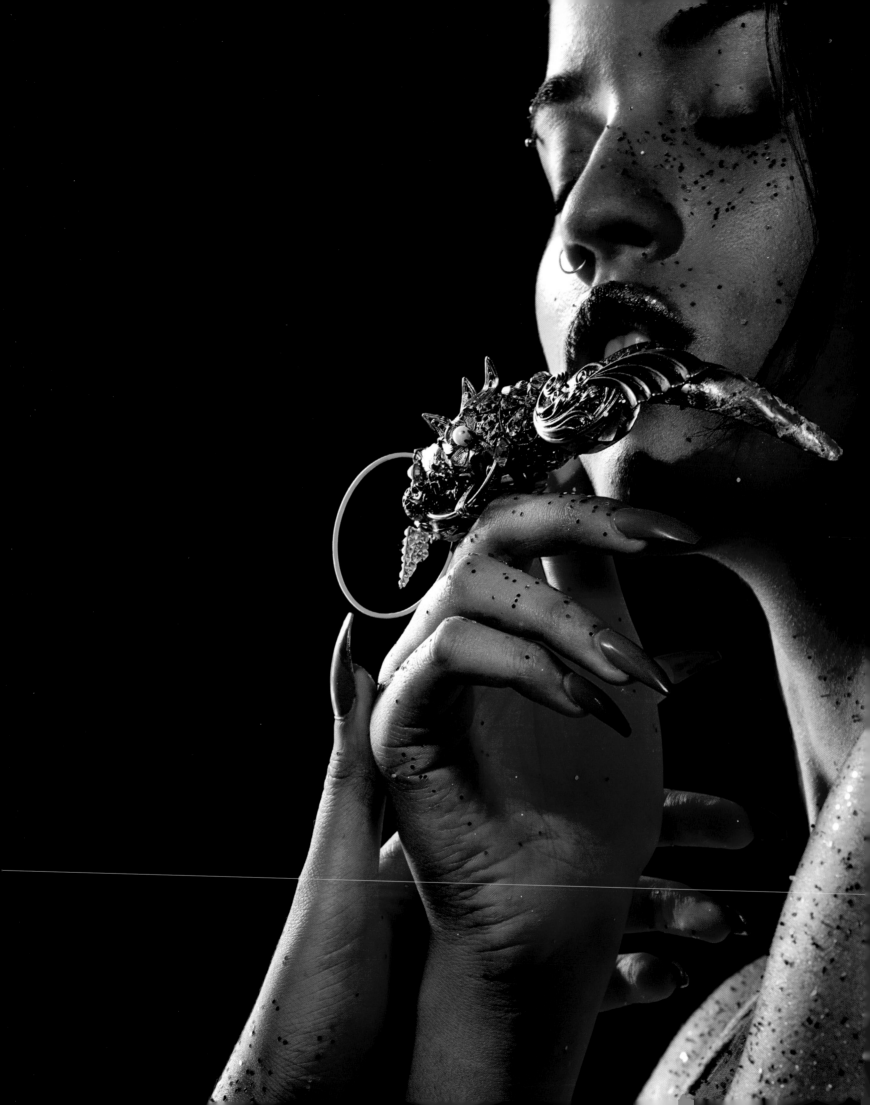

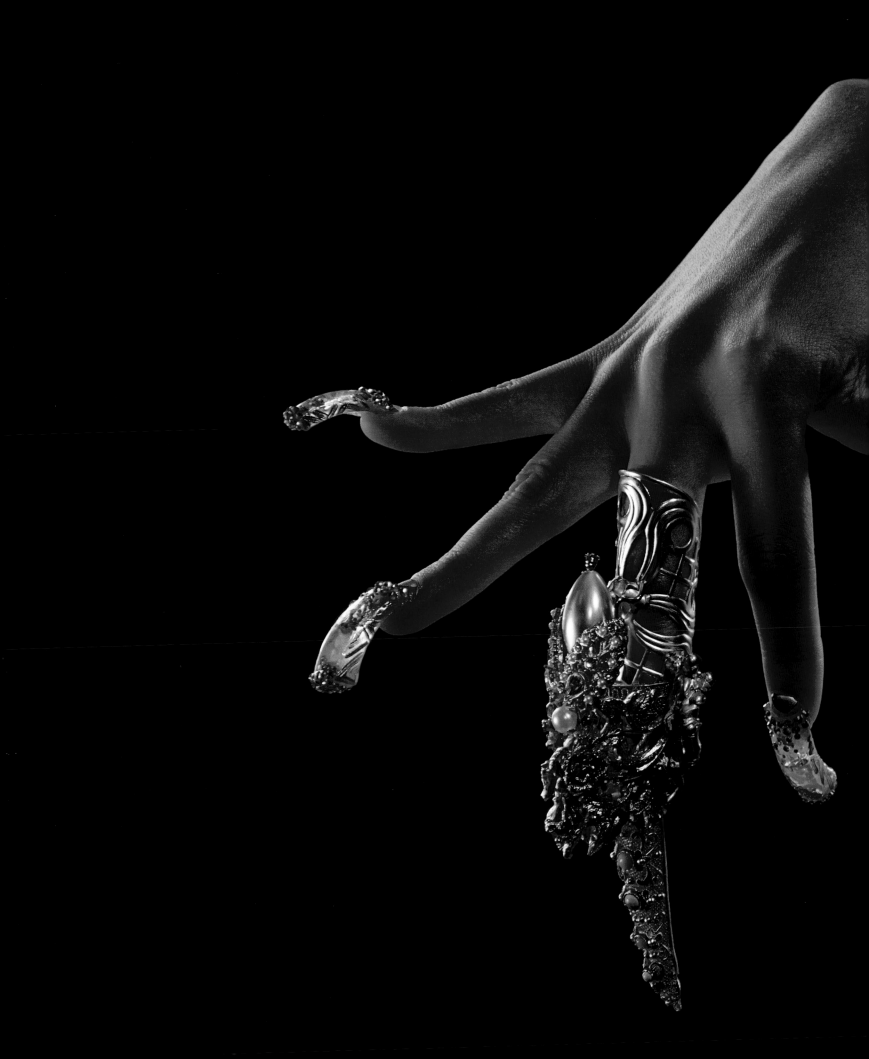

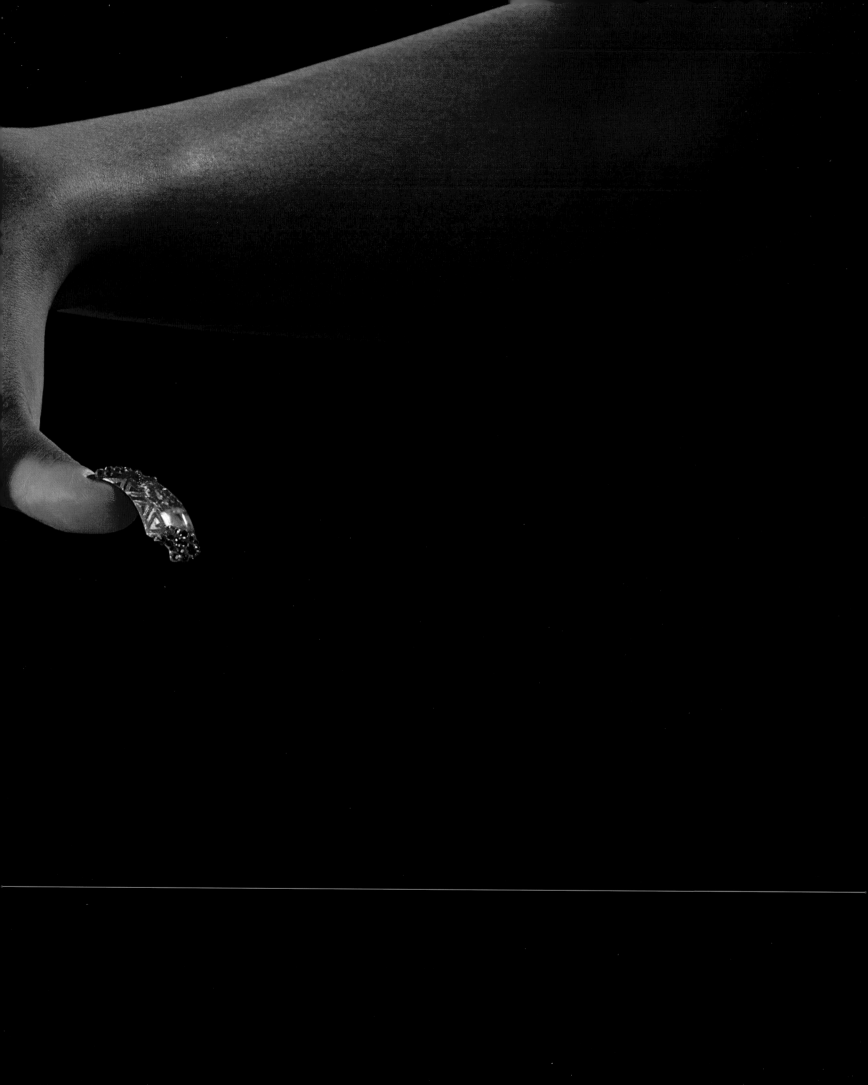

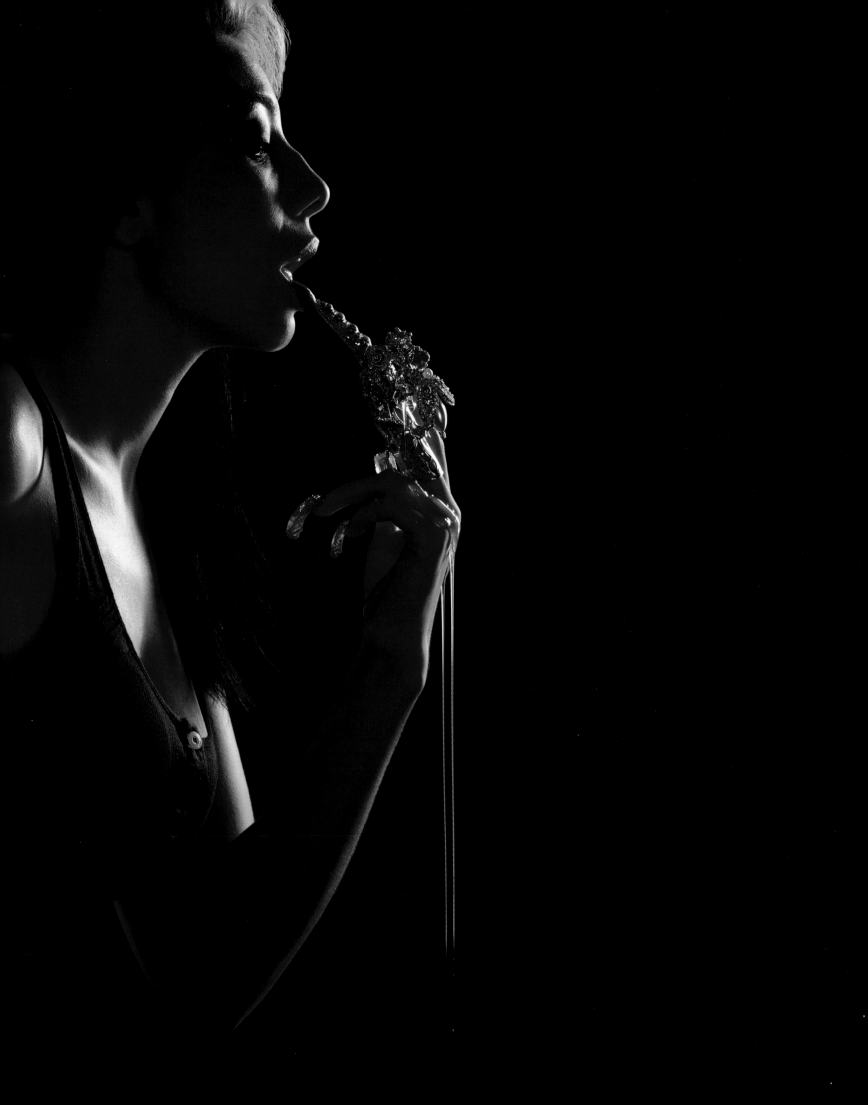

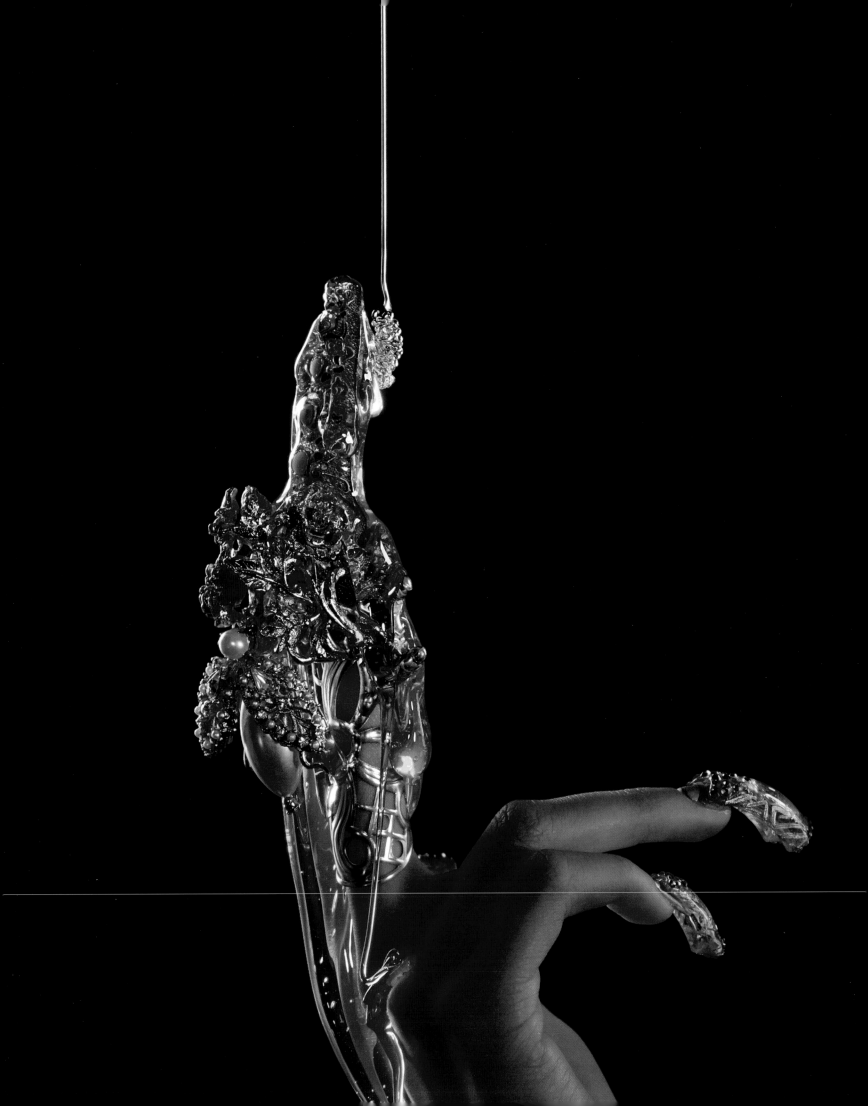

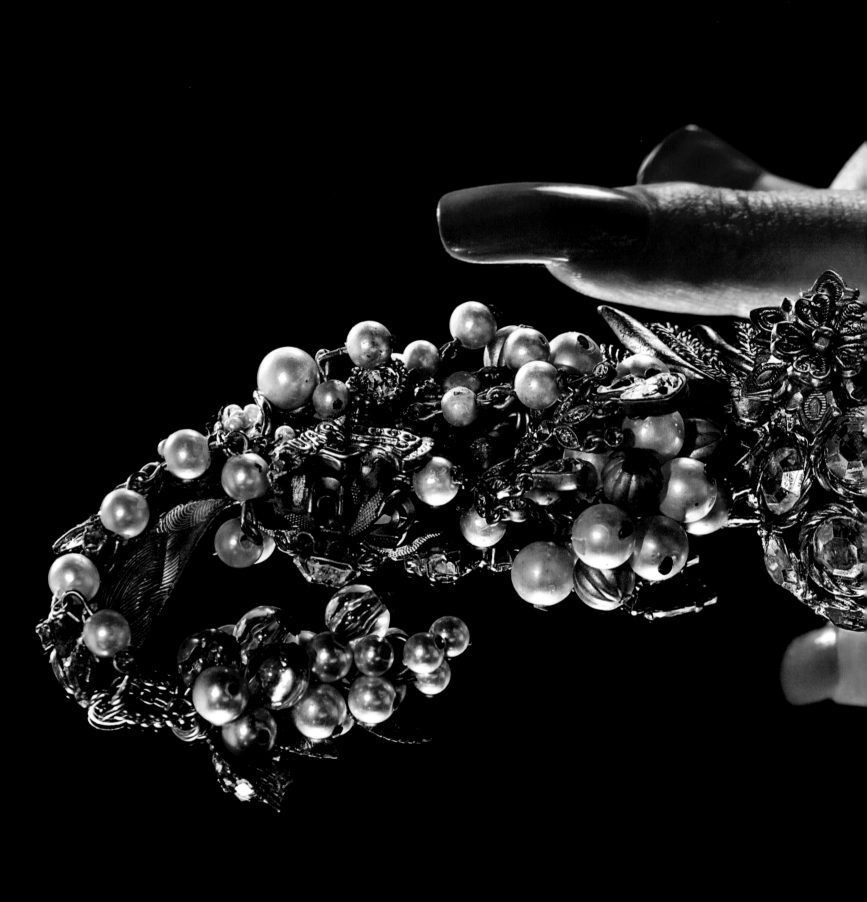

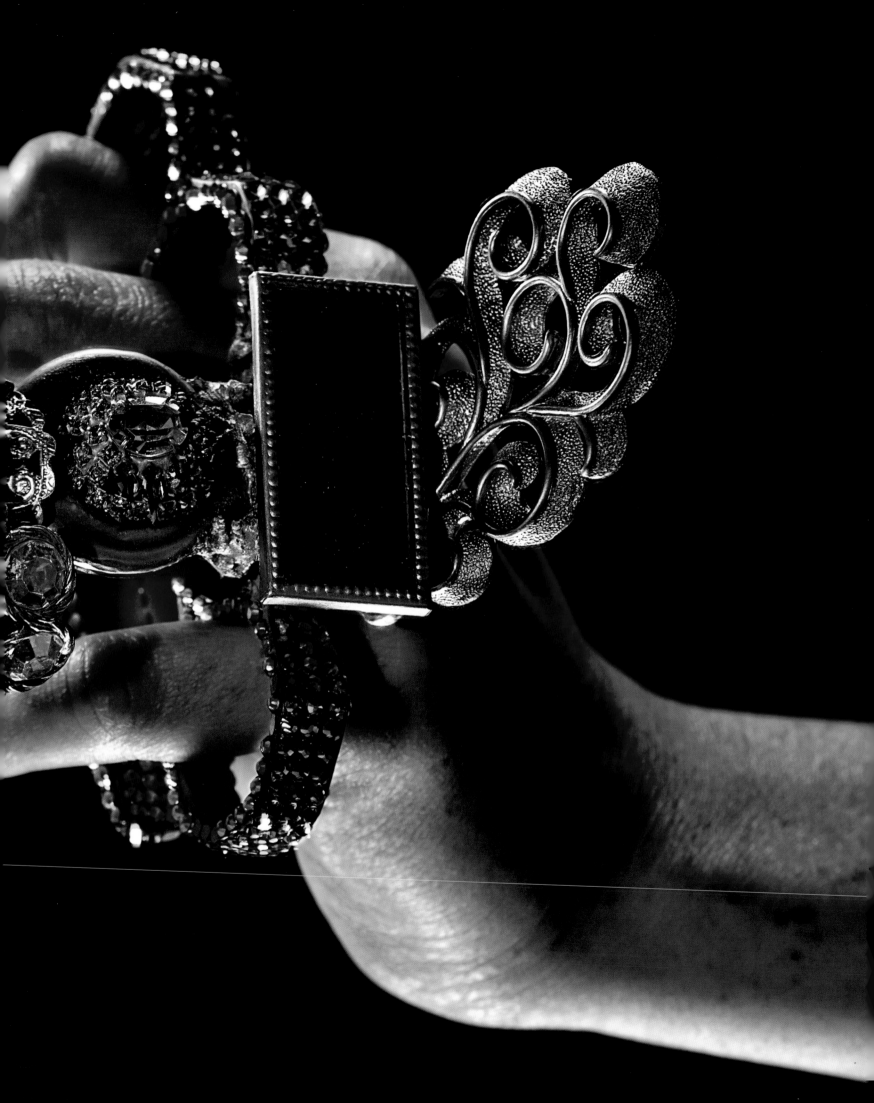

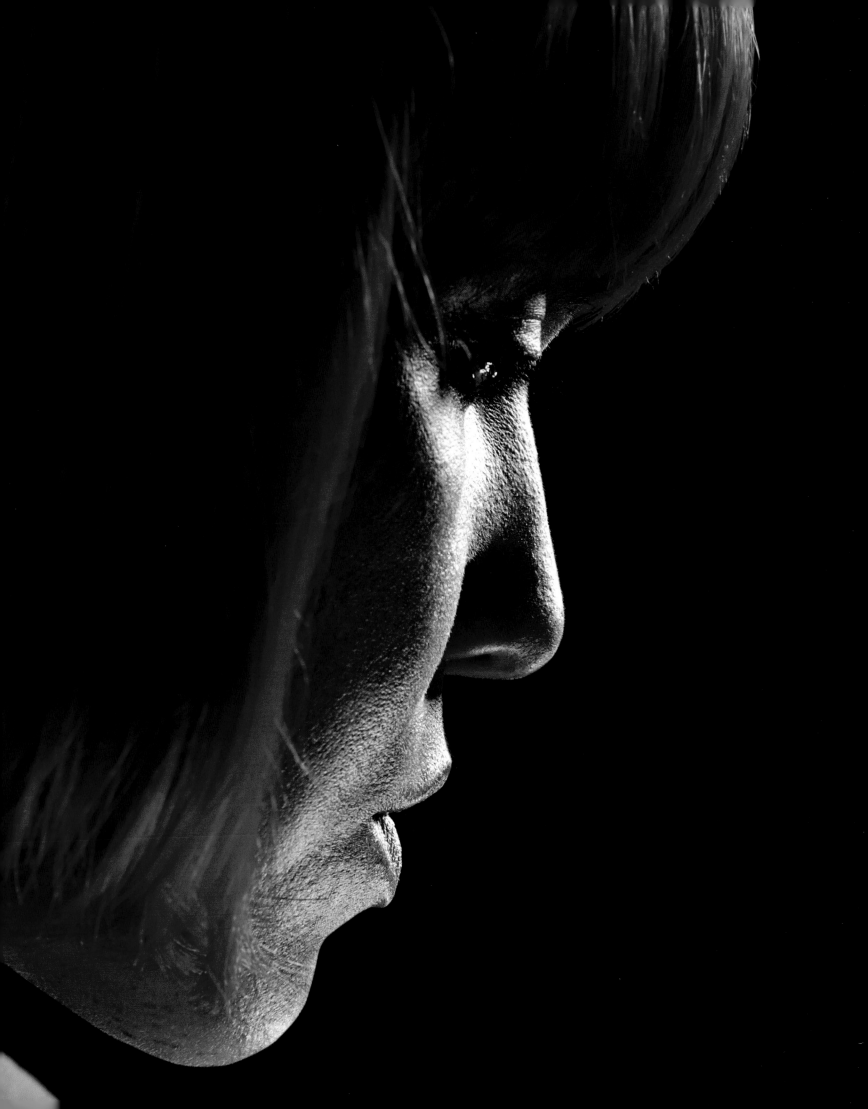

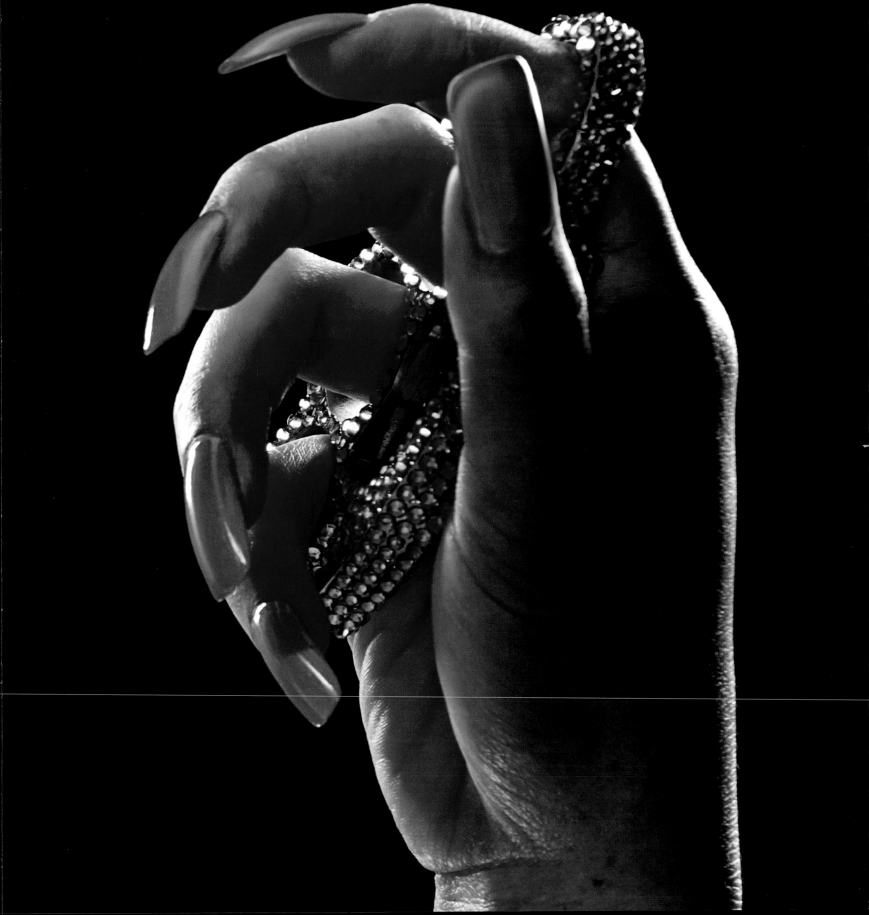

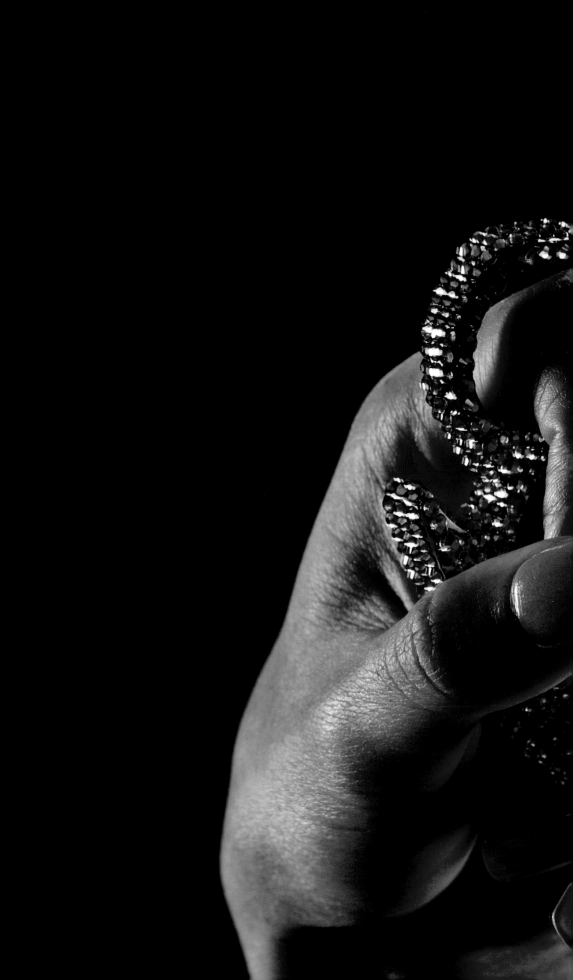

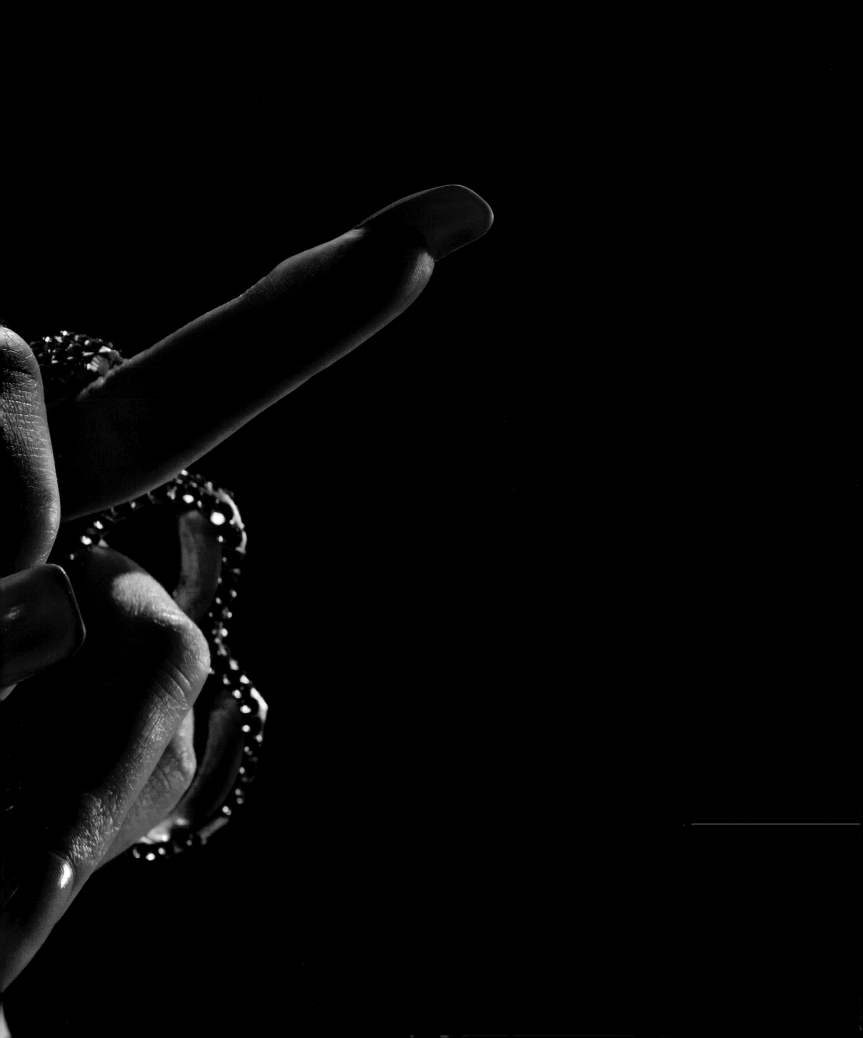

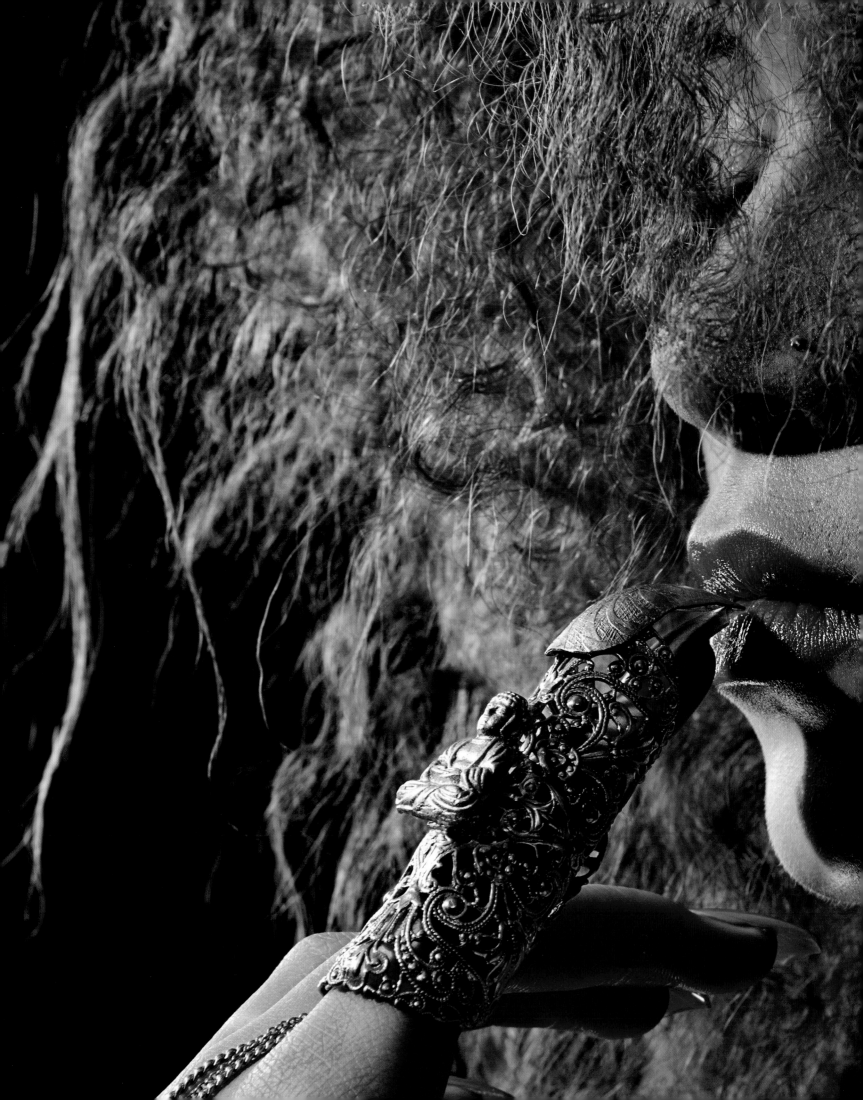

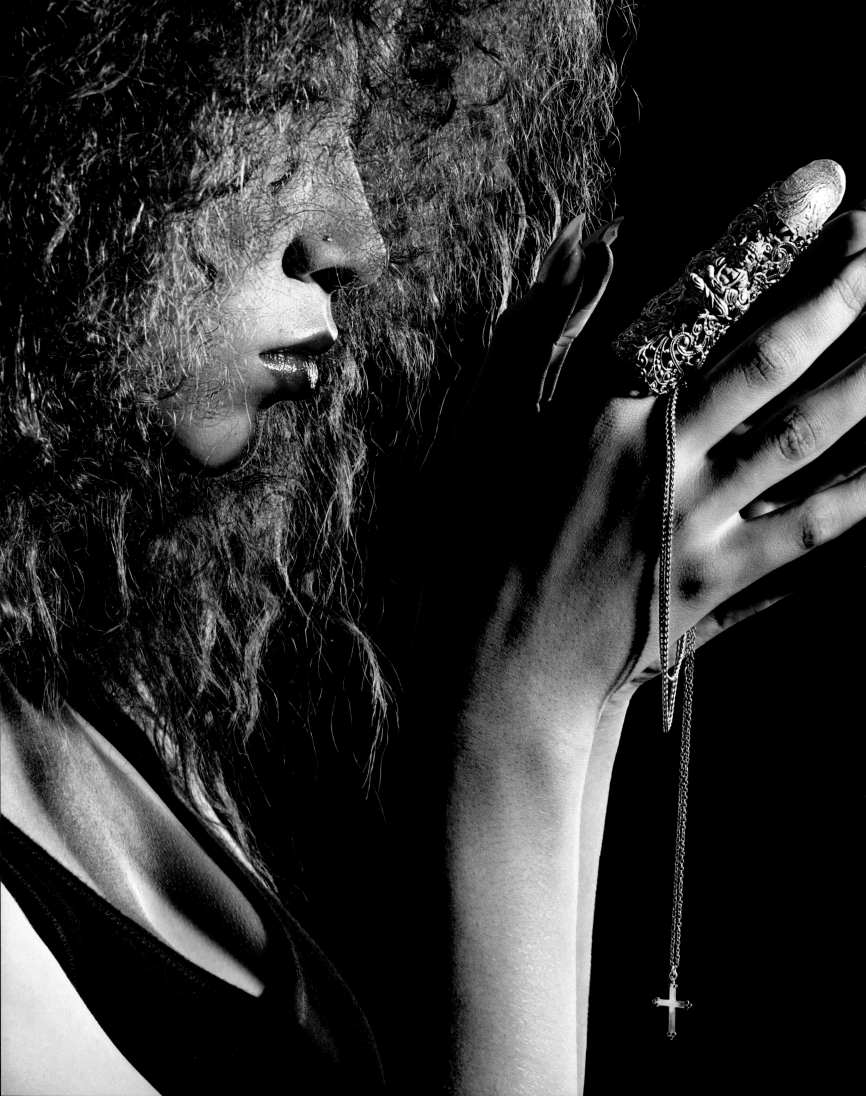

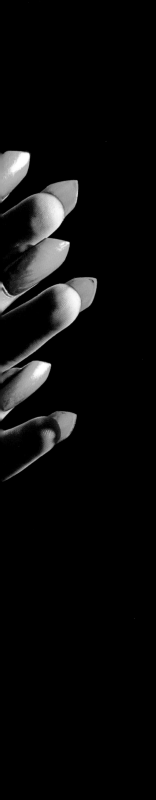

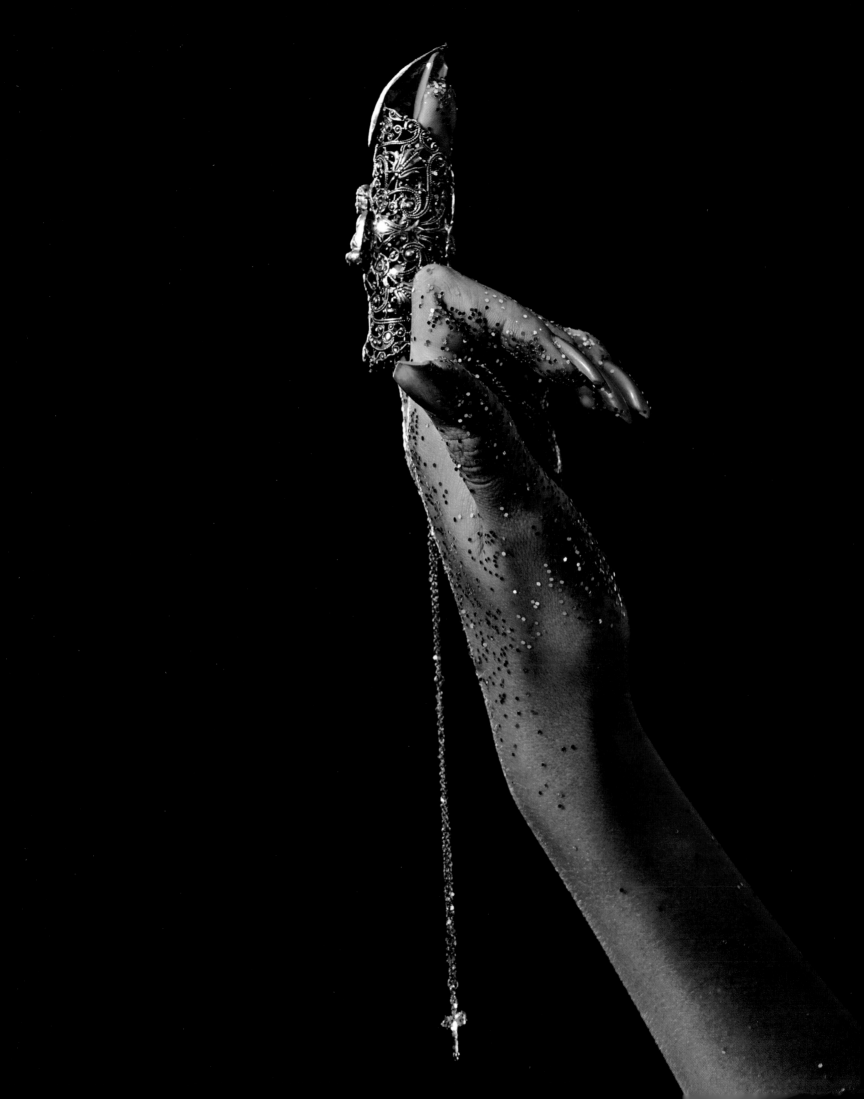

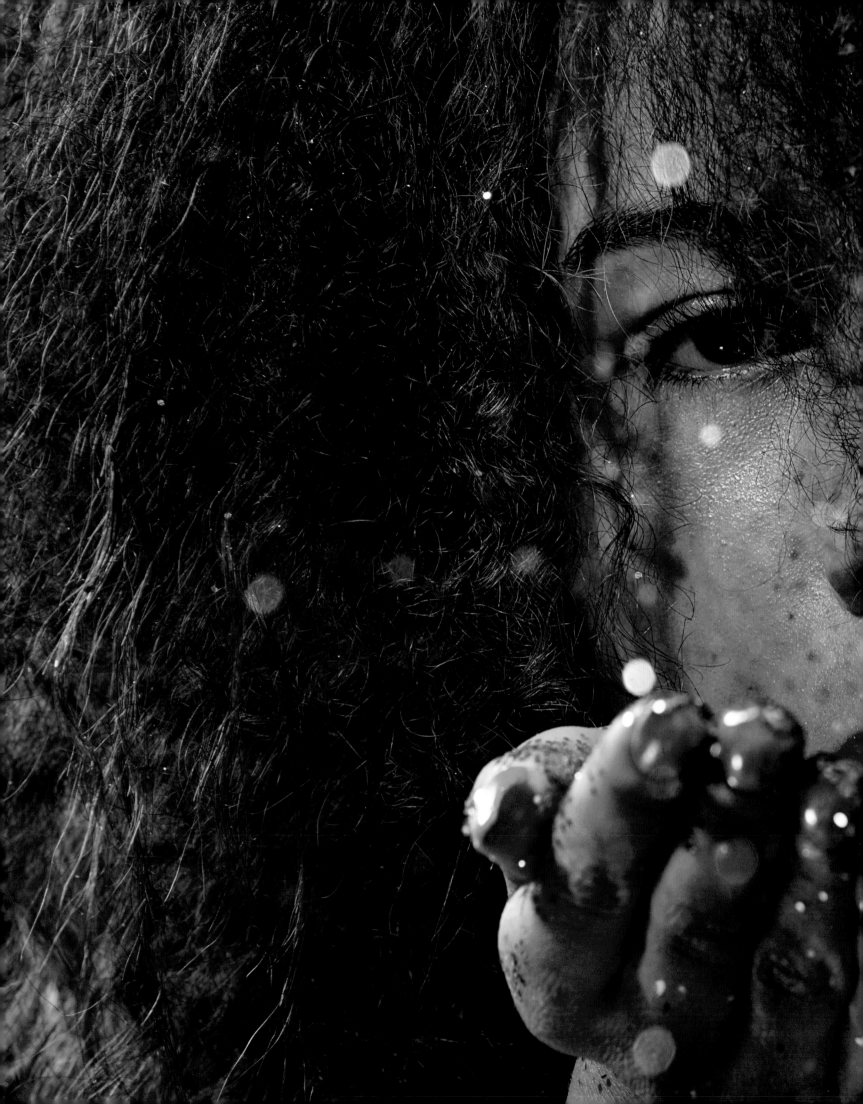

IMPERIAL NAILS

- - -

SEPTEMBER 2011 NYC

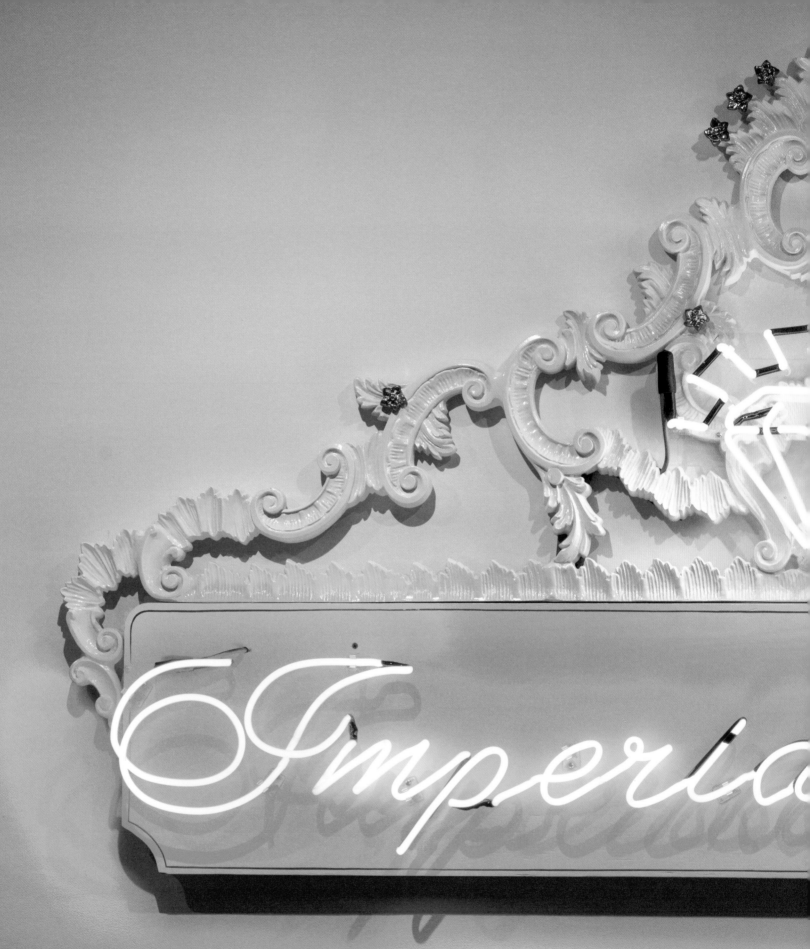

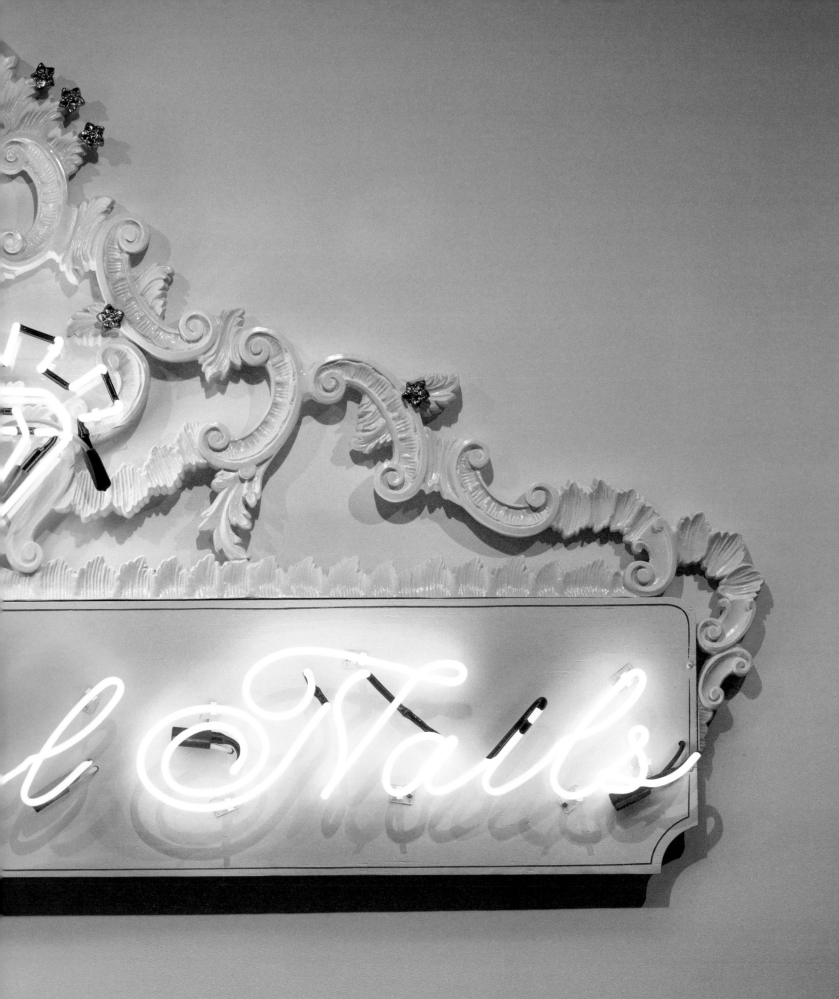

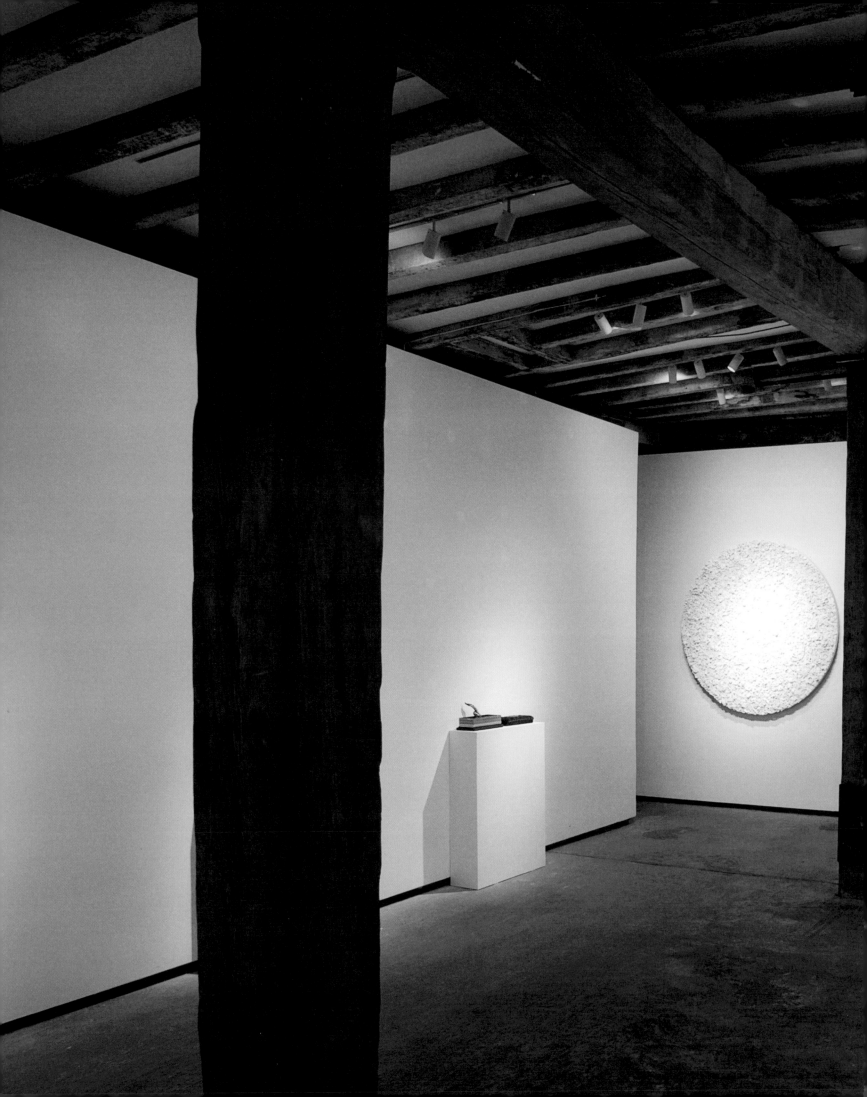

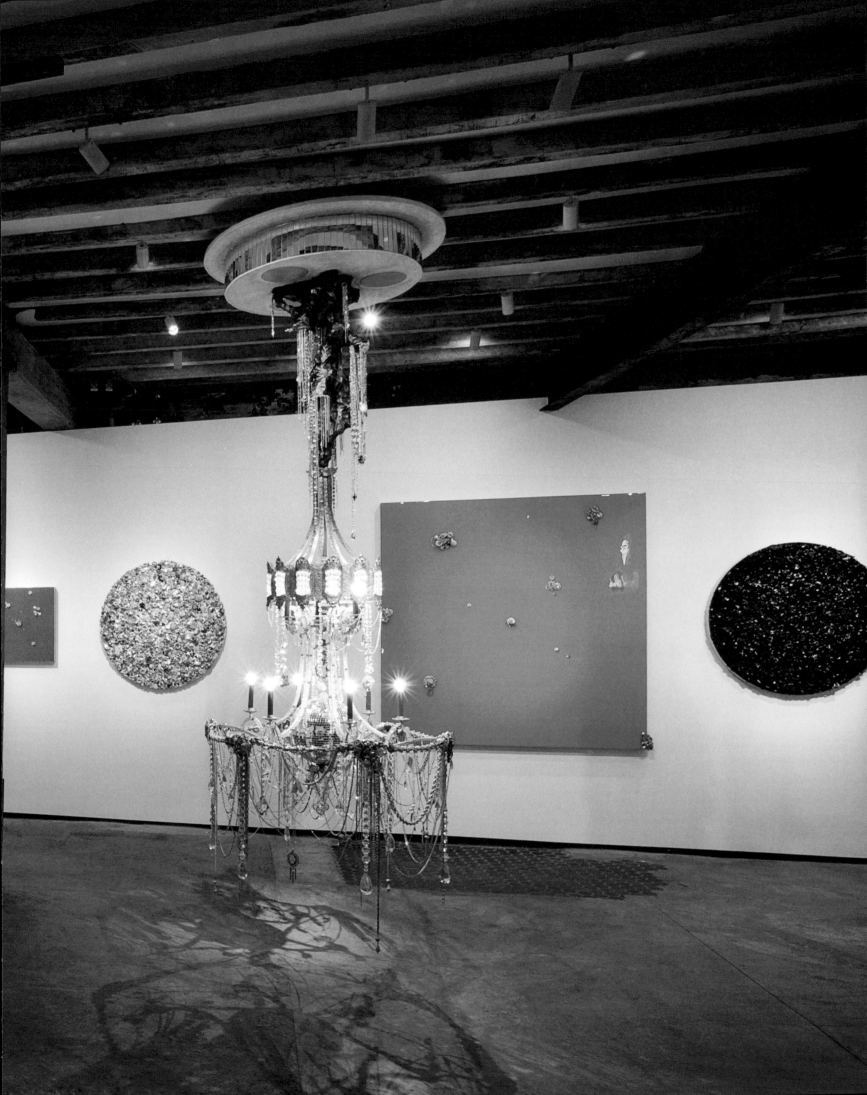

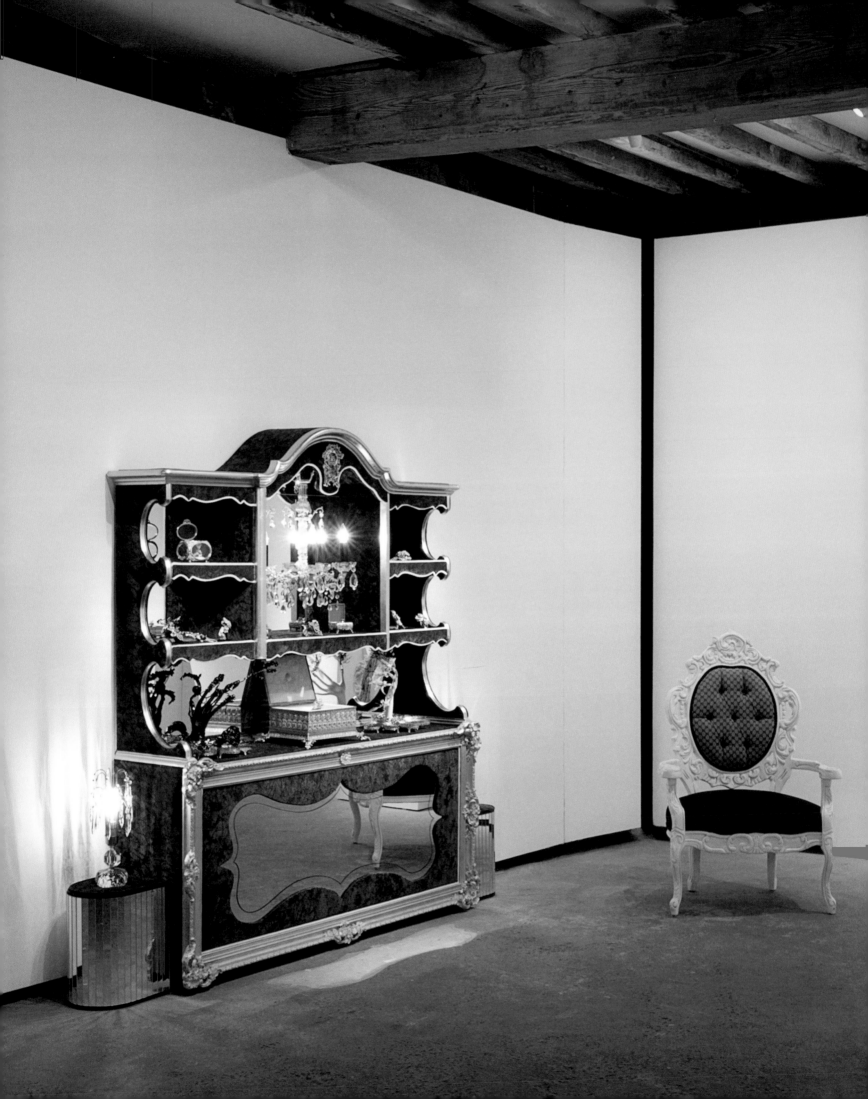

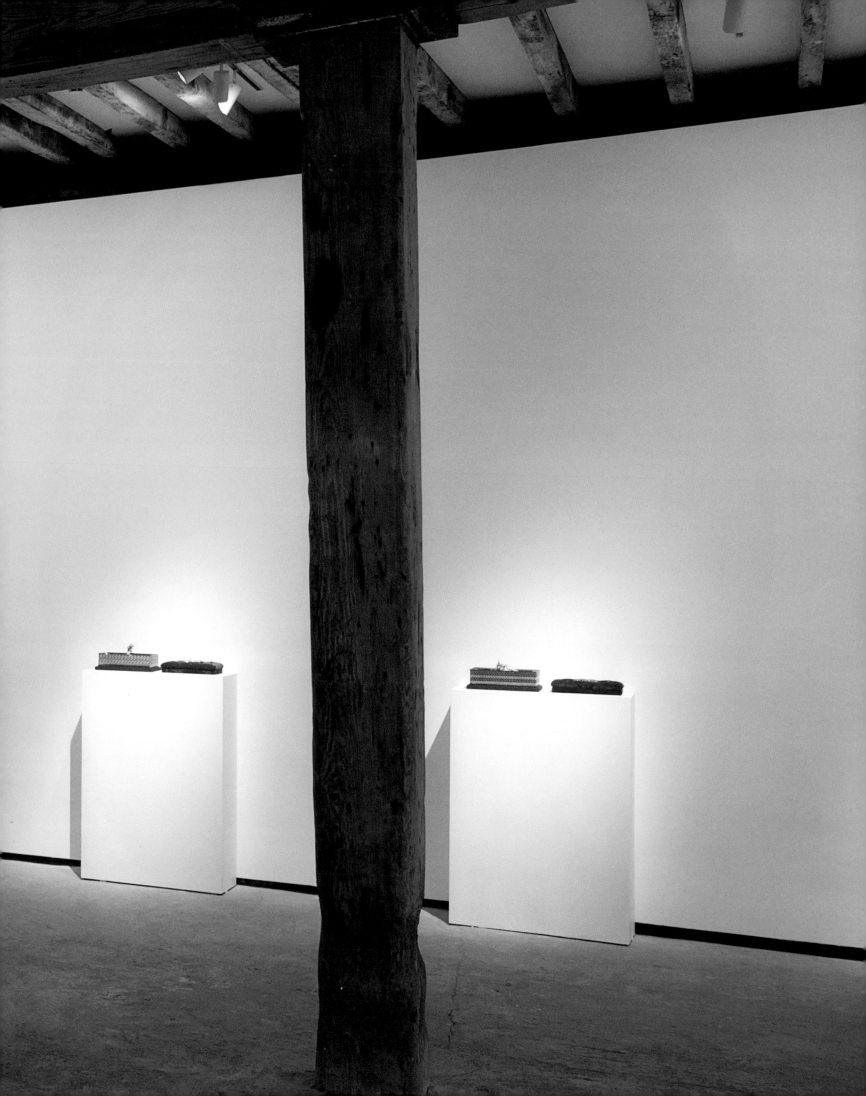

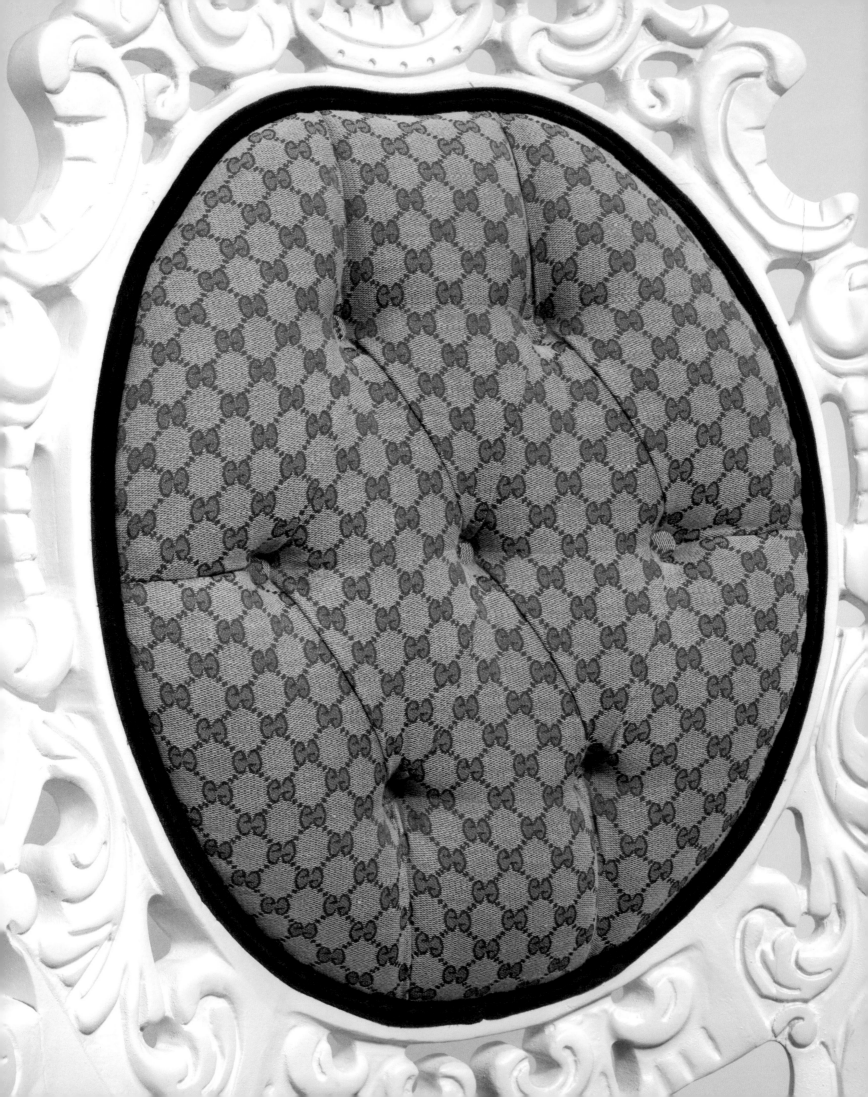

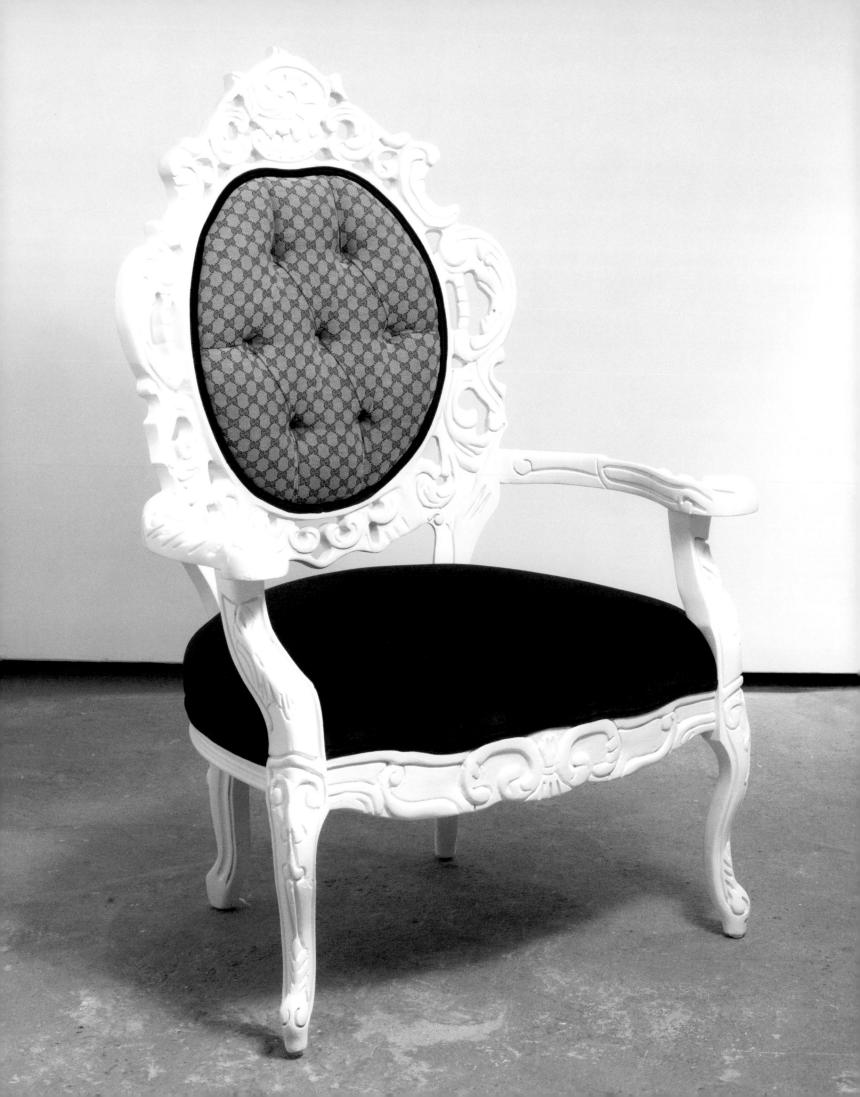

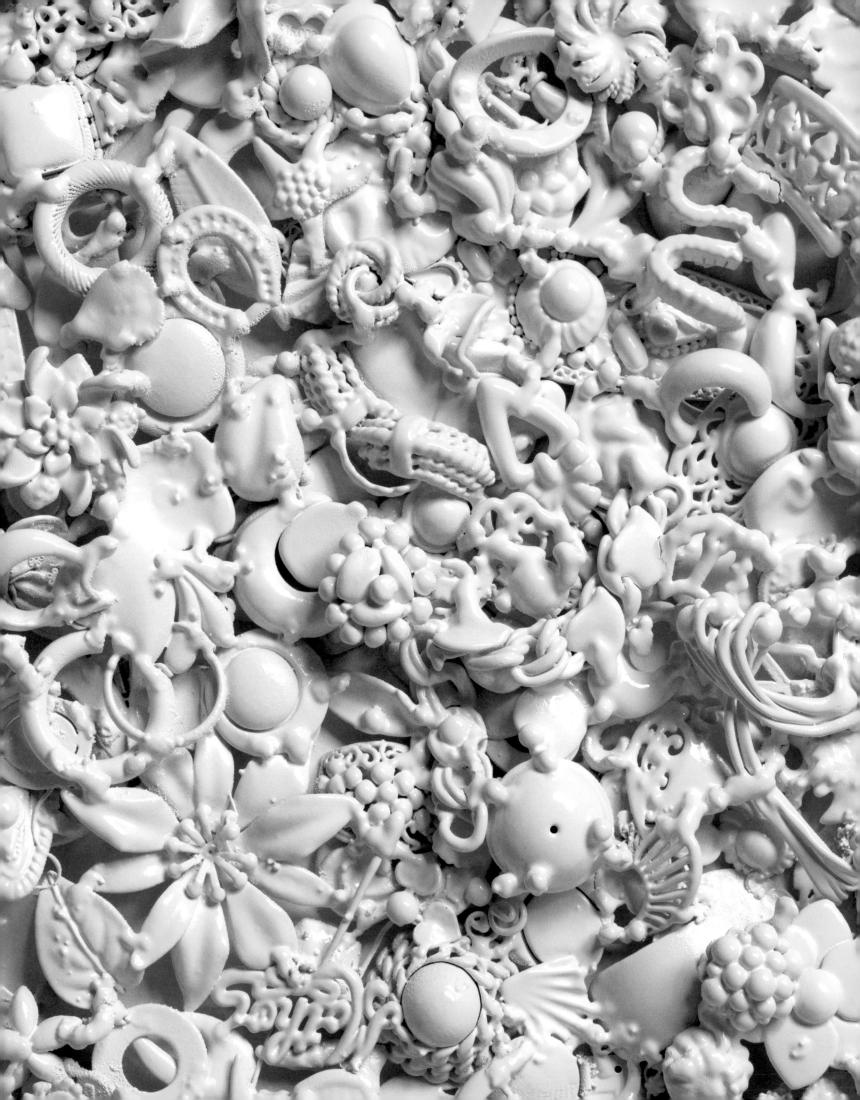

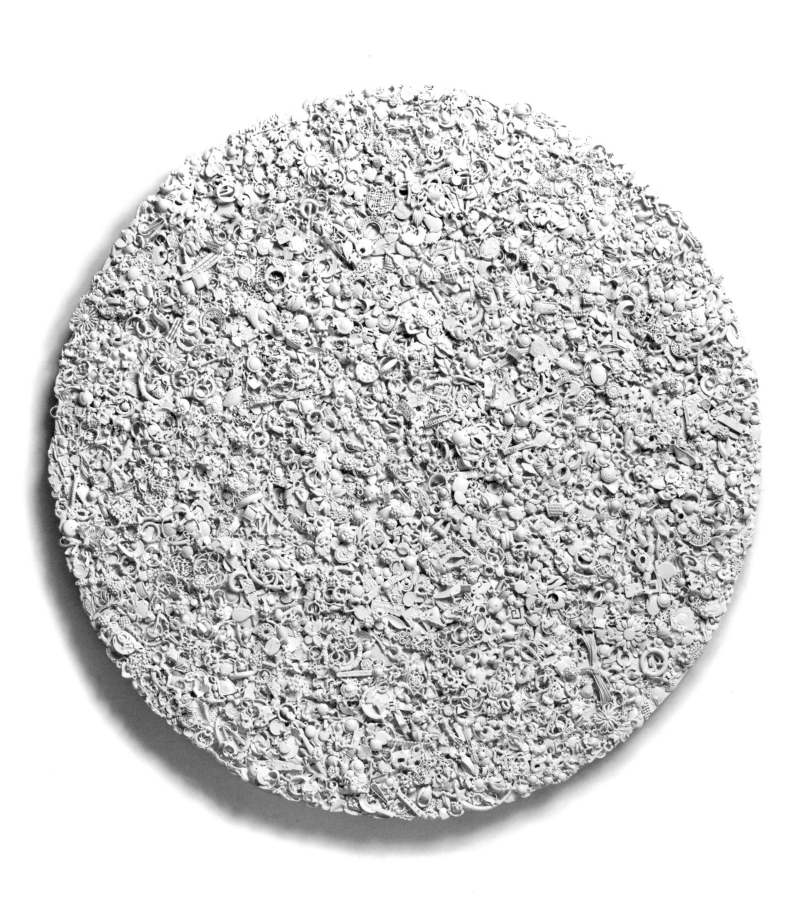

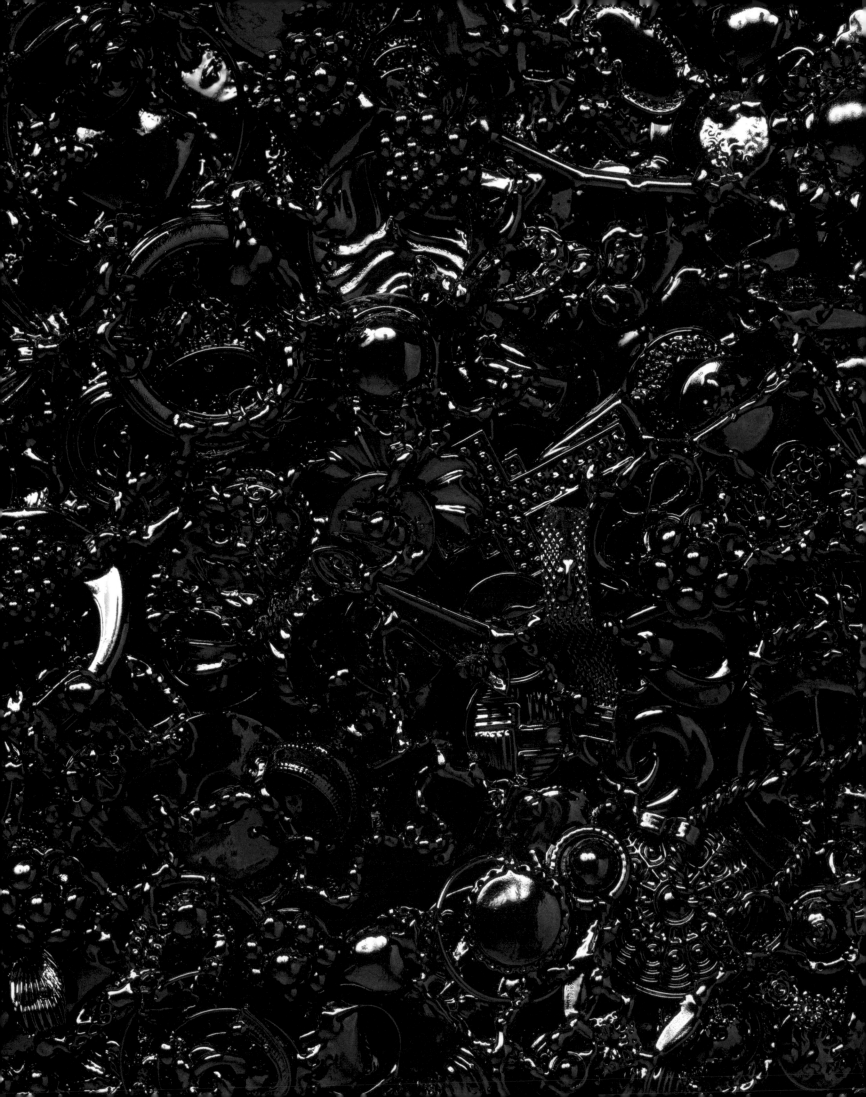

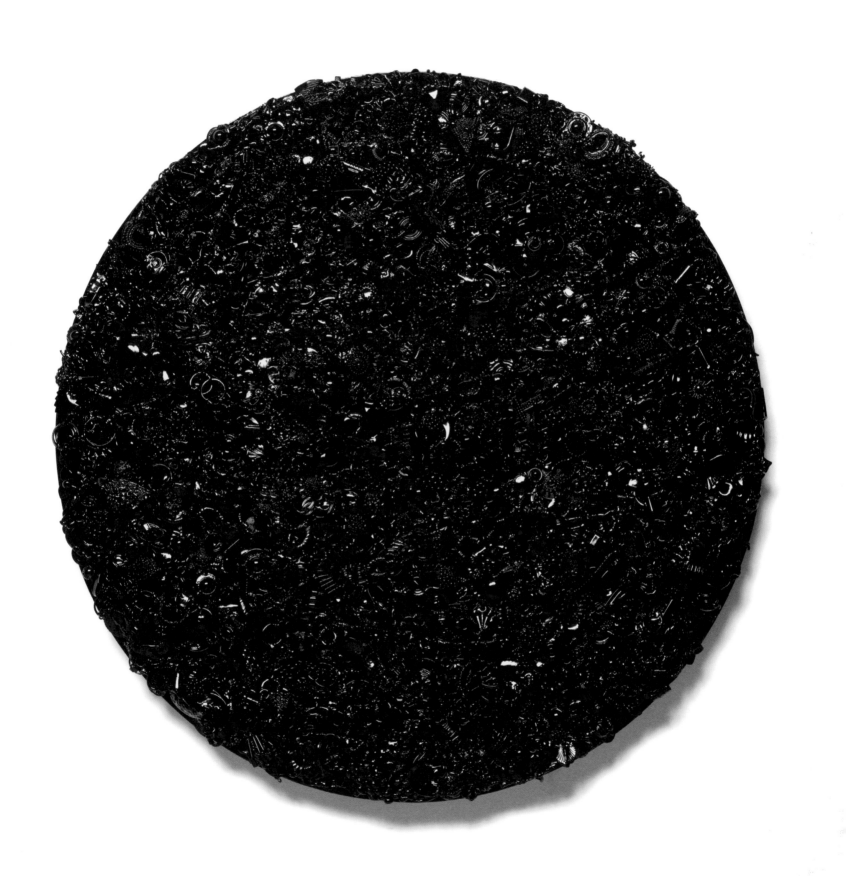

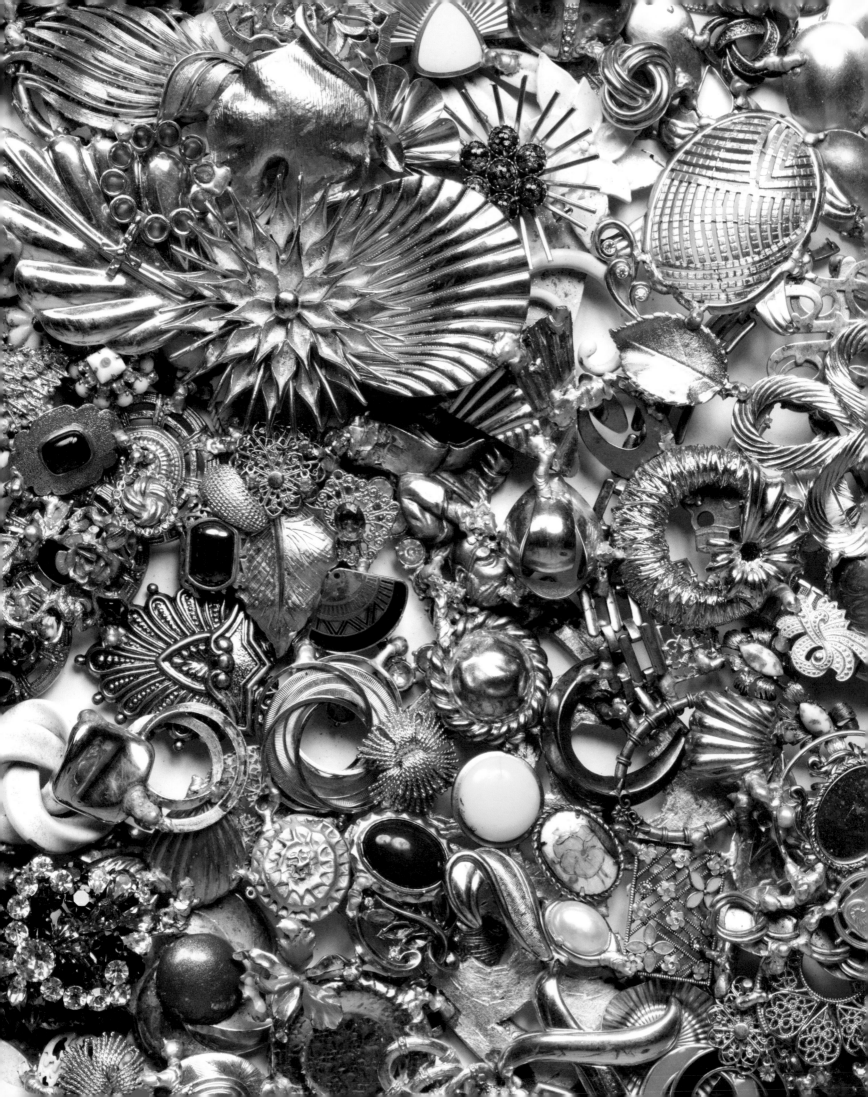

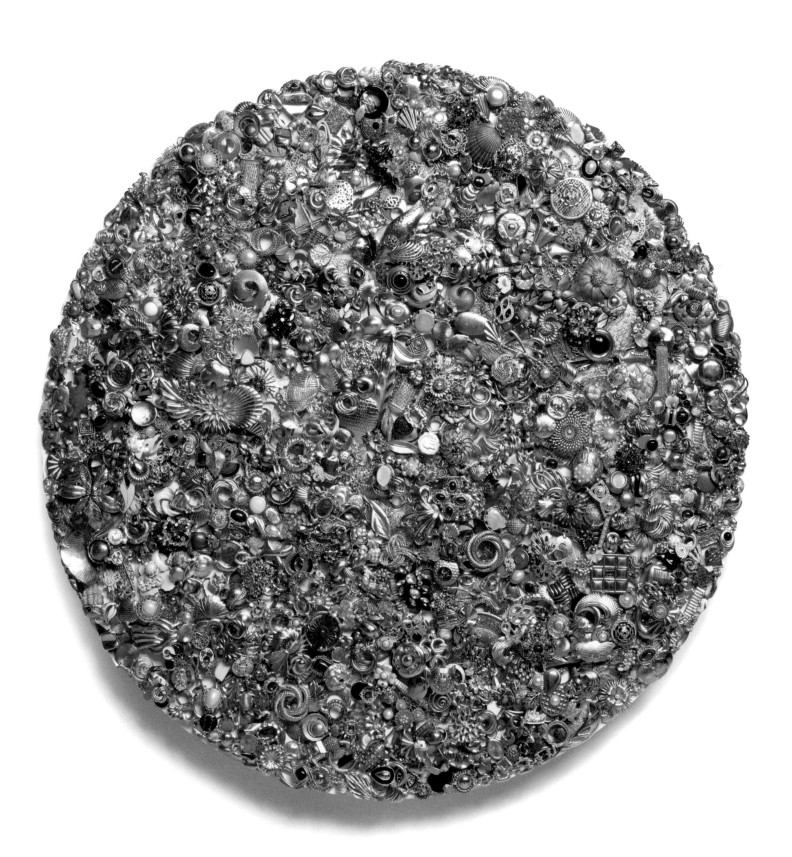

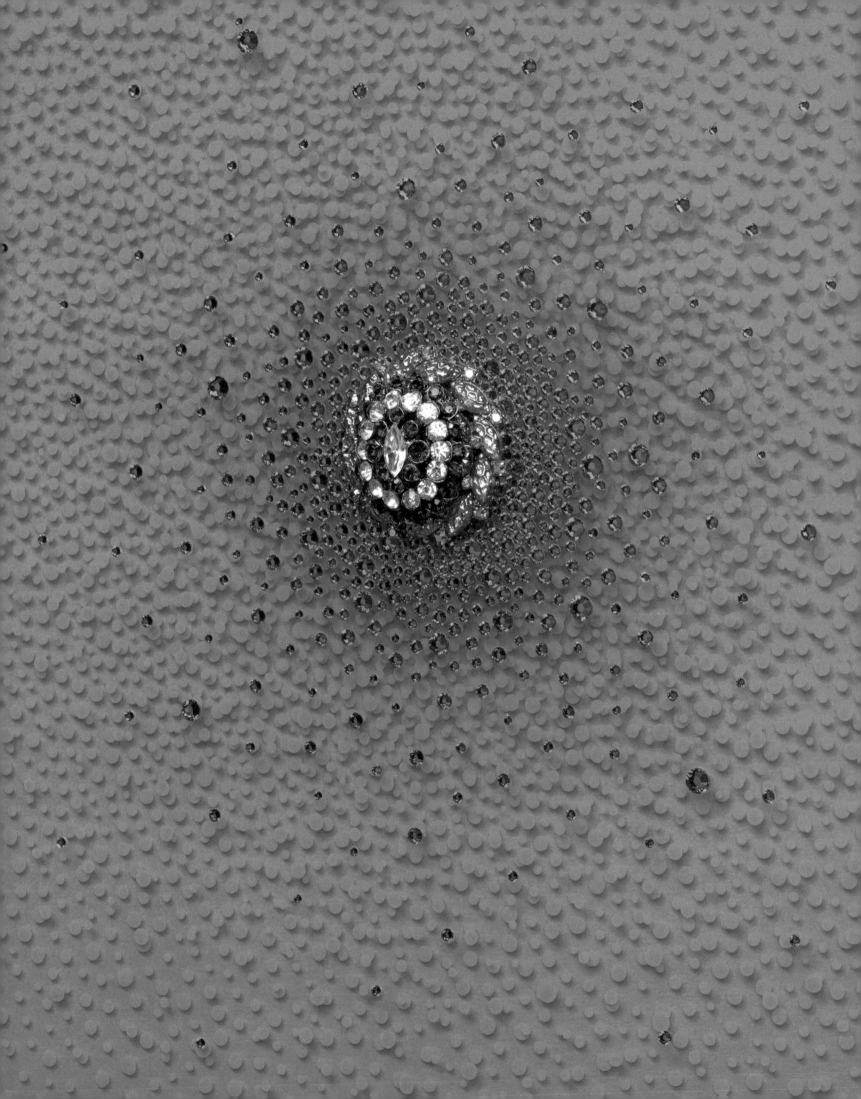

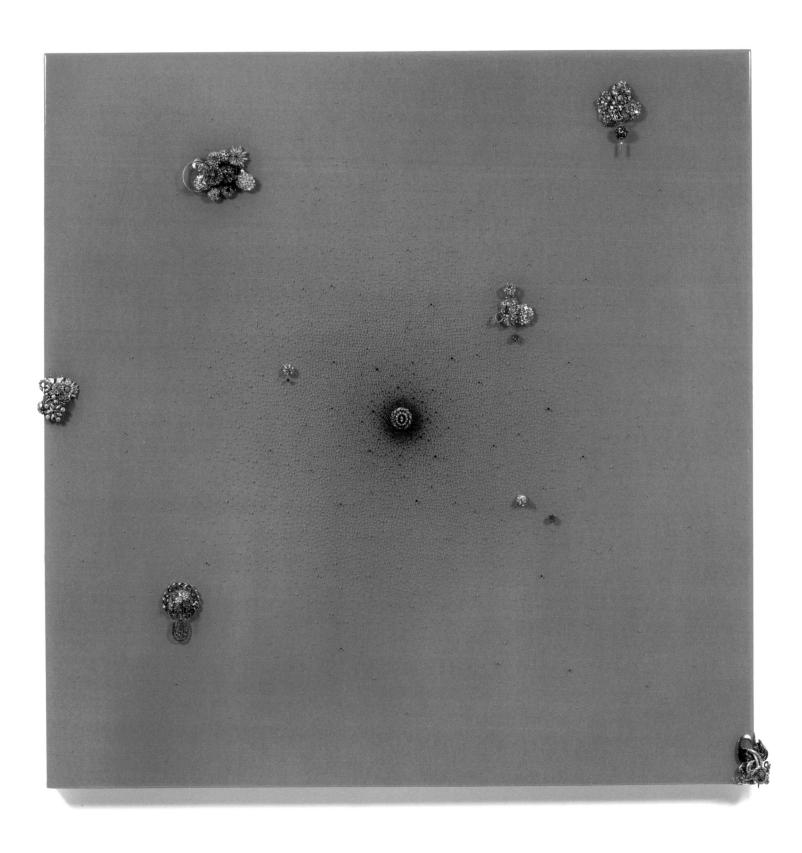

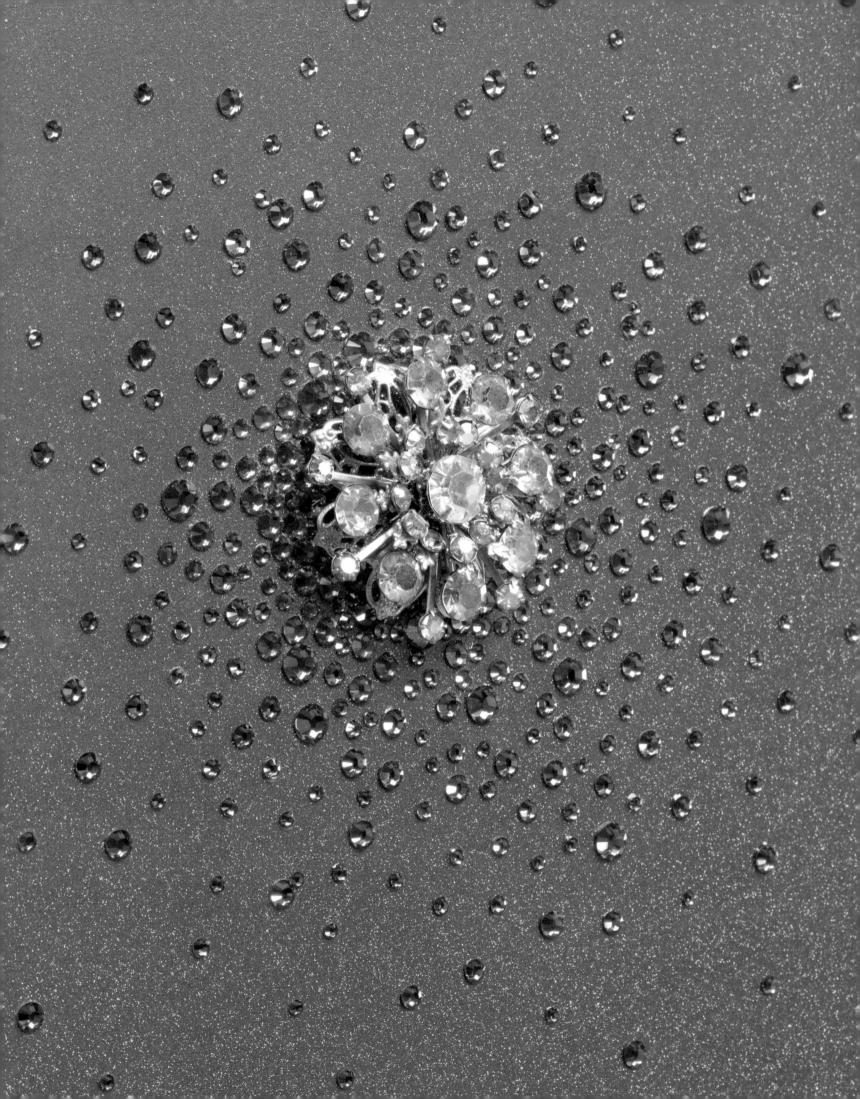

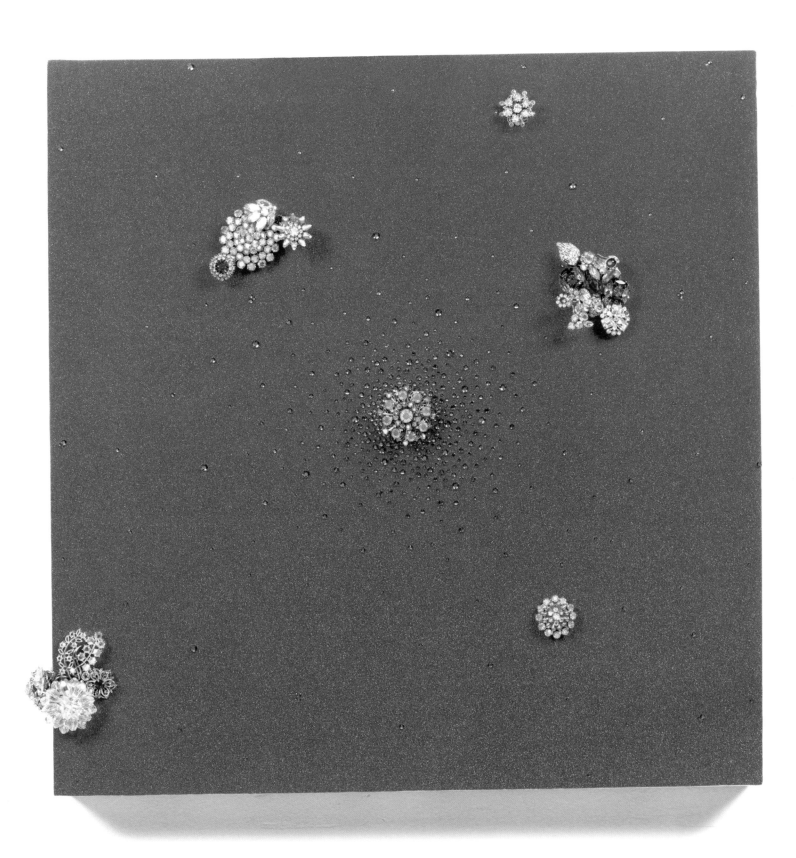

Thank you Claire Darrow, Willa Scout, Chris Mosier, The Standard family and Tony Arcabascio, Kai Regan, Andrea Albertini, Alexander Galan - who are the backbone to this project. The photographers and nail technicians -- without your eyes, cameras and creativity, this publication could not have been possible. My heart -- Casey, Paolo and Mila whose love and energy keep me focused and support my work unconditionally. Peter Doroshenko and Hector Gonzalez -- for their trust and devoted, creative friendship. Brittany Reilly, Jose and Rey Parla, Luis Gispert, Mickalene Thomas, Sally Berman, Fab Five Freddy, Paul Laster, Kim, Carlo and the crew at Paper Magazine, Jeanne Greenberg Rohatyn, Alissa Friedman and the whole team at Salon 94, Daniel Thiem and the New Museum, New York. Lastly, the team at Dzine Studio Inc. who assisted in creating this project – Kimberly Nieves, Lindsey Lewis, Bill Dougherty, Hector Gonzalez, James Prinz, DR, Andrea Donadio and Kay Amore.

IMAGE INFO and BIBLIOGRAPHY

1. Franciso de Goya Se Repulen (They Spruce Themselves Up). Caprichos No 51, 1796/97 Etching, burnished aquatint and burin

2. Finger and Toe Stalls. Egyptian, Reign of Thutmose III (r. 1479-1425 BCE.). Gold sheet. Fletcher Fund, 1926 (26.8.149, .154-.155, .157-.161, .163, .166, .190-.192, .195-.197, .200-.202). Image copyright © The Metropolitan Museum of Art / Art Resource, NY

3 Ancient cedar cosmetic box containing precious glass jars filled with oils and pigments, as well as cosmetic applicators. Originally published in What life was like on the banks of the Nile: Egypt, 3050-30 BC. By the editors of Time-Life Books

4. Back of a Woman's hand painted with henna originally published in The Painted Body. New York: Skira/Rizzoli, 1984, photographer unknown

5. The Devil applying cosmetics, English woodcut, early seventeenth century

6. Chinese Ancestral Portrait, Gouache on Paper, Date and Provenance unknown. Collection of Carlos Rolon, Chicago, Illinois. Photographer James Prinz

7. "Hampden" Oil on canvas transferred from panel, 77¼" x 55¼ " Scanned in the US from Sotheby's Catalogue, Important British Paintings 1500-1850 22 November 2007

8. Victorian Image, 1870s, photographer unknown

9. Photograph of the Antoine beauty salon in Paris, 1929, photographer unknown

10. An army officer receiving a manicure, 1934, photographer unknown

11. Woman painting her fingernails, Time & Life 1950s Getty Image, Photographer Nina Leen

12. Magazine advertisement, October 1968, photographer unknown

13. Magazine advertisement for The Colorifics, April 1973, photographer unknown

14. From John Hedgecoe's Advanced Photography, New York: Simon & Schuster, 1982, photographer John Hedgecoe

15. Newspaper feature published on August 31, 1997 New Jersey, USA, photographer unknown

Bibliography
Print:
Angeloglou, Maggie. A History of Makeup. London: The Macmillan Company, 1970.
Corson, Richard. Fashions in makeup. New York: P. Owen, 1972.
Fabius, Carine. Mehndi: the art of henna body painting. New York : Three Rivers Press, 1998.
Manniche, Lise. Sacred luxuries: fragrance, aromatherapy, and cosmetics in Ancient Egypt. Ithaca: Cornell University Press, 1999.
Pointer, Sally. The artifice of beauty: a history and practical guide to perfumes and cosmetics. New York: Sutton, 2005.
Polhemus, Ted. Hot Bodies, Cool Styles: New Techniques in Self-Adornment. London: Thames & Hudson, 2004.
Ragas, Meg, and Karen Kozlowski. Read my lips: a cultural history of lipstick. San Francisco: Chronicle Books, 1998.
Riordan, Teresa. Inventing beauty: a history of the innovations that have made us beautiful. New York: Broadway Books, 2004.
Roome, Loretta. Mehndi: the timeless art of henna painting. New York, New York: St. Martin's Griffin, 1998.
Santlofer, Doria . "Black Nail Polish: A Brief History." New York Magazine 24 July 2006.
The science of beautistry: official textbook approved for use in all the national schools of cosmeticians affiliated with Marinello. New York : National School of Cosmeticians, 1932.
Weinberg, Norma Pasekoff. Henna from head to toe!. North Adams: Storey Books, 1999.
Weingarten, Rachel C.. Hello gorgeous!: beauty products in America, '40s-'60s. Portland, OR: Collectors Press, 2006.

Web:
"Mary Quant Biography." MARY QUANT OFFICIAL WEBSITE. <http://www.maryquant.co.jp/>. Web, July 2011.
"Minx, About Us." MINX OFFICIAL WEBSITE.
<http://www.minxnails.com/>. Web, July 2011.
"OPI." OPI OFFICIAL WEBSITE.
<http://www.opi.com/>. Web, July 2011.
"Who is Essie, Essie through the years, Essie Nail Polish." ESSIE OFFICIAL WEBSITE. <http://www.essie.com/about-us/essie-through-the-years.php>. Web, July 2011.
"World's Most Expensive Nail Polishes."
<http://most-expensive.net/nail-polish>. Web, July 2011.

DZINE
Nailed

Texts
Kim Hastreiter, Carlos Dzine Rolon, and Brittany Reilly

Photography
Kai Regan / cover & images on black
James Prinz / exhibition images

Art Direction
Tony Arcabascio

Editorial Direction and Production
Claire Darrow

Project Management for the artist and Dzine Studio Inc.
Brittany Reilly, David Rasool Robinson, Andrea Donadio and Serena Maria Daniels

All exhibition artworks courtesy of Salon 94, New York

[DAMIANI]

Damiani editore
via Zanardi, 376
40131 Bologna, Italy
t. +39 051 63 56 811
f. +39 051 63 47 188
info@damianieditore.it
damianieditore.com

StandardPRESS

23 E.4th Street 5th Floor
New York, NY 10003
standardculture.com

Printed in October 2011 by Grafiche Damiani, Bologna, Italy.

ISBN 978-88-6208-205-1

Printed on Arcoset 140 gram, Condat Silk 150 gram, Condat Silk 200 gram

Printed in Italy by
Grafiche Damiani
www.grafichedamiani.it

Distributed in the United States of America by
D.A.P./Distributed Art Publishers, Inc.
155 Sixth Avenue
New York, NY 10013
www.artbook.com